M000159281

Movies with Meaning

ALSO AVAILABLE FROM BLOOMSBURY

Movies with Meaning

EXISTENTIALISM THROUGH FILM

DANIEL SHAW

Bloomsbury Academic
An imprint of Bloomsbury Publishing Plc

B L O O M S B U R Y
LONDON • OXFORD • NEW YORK • NEW DELHI • SYDNEY

Bloomsbury Academic

An imprint ofBloomsbury Publishing Plc

50 Bedford Square	1385 Broadway
London	New York
WC1B 3DP	NY 10018
UK	USA

www.bloomsbury.com

BLOOMSBURY and the Diana logo are trademarks of Bloomsbury Publishing Plc

First published 2017

© Daniel Shaw, 2017

Daniel Shaw has asserted his right under the Copyright, Designs and Patents Act, 1988, to be identified as Author of this work.

All rights reserved. No part of this publication may be reproduced or transmitted in any form or by any means, electronic or mechanical, including photocopying, recording, or any information storage or retrieval system, without prior permission in writing from the publishers.

No responsibility for loss caused to any individual or organization acting on or refraining from action as a result of the material in this publication can be accepted by Bloomsbury or the author.

British Library Cataloguing-in-Publication Data
A catalogue record for this book is available from the British Library.

ISBN:	HB:	978-1-4742-9929-9
	PB:	978-1-4742-9930-5
	ePDF:	978-1-4742-9928-2
	ePub:	978-1-4742-9931-2

Library of Congress Cataloging-in-Publication Data
A catalog record for this book is available from the Library of Congress.

Typeset by Integra Software Services Pvt. Ltd.
Printed and bound in India

This book is dedicated to my wife Marie,
daughter Anna and son Patrick,
for the sake of whom I exist,
and without whom I would be lost.

CONTENTS

ACKNOWLEDGEMENTS

My thanks to Lock Haven University and President Michael Fiorentino for granting me an Alternative Workload Leave for Fall semester, 2014, during which time I was able to virtually complete the first draft of this manuscript. I am also grateful to Liza Thompson for acquiring the title for Bloomsbury Academic. My work benefitted from comments by several colleagues, at conferences and elsewhere, and by students in my Existentialism class. I would also like to thank Manikandan Kuppan and Frankie Mace for shepherding this volume into publication.

Introduction: Why Existentialism and Film?

From the start, the philosophical movement that came to be known as existentialism was associated with literature. Søren Kiekegaard used several literary pseudonyms to express his various perspectives on philosophical issues. Friedrich Nietzsche's doctoral dissertation, and greatest public success, proposed a theory of tragedy (and its rebirth in Wagnerian opera), and he is known as a 'literary' (rather than systematic) philosopher. Both Jean-Paul Sartre and Albert Camus expressed their respective philosophies in novels, short stories and plays, and were deeply appreciative of the cinema. Sartre wrote a rejected screenplay for John Huston's biopic *Freud*, and his paramour Simone de Beauvoir published an essay in a 1959 edition of *Esquire* magazine on the iconic power of Brigitte Bardot.

All this occurred because there is a natural affinity between existential philosophy and narrative forms of art. Existentialists agree on the primacy of individual existence, of the lived experience of concrete human beings. Cinematic narratives tell stories of beings such as ourselves, helping us to make sense of our existence and opening up possibilities that we might never have considered otherwise.

Narratives can convey the meaning of philosophical theories by showing their behavioural implications. Sartre's most famous novel, *Nausea*, and Camus's bleakest play, *Caligula*, embody their absurdist philosophies so aptly that these literary creations are (at least in some ways) more instructive than their philosophical treatises on the subject. They depict their protagonists in complex ways that illuminate some tough-to-understand philosophical concepts.

Friedrich Nietzsche, the archetypal existentialist, called himself a perspectivist; he stressed how different the world looks from individual to individual and was critical of how common it is for us to take our own way of looking at things as 'the truth'. Films are explicitly perspectival: they depict events from certain points of view (first person, third person, omniscient detached, etc.), which helps make us aware that there are perspectives other than our own through which to view the world.

The narrative connection to existential philosophy can also be made with reference to famed Nietzsche scholar Alexander Nehemas and his influential book *Nietzsche: Life as Literature*. For Nehemas (whose approach I enthusiastically endorse), Nietzsche was also an aestheticist, by which he meant that Nietzsche had the tendency to view human beings as most fundamentally defined by the stories we tell ourselves about ourselves.

We gain material for *our* unique narrative from the stories of others, integrating aspects of our favourite tales into the telling of our own odyssey. In the age of movies, cinematic stories define us more than any other type of narrative. So it is of the utmost importance to be able to appreciate the philosophical implications of films, in order to better understand ourselves as well.

Existentialist philosophy can help us to appreciate what (at least some) films mean, and films can help us see more clearly what philosophers have in mind as well. The theoretical treatises of most of the giants of existential philosophy, including Kierkegaard, Heidegger, Sartre and Foucault, are extremely challenging for

even the most attentive of readers. Films show us the concrete implications of living out their philosophies (such as individuals who are willing to die for the causes they believe in), allowing us to better appreciate their existential import.

Before going into specifics, let me describe the limited didactic scope of my book here. The following analyses do *not* claim to reveal what the filmmakers intended, or to have the last word on what the films themselves *really* mean. This book carefully avoids such locutions as 'the film contends' or 'this movie argues', which seem to attribute intentional states to inanimate objects, nor does it often speculate on the intentions of the filmmakers (only when those intentions appear explicitly philosophical, as is the case with Woody Allen and Terrence Malick).

These readings fail to do complete justice to some of the aesthetic elements in the films, due to their primary focus on narrative content. But I hope that each chapter lucidly explicates a philosophy, by demonstrating how the movie illustrates its existential implications, and by showing how the philosophical content of the story line helps us to interpret a difficult film. The meaning of a film cannot be exhausted by an account of its narrative content. A lot of what it says is in how it says it, and each of the chapters will note the characteristic cinematic techniques of their respective movies and relate them to the philosophical ideas being considered.

But the 'meaning' of the movies on which I will be focusing is primarily *narrative*. This book will cite and unpack the significance of relevant quotes from these films, highlighting the striking similarities between the characters and events depicted therein and the philosophies with which they are paired. Whether those similarities are intentional or coincidental, they will be shown to exist, and hence to justify (and render useful) relating a particular existentialist philosophy to a particular film. If the philosophies I discuss have real insights into human existence, those insights can be relevant to appreciating films by directors who have no direct knowledge of the philosophers who proposed them.

Films can be considered 'philosophical' if they can be fruitfully related to philosophical theories in the process of interpreting them. That doesn't mean that they are intentionally based on such philosophies (although some are), nor that they make unique contributions to the philosophical conversation about nihilism and

the meaning of life (though some do). What it *does* mean is that such films provide striking illustrations of some of the major tenets of the philosophies with which they are paired. Let me explain specifically.

The book begins by examining two philosophical precursors of existentialism, the Hindu-influenced pessimism of Arthur Schopenhauer and the radical egoism of Max Stirner. Each sounded themes that would become central to the subsequent movement, and each stopped short of recognizing the radical implications of the emerging view. The films they are paired with, *Waking Life* and *Hud*, show us what an Eastern-influenced pessimistic world view, and the perspective of an unrepentent Egoist, might look like.

Following a roughly chronological trajectory, this book then proceeds to summarize the philosophy of Søren Kierkegaard, who, along with Friedrich Nietzsche, is considered to be one of the two major founders of the movement. This chapter will focus on his analysis of the various types of despair to which men fall prey, and his argument that the only way to avoid these depressed and alienated states is through faith in God. Kierkegaard is justly famous for having advocated an irrational 'leap of faith', for his psychological insights into the varied depths of despair and for his critique of organized religion and the socially conventional 'mass man' that it helps produce. His claim that truth is essentially subjective, which means that what makes a belief true is *how* it is held (i.e. with passionate intensity) and not *what* is believed in, was highly influential, that in itself qualifies him as being one of the first existentialists. We can better understand the different types of despair he delineates by seeing them exemplified in Ingmar Bergman's *Winter Light*, which also offers an inspirational depiction of true belief in the unwavering faith of one of its humblest characters.

Friedrich Nietzsche, and his notorious doctrines of the death of God and the overman, is our next subject. In Nietzsche, several of the most central themes of existentialism are sounded, including the non-existence of a spiritual realm, the subsequent threat of nihilism, the primacy of the individual, the human creation of value and the acceptance of our mortality. Given Nietzsche's unfortunate (and largely undeserved) association with the Nazis in the post-war world, it is hard to find anything like his notion of the *Übermensch* depicted in a positive light in mainstream films. But Ayn Rand has, in her script for the film version of *The Fountainhead*, revealed an

unacknowledged intellectual debt to Nietzsche, and her ideal artist, architect Howard Roark, possesses a number of the character traits that fulfill Nietzsche's proposed criteria for achieving the status of overman.

One of Nietzsche's more enthusiastic commentators was Martin Heidegger, who wrote a four-volume treatise on him. Heidegger's philosophy was arguably of even greater influence than that of his predecessor, but together they helped define the problems that dominated much of Continental Philosophy for the rest of the twentieth century. He is the first of three figures to whom we will devote two chapters, as their philosophies evolved significantly over the course of their careers.

Heidegger's unfinished classic, *Being and Time* (1925), would help shape an age. His analysis of *Dasein* (human beings) as deriving life's meaning from commitment to future projects proposed a radically new conception of the temporality of human existence. But his personal flirtation with the Nazis raised questions about whether there were any limits to authentically being oneself. His theory of personhood is directly relevant to solving one of the most persistent questions in the philosophy of artificial intelligence (and in movies about cyborgs and robots): Can a humanly fabricated organism be a person, in the sense relevant for having political rights (like the right to life) or for being loved? This issue is at the heart of Ridley Scott's sci-fi classic, *Blade Runner*, where at least one of the artificial replicants appears to qualify as Dasein by Heidegger's lights.

Heidegger's subsequent writings seem to shift the focus from an analysis of *Dasein* in general to narrower explorations of the meaning and social significance of crucial cultural forms of expression, such as art and technology. His detailed accounts of three exemplary artworks – Van Gogh's painting of a pair of peasant shoes, a Greek temple and a Rilke poem about a Roman fountain (in his 1930s essay 'The Origin of the Art Work') – illustrate his notion that true art praises what makes life worth living, inspiring conviction in the values that it shows in a positive light. A study of any of the films of former Heidegger scholar Terrence Malick would help fill in the details of what it means for art to reveal the truth and create value. But his best marriage of complex cinematic form and Heideggerean content can be found in his multifaceted meditation on war and nature, *The Thin Red Line*.

Next we have to tackle the complex philosophies of the two most influential French existentialists of the mid-twentieth century – Albert Camus and Jean-Paul Sartre. Each will require two chapters to do justice to the evolution of his world views. Camus's early absurdism gives way to an almost classical humanism, which led him to denounce the nihilism of his earlier views and affirm the value of each and every individual human life. He acted on his newfound humanism and engaged in public resistance to war, capital punishment and exploitive colonialism for the rest of his days. Sartre evolves from a position where he described human consciousness as a nothingness at the heart of Being to advocating an existentialist version of Marxism that takes up the gauntlet and urges the violent overthrow of capitalism.

Relating *Leaving Las Vegas* to early Camus will highlight a tension within his absurdist philosophy. In *The Myth of Sisyphus*, he described all human striving as meaningless, yet condemned people who choose to end their lives after recognizing its absurdity. Camus also sketched vivid examples of heroic character types who lived lives of absurd freedom in that early essay. Ben Sanderson, the protagonist in *Leaving Las Vegas*, embodies many of the traits of Camus's absurd hero, while making suicide his committed project. We will explore what Camus might have thought of the man, especially in light of the self-destructiveness of so many of his own literary protagonists.

By the time he wrote *The Rebel*, after the Second World War, Camus had thrown off his absurdist trappings and become a committed social activist and a moderate voice at an extreme time for France and its colonies. His central thesis there was that resisting authority requires affirming some positive value that you are unwilling to permit that authority to defile. Camus declared the lives of individual human beings to be pre-eminent, and for the rest of his career, he condemned murder in all of its politically sanctioned forms. In *Missing*, a New York businessman flies down to Chile to find his correspondent son, who disappeared days after a military coup that the United States supported. He gets a lesson in global politics, eventually finds out that his son had been murdered by the Chilean military police and ends up suing the Embassy and the State Department for its tacit consent to this atrocity. The story of Ed Horman's radicalization captures some of the rebellious spirit

of the late 1960s and early 1970s, when even members of Nixon's 'Silent Majority' started speaking out against their government.

While there is much in *Being and Nothingness* that remains of vital interest, I find Sartre's account of human Being-for-others (the Hegelian notion that we require recognition from others to feel like we lead meaningful lives) to be the most intriguing aspect of that work, and also the most relevant to this day and age. In his view, romantic love and monogamous marriage are ultimately self-defeating endeavours. His pessimistic conclusions are almost perfectly mirrored by developments in Woody Allen's film *Husbands and Wives*, and in this case at least, the similarities may well be more than coincidental.

In his later writings and public statements, Sartre has a good deal less to say about romantic love and the self-alienation that results from being with others. His newfound passion was inciting the revolution that would catalyse the collapse of capitalism. In *Critique of Dialectical Reason*, Sartre attempted to translate the economics of *Das Kapital* (Marx's defining work on capitalism) into an existential blueprint for social action. Famously disagreeing with Camus, Sartre condoned the murderous tactics of terrorism and guerrilla warfare used by the Algerians and the Vietnamese against their French colonial oppressors. The broad applicability of his reasons for doing so will be illustrated here by the movie *Michael Collins*, which tells the story of the violent rebellion that led to partial Irish Independence, and the leader of that successful guerrilla war against the British occupation.

Sartre's 'significant other' for decades, Simone de Beauvoir was a profound philosopher in her own right. She is credited with formulating one of the first (and most powerful) versions of feminist philosophy in *The Second Sex* (1949) and the only consistent existentialist ethics in *The Ethics of Ambiguity* (1947). Her critique of gender stereotypes, and the traditional social roles on which they are based, finds a detailed counterpart in the film version of the early 1960s novel *Revolutionary Road*. The married couple in this story tries to reverse their traditional roles, seeking to free themselves from gender stereotypes in very much the way that de Beauvoir recommended.

The book concludes with a discussion of the Nietzschean philosophy of Michel Foucault and the genealogy of the insane

asylum that he traces in *Madness and Civilization*. Foucault wasn't the first to suggest that many who are institutionalized are saner than average (see *Revolutionary Road*), but he was one of the first to critique mental institutions with such philosophical and sociological insight. Many striking similarities will be pointed out between the bleak depiction of life in the State asylum featured in *One Flew Over the Cuckoo's Nest* and Foucault's withering analysis of the repressive power of such generally reputable institutions.

The existentialist philosophers we will discuss had all given up the search for timeless essences of truth, justice, goodness and human nature. Rather, they sought to restore the choice of what such notions mean to particular human beings, and to particular societies, at particular times. For all their differences, the existentialists instituted a gestalt shift in philosophy, which, by the mid-twentieth century, no longer focused primarily on epistemology and linguistic analysis and had to address the issue of the meaning of Being.

Existentialists (and I consider myself to be one) also believe that individuals define themselves by committed action over time. If human nature has an essence (whether it be spirit or reason, hedonism or altruism), then our only choice would be whether or not to fulfil that essence. But if we are truly free to set our own priorities, then we are able to define ourselves, by choosing the hierarchy of values we commit to over the course of our lifetimes.

This is also where the films come in. The cinematic protagonists I have chosen act and think in ways that either reflect or confirm the values and theories of the philosophies with which I have paired them. In doing so, each embodies some of the major tenets of that philosophy, showing us what it is like to see the world from that point of view. Hopefully, in the process of watching such films philosophically, readers will be made aware of the limits of their own personal perspectives and of the existence of other viewpoints besides their own. If this book achieves that task, it will be fulfilling one of the fundamental purposes of education, as both Schopenhauer and Nietzsche would have agreed.

It will do so without relying on claims regarding the intentions of filmmakers. If the philosophers discussed herein are on to something, then it should be reflected in the actual or fictional existences of recognizable human beings. Even if filmmakers are not explicitly aware of the philosophical foundations of the perspectives

that they depict, they can tell cinematic tales that relate to those foundations. Part of the process of interpretation that Heidegger called 'hermeneutics' involves going from theory to practice and back again. This book proceeds from theoretical characterizations of a variety of existentialist perspectives to concrete interpretations of particular works of art. I am primarily asking a Heideggerean question: 'How does this particular film praise its subject matter, and inspire conviction by privileging a perspective and showing it in a positive light?' My answer in each case will be offered by relating existentialist theories to cinematic practice.

CHAPTER ONE

Dreams, Illusions and Will in *Waking Life* and *Studies in Pessimism*

Arthur Schopenhauer is one of the few Western philosophers to have ever incorporated significant elements of Eastern thought in his world view. His amalgam of these two contrasting perspectives was based on an inherently pessimistic outlook that proposed a metaphysical theory of blindly striving Will as the

thing-in-itself behind all appearances in the world (more on this soon). He rejected Western teachings about God, freedom and immortality, preferring Buddhism and Hinduism to Christianity and determinism to theories of free will. He was an eloquent cynic, who would dispassionately discuss suicide while relishing an upper-class meal among friends. Richard Linklater's animated film *Waking Life* (2001) is difficult to understand, in part because it represents a similar synthesis of Eastern and Western notions of reality. Relating Schopenhauer's philosophy to *Waking Life* will aid in our comprehension of both.

Schopenhauer was an essentialist, who thought he had discovered the reality that is behind all deceptive representations. But he had a significant influence on the philosophy of Friedrich Nietzsche, and, at least in that sense, was a precursor to existentialism. His central work, *The World as Will and Representation* (first published in 1818), is equal in degree of difficulty to Heidegger's *Being and Time*, Sartre's *Being and Nothingness* or Hegel's *Phenomenology of Spirit*, all of which seem virtually impenetrable at times. But, luckily, Schopenhauer popularized his more esoteric notions in a collection of subsequent essays called *Parerga and Paralipomena*, which made him famous. We will be analysing selections from this work, which are also collected in a separate volume called *Studies in Pessimism*.

The first essay, 'On the Sufferings of the World', begins with a remarkable claim:

> Unless *suffering* is the direct and immediate object of life, our existence must entirely fail of its aim. It is absurd to look upon the enormous amount of pain that abounds everywhere in the world, and originates in needs and necessities inseparable from life itself, as serving no purpose at all and the result of mere chance. Each separate misfortune, as it comes, seems, no doubt, to be something exceptional; but misfortune in general is the rule.[1]

Schopenhauer rejects the possibility (raised by David Hume and others) that a devilish and mischievous God is behind it all, while agreeing with Hume that the amount of suffering in the universe makes the existence of a perfect designer seem highly improbable.

In Schopenhauer's estimation, most Western thinkers, including Plato and Aristotle, have made the same profound error:

> I know of no greater absurdity than that propounded by most systems of philosophy in declaring evil to be negative in its character. Evil is just what is positive; it makes its own existence felt. ... It is the good which is negative; in other words, happiness and satisfaction always imply some desire fulfilled, some state of pain brought to an end.[2]

Human life is miserable because our behaviour is driven by our desires, over which we can have little control. Happiness comes from the satisfaction of desire, but like the compulsive scratcher, the more we give in to our desires, the greater and more insatiable they become.

Both Eastern and Western religions have reached the conclusion that physical existence is laden with misery. Both also agree that the major causes of suffering are worldly desires and that the way to achieve peace is to overcome those desires. Schopenhauer believed that human beings are generally miserable because we are governed by the instinct for survival and are condemned to make fruitless attempts to gratify our insatiable impulses. Optimists claim that, on balance, there is more pleasure than pain in existence. As a test of that statement, Schopenhauer suggested that his readers should 'compare the respective feelings of two animals, one of which is engaged in eating the other'.[3]

Schopenhauer concludes that it would have been better had humanity never been born.[4] A resolute bachelor himself, he cynically asked:

> If children were brought into the world by an act of pure reason alone, would the human race continue to exist? Would not a man rather have so much sympathy with the coming generation as to spare it the burden of existence? or at any rate not take it upon himself to impose that burden upon it in cold blood.[5]

Advocating an ethic of compassion based on his Buddhist-influenced description of existence, Schopenhauer came to the most pessimistic of conclusions: 'The conviction that the world and man is something

that had better not have been, is of a kind to fill us with indulgence towards one another.'[6] This feeling for our fellow sufferers is also justified by Schopenhauer's determinism ... none of us are to blame for our actions. Only a forgiving attitude can help:

> *Pardon's the word to all!* Whatever folly men commit, be their shortcomings or their vices what they may, let us exercise forbearance; remembering that when these faults appear in others, it is our follies and vices that we behold. They are the shortcomings of humanity, to which we belong; whose faults, one and all, we share; yes, even those very faults at which we now wax so indignant, merely because they have not yet appeared in ourselves.[7]

Moralizing simply worsens the human condition.

The primary causes of our dissatisfaction with life are clear: ambition for public power, the search for honour, greedy materialism, and an obsession with the future (which robs us of our ability to enjoy the moment). Furthermore,

> how insatiable a creature is man! Every satisfaction he attains lays the seeds of some new desire, so that there is no end to the wishes of each individual will. And why is this? The real reason is simply that, taken in itself, Will is the lord of all worlds: everything belongs to it, and therefore no one single thing can ever give it satisfaction.[8]

The fulfilment of desire is always fleeting and simply gives rise to further passions.

Schopenhauer acknowledged the wisdom of the Four Noble Truths of Buddhism: Life is essentially suffering, suffering is caused by desire, desire can be overcome and there is a way of doing so. He also embraced the therapeutic recommendations of the Buddha: detachment from the ego and from things in this life will free the compassion within us and allow us to attain what peace there is in material existence.

The essence of everything is what Schopenhauer called Will:

> He maintains that the world as it is in itself ... is an endless striving and blind impulse with no end in view, devoid of knowledge,

lawless, absolutely free, entirely self-determining and almighty. Within Schopenhauer's vision of the world as Will, there is no God to be comprehended, and the world is conceived of as being meaningless. When anthropomorphically considered, the world is represented as being in a condition of eternal frustration, as it endlessly strives for nothing in particular, and as it goes essentially nowhere. It is a world beyond any ascriptions of good and evil.[9]

Schopenhauer argued that turning away from these stark realities and embracing the consoling illusions of Christianity is irrational:

> There are two things which make it impossible to believe that this world is the successful work of an all-wise, all-good, and, at the same time, all-powerful Being; firstly, the misery which abounds in it everywhere; and secondly, the obvious imperfection of its highest product, man, who is a burlesque of what he should be.[10]

Rather than believe in consoling illusions, we must face existence as it is, in all its futility.

Despite this consensus, Western and Eastern thinkers take fundamentally different approaches to determining how to live:

> Between the ethics of the Greeks and the ethics of the Hindoos, there is a glaring contrast. In the one case ... the object of ethics is to enable a man to lead a happy life; in the other, it is to free and redeem him from life altogether.[11]

The key to Eastern thought, which Schopenhauer adopts as the cornerstone of his philosophy, is the claim that 'a man must turn his back upon the world, and that the denial of the will to live is the way of redemption'.[12] In Buddhist thought, only such a denial will end the cycle of rebirth that continues our suffering in further incarnations.

The Will to Live also involves the desire to procreate, and human sexuality is one of the most prominent causes of our misery. The religious demand to be monogamous, and Western notions of romantic love, violates our deepest natural inclinations. To take

heed of Schopenhauer's philosophy, one must accept the fact that human existence is essentially miserable:

> If you accustom yourself to this view of life you will regulate your expectations accordingly, and cease to look upon all its disagreeable incidents, great and small, its sufferings, its worries, its misery, as anything unusual or irregular; nay, you will find that everything is as it should be.[13]

Just as the Buddha himself advocated, we can change our attitudes, trying to detach ourselves from worldly concerns as much as possible, in order to get in touch with our compassionate natures.

If everything is so hopelessly meaningless, why not just live for the hedonistic pleasures of the moment? Schopenhauer raises that possibility (one that Albert Camus eventually embraced in his absurdist phase), only to reject it:

> Considerations of the kind touched on above might, indeed, lead us to embrace the belief that the greatest *wisdom* is to make the enjoyment of the present the supreme object of life; because that is the only reality, all else being merely the play of thought. On the other hand, such a course might just as well be called the greatest *folly*: for that which in the next moment exists no more, and vanishes utterly, like a dream, can never be worth a serious effort.[14]

Besides, indulging our desires only intensifies them. So, what is one to do in the face of such pessimistic truths?

One option is to commit suicide. Though not his personal preference, Schopenhauer does not unconditionally condemn it. He begins his discussion of the issue by noting that

> none but the votaries of monotheistic, that is to say, Jewish religions, look upon suicide as a crime. This is all the more striking, inasmuch as neither in the Old nor in the New Testament is there to be found any prohibition or positive disapproval of it.[15]

The Church believes 'that suffering – *the Cross* – is the real end and object of life. Hence Christianity condemns suicide as thwarting

this end'.[16] But he offers a more persuasive account of their 'secret reason' for doing so:

> May it not be this – that the voluntary surrender of life is a bad compliment for him who said that *all things were very good?* If this is so, it offers another instance of the crass optimism of these religions – denouncing suicide to escape being denounced by it.[17]

Schopenhauer endorses the attitude towards suicide of the ancient Greeks, who saw it as a noble and courageous choice, at least in some situations.

It is in this essay on suicide that Schopenhauer makes one of his most eloquent references to the dreamlike state of human existence:

> When, in some dreadful and ghastly dream, we reach the moment of greatest horror, it awakes us; thereby banishing all the hideous shapes that were born of the night. And life is a dream: when the moment of greatest horror compels us to break it off, the same thing happens.[18]

To awake from this dream world requires us (in terms borrowed from Hinduism) to rend the veil of Maya (illusion) through which we view life. Behind the veil, we will see that individuality is merely apparent and that we are all part of one cosmic Will, from which we should want to be freed.

Two interrelated ways we can free ourselves are to quit being so obsessed with our egos and to cease caring so much about playing our assigned social roles:

> In all European languages, the word *person* is commonly used to denote a human being. The real meaning of *persona* is *a mask*, such as actors were accustomed to wear on the ancient stage; and it is quite true that no one shows himself as he is, but wears his mask and plays his part. Indeed, the whole of our social arrangements may be likened to a perpetual comedy; and this is why a man who is worth anything finds society so insipid, while a blockhead is quite at home in it.[19]

The most effective method of denying one's ego, shedding one's mask and attaining a more objective world view is, in Schopenhauer's unsurprising estimation, the study of philosophy. In common parlance, to take bad events philosophically means to see them in the proper perspective, and hence to avoid becoming overly excited. This is indeed part of what Schopenhauer has in mind, and he quotes Plato as agreeing with him that nothing in this life is worth getting too anxious about. But the study of philosophy also helps us to overcome one of our worst blind spots:

> Every man takes the limits of his own field of vision for the limits of the world. This is an error of the intellect as inevitable as that error of the eye which lets us fancy that on the horizon heaven and earth meet. This explains many things, and among them the fact that everyone measures us with his own standard.[20]

One should seek to attain a philosophical perspective, because

> this condition of mind is due to the intellect having gotten the upper hand in the domain of consciousness, where, freed from the mere service of the will, it looks upon the phenomena of life objectively, and so cannot fail to gain a clear insight into its vain and futile character.[21]

Detachment from egotistical desires, and compassion for one's fellow humans, can actually lessen the degree of suffering in this world. Although these measures can never tip the balance, allowing happiness and pleasure to predominate, they *can* ameliorate the misery of the world.

Schopenhauer characterizes his inspiring ideal, in a passage that is worth quoting at length:

> Then, finally, look at the poet or the philosopher, in whom reflection has reached such a height, that, instead of being drawn on to investigate any one particular phenomenon of existence, he stands in amazement *before existence itself*, this great sphinx, and makes it his problem. In him consciousness has reached the degree of clearness at which it embraces the world itself: his intellect has completely abandoned its function as the servant of his will, and now holds the world before him; and the world

calls upon him much more to examine and consider it, than to play a part in it himself. If, then, the degree of consciousness is the degree of reality, such a man will be said to exist most of all, and there will be sense and significance in so describing him.[22]

But such exalted states of mind (and of poetic expression) are fleeting at best. Most importantly, children must be educated in ways that prepare them for a life of realistic reflection:

> And above all let care be taken to bring them to a clear and objective view of the world as it is, to educate them always to derive their ideas directly from real life, and to shape them in conformity with it – not to fetch them from other sources, such as books, fairy tales, or what people say – then to apply them ready-made to real life. For this will mean that their heads are full of wrong notions, and that they will either see things in a false light or try in vain to *remodel the world* to suit their views, and so enter upon false paths.[23]

As we shall see, *Waking Life* represents both the dreamers who want to remodel the world and the realists who have given up trying to do so.

Waking Life was released in 2001 (not long after 9/11) by Richard Linklater, best known at the time for his stoner comedies (*Slacker* and *Dazed and Confused*) and for the romantic duet *Before Sunrise*. He invented a new form of animation that began with live filming and then transformed those actual images with a technique called rotoscoping (which he would again use in *A Scanner Darkly*). The effect can best be described as 'trippy', as the figure/ground relationship shifts and the images come on in waves. After a brief opening episode (there are 19), that introduces the notion that 'dream is destiny', the writer-director Linklater has us follow an unnamed protagonist, a young man (played by Wiley Wiggins) with a problem: he is caught in a series of dreams, from which he cannot awaken.

The dreamer (as I will call him) has just gotten back into town and needs a ride. Our first hint that this is no conventional narrative is that he is picked up by a boat car, piloted by a guy who gives him an existentialism-inspired pep talk and then asks where he is going.

The dreamer states no preferences, so his fellow passenger (whom we later learn is voiced by Linklater) proposes a location for him to be dropped off. When the dreamer asks where that is, the driver sounds the destiny theme again:

> Well I don't know either, but it's somewhere, and it's going to determine the course of the rest of your life. All ashore that's going ashore. Ha ha ha ha ha. Toot, toot.[24]

When the dreamer gets out, he sees a note on the ground; it says to look to his right, and when he does so, he is hit by a truck. This appears to awaken him from the dream, and he gets up and goes to what is apparently his philosophy class.

The professor is Robert Solomon, who (like several of the other academic types that participate here) actually taught Linklater when he studied at the University of Texas at Austin. Solomon sounds the heroic call to freedom issued by Jean-Paul Sartre, which functions as a counterpoint to more deterministic and pessimistic perspectives that later emerge. In his lecture, Solomon warns of a disturbing trend:

> The reason why I refuse to take existentialism as just another French fashion or historical curiosity is that I think it has something very important to offer us for the new century. I'm afraid we're losing the real virtues of living life passionately, the sense of taking responsibility for who you are, the ability to make something of yourself and feel good about life.

Solomon elaborates on this Sartrean world view after class:

> The more that you talk about a person as a social construction or as a confluence of forces or as fragmented or marginalized, what you do is you open up a whole new world of excuses. And when Sartre talks about responsibility, he's not talking about something abstract. He's not talking about the kind of self or soul that theologians would argue about. It's something very concrete. It's you and me talking. Making decisions. Doing things and taking the consequences. It might be true that there are six billion people in the world and counting. Nevertheless,

what you do makes a difference. It makes a difference, first of all, in material terms. Makes a difference to other people and it sets an example. In short, I think the message here is that we should never simply write ourselves off and see ourselves as the victim of various forces. It's always our decision who we are.[25]

We will discuss Sartre's position later in this book, but suffice it to say that Solomon's is one of the most life affirming and positive perspectives to which the dreamer will be exposed.

His other two encounters in chapter 3 are also basically optimistic. Screenwriter Kim Krizan praises the worth of her craft while recognizing its difficulties:

> Because words are inert. They're just symbols ... so much of our experience is intangible. So much of what we perceive cannot be expressed. It's unspeakable. And yet, you know, when we communicate with one another, and we feel that we've connected, and we think that we're understood, I think we have a feeling of almost spiritual communion. And that feeling might be transient, but I think it's what we live for.[26]

The rare but achievable feeling of truly communicating with other human beings is what gives her life meaning.

Chemistry professor Eamon Healey next offers a remarkably upbeat take on evolution, one that contradicts Darwin's claim that natural selection does not necessarily lead to progress:

> The old evolution is cold. It's sterile. It's efficient, okay? And its manifestations of those social adaptations. We're talking about parasitism, dominance, morality, okay? Uh, war, predation, these would be subject to de-emphasis. These will be subject to de-evolution. The new evolutionary paradigm will give us the human traits of truth, of loyalty, of justice, of freedom. These will be the manifestations of the new evolution. And that is what we would hope to see from this. That would be nice.[27]

His concluding phrase, however, suggests that Healey is engaged in wishful thinking and not scientific objectivity.

In the context of the earlier monologues, the next episode, 'Alienation', is a shock. The dreamer is walking alongside a man carrying a gas can, who declares:

> A self-destructive man feels completely alienated, utterly alone. He's an outsider to the human community. He thinks to himself, 'I must be insane'. What he fails to realize is that society has, just as he does, a vested interest in considerable losses and catastrophes. These wars, famines, floods and quakes meet well-defined needs. Man wants chaos. In fact, he's gotta have it. Depression, strife, riots, murder, all this dread. We're irresistibly drawn to that almost orgiastic state created out of death and destruction. It's in all of us. We revel in it.[28]

Having offered this extremely pessimistic view of human nature, he then asks the dreamer for a match, and after bemoaning the fruitlessness of the two-party political system, he douses himself with gasoline and lights himself on fire, as some sort of obscure political statement. The episode ends with his immolation.

In chapter 5, 'Death and Reality', Julie Delpy and Ethan Hawke pick up where they left off in *Before Sunrise*, discussing life after death, and especially reincarnation (a Hindu concept). Rejecting the literal notion that we have all lived past lives, Hawke and Delpy take it as a symbol of a collective unconscious that all of us can draw on and they relate this to telepathy and the remarkably coincident discoveries that happen throughout the world at the same time periods. Perhaps coincidentally, Schopenhauer himself had a strikingly similar interpretation of reincarnation.[29] But once again this rather upbeat tone is countered by the second half of the episode, where a red-faced prisoner who is deeply disturbed rants on in grotesque detail about his plans to inflict torturous acts of violent revenge on those who imprisoned him.

Next up, in a chapter called 'Free Will and Physics', another renowned philosophy professor, David Sosa, raises serious questions about free will:

> Nowadays we know that the world operates according to some fundamental physical laws, and these laws govern the behavior of every object in the world. Now, these laws, because they're so trustworthy, they enable incredible technological

achievements. But look at yourself. We're just physical systems too, right? We're just complex arrangements of carbon molecules. We're mostly water, and our behavior isn't gonna be an exception to these basic physical laws. So it starts to look like whether its God setting things up in advance and knowing everything you're gonna do or whether it's these basic physical laws governing everything, there's not a lot of room left for freedom.

Much as he would like to find room for deliberate human choice, Sosa admits that even quantum physics is of no help on that score, for the indeterminacy at the quantum level comes from random swerves of subatomic particles and not from free choices made by individuals.

The next three speakers counter this deterministic point of view; a libertarian talk show host, a reflective older gentleman and a rather mystical writer each state their cases. The libertarian gives a pep talk:

Resistance is not futile. We're gonna win this thing. Humankind is too good! We're not a bunch of underachievers! We're gonna stand up and we're gonna be human beings! We're gonna get fired up about the real things, the things that matter: creativity and the dynamic human spirit that refuses to submit!

The old man offers an idea from Nietzsche: 'To say yes to one instant is to say yes to all of existence'. Then the writer utters an enthusiastic paradox:

The moment is not just a passing empty nothing, yet – and this is the way in which these secret passages happen – yes, it's empty with such fullness.[30]

After an interlude that features two women in their forties embracing the values of ageing (they are glad they don't get so excited and impatient about things anymore), a chimp at a projector sums up the positives that have been affirmed thus far. It talks about the value of art as offering us new possibilities, the achievement of true communication and the prospects for fashioning a new world out of the old. But then another philosopher, Louis Mackey, throws

cold water on all that nonsense. He observes: 'There are two kinds of sufferers, those who suffer from a lack of life and those who suffer from an overabundance of life.'[31] He then mocks the notion of progress:

> Why is world history and evolution not stories of progress but rather this endless and futile addition of zeroes. No greater values have developed. Hell, the Greeks 3,000 years ago were just as advanced as we are.[32]

The only question in his mind is what holds us back more, fear or laziness.

A pattern has emerged by now that continues throughout the film: our dream pilgrim encounters a significant number of conflicting perspectives on a recurring set of themes and must make sense of them for himself. Art, and especially film, is seen as having a potentially redemptive quality, allowing us to put together the stories of our lives better and create holy moments of epiphany. Yet these insights, and instances of successful communication, remain as ephemeral as dreams.

Speakers in the film suggest at several points that dreaming is a necessary part of a satisfying existence. In chapter 13, 'Dreamers', the decline of dreaming (I guess, since the 1960s and 1970s) is bemoaned:

> Haven't seen too many around lately. Things have been tough lately for dreamers. They say dreaming's dead, that no one does it anymore. It's not dead, it's just been forgotten. Removed from our language. No one teaches it so no one knows it exists. The dreamer is banished to obscurity. Well I'm trying to change all that, and I hope you are too. By dreaming every day. Dreaming with our hands and dreaming with our minds.[33]

This affirmation of dreaming in *Waking Life* seems to contradict Schopenhauer's emphasis on hard-headed realism, and his condemnation of those who, under the influence of illusory ideals, try to change reality. Yet the Buddhist notion of nirvana also resounds in this chapter. Our dreamer converses with a thin boy in the process of some kind of transformation, who exhorts him to

> feel the joy and sorrow, the laughter, the empathy, compassion and tote the emotional memory in your travel bag. I remember

where I came from and how I became a human, why I hung around, and now my final departure is scheduled. This way out. Escape velocity. Not just eternity, but infinity.[34]

Nirvana, too, is a dream state to be cherished. In chapter 14, the main character is asked about his own 'consistent perspective', and for the first time he reveals what he has been making out of the passing somnambulant show:

> We seem to think we're so limited by the world and its confines, but we're really just creating them. You keep trying to figure it out, but it seems like now that you know that what you're doing is dreaming, you can do whatever you want to. You're dreaming, but you're awake. You have, um, so many options, and that's what life is about. ... It's up to me. I'm the dreamer.

The next chapter, 'We Are the Authors', elaborates on this notion, and it looks like we have arrived at the perspective that the director is recommending. This reading is confirmed by the conclusion of the film, when the dreamer embraces the dream and soars high above the world of gravity.

Further evidence for this pro-dream position can be found in chapter 15: 'And as one realizes that one is a dream figure in another person's dream, that is self awareness.' But, as the speaker (poet Timothy Levitch) is shown wandering off in an ecstatic trance, stars twinkle around his head in a deflating commentary on his utterances, which are depicted as reminiscent of the overly idealistic late 1960s.

Further doubts about the quasi-mystical nature of all this surface quickly. The dreamer is watching TV again, where director Steven Soderburgh is sharing this choice Hollywood story about Billy Wilder and Louis Malle in the early 1960s:

> And Louis Malle had just made his most expensive film, which has cost 2 1/2 million dollars. And Billy Wilder asks him what the film is about. And Louis Malle says 'Well, it's sort of a dream within a dream'. And Billy Wilder says 'You just lost 2 1/2 million dollars.'[35]

The plausibility, and practicality, of urging such a world view is thrown into question almost immediately.

After noting in an extremely brief chapter 17 that Kierkegaard's dying words were 'sweep me up', the next to last chapter gives Linklater himself a chance to speak. It turns out that he was the other passenger in the boat car ride, and the dreamer recognizes him playing pinball in a corner. Since his is the last lengthy monologue of the film, one might assume that the director will have the last word on these issues. But, rather than clarify all the ambiguities, he only deepens them.

Refusing to take sides, he articulates two opposing positions with equal eloquence. After noting amazing coincidences between his life and his writings, the speaker concludes:

> That, you know, behind the phenomenal difference, there is but one story, and that's the story of moving from the 'no' to the 'yes'. All of life is like, 'No thank you. No thank you. No thank you.' then ultimately it's 'Yes, I give in. Yes, I accept. Yes, I embrace.' I mean, that's the journey. I mean, everyone gets to the 'yes' in the end, right?

But then he starts talking as if life were a dream and the scenario turns much darker:

> So we continue walking, and my dog runs over to me. And so I'm petting him, really happy to see him, you know, he's been dead for years. So I'm petting him and I realize there's this kind of gross oozing stuff coming out of his stomach. And I look over at Lady Gregory (a literary character), and she sort of coughs. She's like [cough] [cough] 'Oh, excuse me.' And there's vomit, like dribbling down her chin, and it smells really bad. And I think, 'Well, wait a second, that's not just the smell of vomit,' which is, doesn't smell very good, 'that's the smell of like dead person vomit.' You know, so it's like doubly foul. And then I realize I'm actually in the land of the dead, and everyone around me is dead. My dog had been dead for over ten years, Lady Gregory had been dead a lot longer than that. When I finally woke up, I was like, whoa, that wasn't a dream, that was a visitation to this real place, the land of the dead.

The spectre of finitude and meaninglessness still hangs over the proceedings, as does the suspicion that all of this talk about dreams

is simply whistling past the graveyard. There is no stirring rhetoric about heroically changing the world through human progress, and the real stress is on accepting and saying yes to life as it is. Most of the questions raised in the film remain unanswered at its end. Another piece of the puzzle can be found in the way the film is hypnotic, almost inducing an altered state of mind. James Berardinelli reported Linklater's preface to its first public screening:

> When he introduced the film at its Sundance 2001 premiere, Linklater posed one question to the audience, and it goes a long way towards setting the stage for *Waking Life*: 'How many of you out there are on drugs?' he asked. When a number of hands went up, he added, 'Good. This is for you. The rest of you, just bear with me.'[36]

What does this have to do with Schopenhauer? Well, as the Encyclopaedia Britannica pointed out in its entry on drug use:

> To German philosopher Arthur Schopenhauer ..., contemplation was the one requisite of aesthetic experience; a kind of contemplation that enables one to become so absorbed in the quality of what is being presented to the senses that the 'Will' becomes still and all needs of the body silent. Drugs reportedly foster this kind of nirvana and are so used by many today.[37]

Psychoactive drugs induce an altered state of consciousness, in which one can see through the conventional appearances of life into their hollow and desperate shell. They can also give rise to a feeling of brotherhood that makes compassion a more likely reaction than violence. At the very least, like beautiful art, they can slow us down and give us a respite from the frantic world of our desires.

So, let me conclude by addressing one major potential criticism of this association of Schopenhauer with the film: *Waking Life* is not consistently bleak and sad. Oh, sure, our hero gets hit by a truck, and some guy burns himself alive, and a prison inmate wants to rip out the heart of the world, and another guy guns down his bartender, and a lot of questions are raised about the goodness of humanity, and whether we are free and responsible for our actions. But it doesn't feel like a dirge at a funeral ... the overall effect is too exhilarating.

It must be remembered here that the Buddha is always depicted as smiling. Having seen through the illusions of human existence, and detached himself from the world of desire, he is impervious to its sufferings and privations. When the dreamer goes off into the sky at the end of the film, it is an apt image for the attainment of nirvana. He embraces the dream and attains its lightness. A comment on Schopenhauer posted on the *High Existence* website puts it well:

> Does Schopenhauer have a point? It seems that he does, as we will either be actively working towards a goal, which requires work and effort, or we'll be inactive and un-stimulated. With that in mind, though, we don't necessarily have to despair. This philosophy is very similar to Buddhism (Schopenhauer was heavily influenced by eastern philosophy), and Buddhists don't seem to be in perpetual misery. Even if life is constant suffering, that doesn't mean we have to be [so bleak] about it.[38]

Waking Life is educational, in precisely the sense that Schopenhauer advocated in the aforementioned. Attaining objectivity requires the synthesis of a number of disparate perspectives, helping us overcome our narrow tendency to take the limits of our own points of view to be the limits of the world. The multifaceted and open-ended nature of the film helps to broaden our perspective in ways which Schopenhauer might well have applauded.

Questions for discussion

1 To use contemporary terminology, Schopenhauer seems to be saying that there is no need to be depressed over recognizing the preponderance of meaningless suffering that characterizes existence. Do you agree or disagree with his overall world view? Why or why not?

2 Look up 'The Noble Eightfold Path' on Google and consider the Buddha's concrete recommendations for overcoming desire. How do they relate to the Ten Commandments? Which do you prefer, and why?

3 Schopenhauer thought that tragedies were perfect object lessons in the futility of striving: 'if Achilles, Oedipus, Othello, Hanlet and Antigone are all ground beneath the wheel of existence, what fools we are to think we can succeed and prosper!', he might have said. Is that really what we come away with from great tragedies?

4 The West has long been fascinated with the Eastern concept of nirvana and has often related it to drugged states of mind. Discuss the rotoscoped animation used by Linklater to tell his story, and whether it did create a hypnotic effect on the audience. Why is this technique so appropriate to the subject matter?

Suggestions for further viewing

The Birds (1963, Alfred Hitchcock) – Nature itself is depicted as possessed by an implacable and malevolent Will, as embodied in the enigmatic bird attacks, which remain otherwise inexplicable. Meanwhile, son, mother and prospective beloved circle one another with an ambivalent mixture of benevolence and hostility in a microcosm of the Will's destructive dynamics.[39]

Little Buddha (1993, Bernardo Bertolucci) – The story of Siddhartha (Gautama, otherwise known as the Buddha) is intercut with a contemporary Lama seeking the reincarnation of a holy man by sending three children on a journey of spiritual discovery to Bhutan. Bertolucci was a devotee and made a most inspiring hymn of praise to that way of life.

Requiem for a Dream (2000, Darren Aronofsky) – The nature of desire itself as addictive has never found more powerful portrayal that in Aronofsky's hard-to-watch film. As an otherwise normal guy and his girlfriend fall deeper and deeper into drug addiction, his mother becomes strung out on diet pills and shopping channel purchases, and all of their lives seem to head straight for the gutter.

Macbeth (1971, Roman Polanski) – Made during the time immediately following the slaughter of the director's wife and unborn child by members of the Manson family, no other cinematic version of the play highlights its pessimistic, deterministic nihilism more effectively. Jon Finch intones the 'tale told by an idiot, full of sound and fury, signifying nothing' speech with great conviction, making it the perfect example for Schopenhauer's theory of tragedy.

CHAPTER TWO

Egoism in Max Stirner's *The Ego and His Own* and in *Hud*

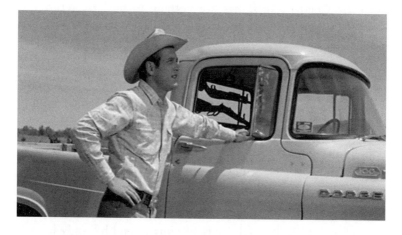

Egoism (the notion that one should seek one's own self-interest, in favour of the interests of others) has come under a consistent barrage of criticism throughout the history of philosophy, at least since Thrasymachus was condemned for it by Socrates in Plato's *Republic*. Max Stirner tried to reverse that trend in the mid-nineteenth century, by composing the most unapologetic defence of egoism ever written, *The Ego and His Own* (*Der Einzige und sein Eigentum*). Hollywood has been similarly critical of egoism, and adherence to its puritanical

Production Code had, until the early 1960s, virtually ensured that its most egoistic characters got their miserable comeuppance in the end. One of the few egoists in the history of classical Hollywood cinema to avoid such a crushing fate was Paul Newman's *Hud*, a powerfully attractive anti-hero (a type which proliferated in the 1960s). This chapter will outline a number of parallels between Stirner's ideal egoist and Newman's glorious bastard.

Stirner's *magnum opus* (i.e. major work) was published in the late 1840s, in a period when nationalism, statism and communism were all on the rise. A German philosopher with an uncanny feel for the period, he saw these forces as dwarfing individuals and hammering them into conformity with social norms. Add to this the religious and moral compunctions that Germans were taught since their early youth, and Stirner claimed that true creativity, and the individuality from which it stems, had almost been annihilated in his homeland.

Stirner begins *The Ego and His Own* by citing the title of a poem by Goethe: 'All things are nothing to me.' He returns to this theme at the end of his lengthy treatise, which has led some commentators to see him as a precursor of nihilism (the claim that human existence is hopelessly meaningless). But this is a hasty conclusion; as we shall see, Stirner affirms the value of unique individuality and advocates the egoistic lifestyle as superior to the alternatives. He sounds his major themes (several of which resound throughout the existentialist movement) in an introduction that grabs one's attention and then proceeds to flesh them out in the body of the work.

Stirner initiates his critique of Christianity by claiming that God, if He exists, must be an egoist:

> Now it is clear, God cares only for what is his, busies himself only with himself, thinks only of himself, and has only himself before his eyes; woe to all that is not well-pleasing to him. He serves no higher person, and satisfies only himself. His cause is – a purely egoistic cause.[1]

If we are to be like God, it, therefore, follows that we should be egoistic.

Everything in the world may be *considered* as nothing to the egoist, for he can value something or deny its worth at his whim; the individual is all important, and the attitude he adopts towards

things, people and events. In terms that prefigure Jean-Paul Sartre, Stirner observes that 'I am not nothing in the sense of emptiness, but I am the creative nothing ... out of which I myself as creator create everything'. As Nietzsche put it subsequently, in the absence of God, we are called upon to be Gods, that is, to create something from nothing by our actions and evaluations.

Morality and moral philosophy are also to be disdained, according to Stirner:

> Away, then, with every concern that is not altogether my concern! You think at least the 'good cause' must be my concern? What's good, what's bad? Why, I myself am my concern, and I am neither good nor bad. Neither has meaning for me.[2]

He goes on to deny *all* types of moral obligation, so it is inaccurate to call him an *ethical* egoist (i.e. one who argues we *ought* to be selfish). He refuses to moralize in the course of advocating the egoistic way of life ... acting on self-interest is not a duty, it is simply prudential. Stirner concludes the introduction with a statement of his ultimate views:

> My concern is neither the divine nor the human, not the true, good, just, free, etc., but solely what is *mine*, and it is not a general one, but is – unique, [*Einzig*] as I am unique. Nothing is more to me than myself![3]

He then begins Part One ('Man') by examining the developmental process of 'A Human Life'.

We start out being intimidated by authority figures and willing to conform to their demands. But 'when, *e.g.,* we have got at the fact that the rod is too weak against our obduracy [i.e. stubborn persistence in wrongdoing], then we ... "have out-grown it"'.[4] The child becomes a man when he can no longer be intimidated into submitting to the will of another:

> Before that which formerly inspired in us fear and deference we no longer retreat shyly, but take *courage*. Back of everything we find our *courage*, our superiority; back of the sharp command of parents and authorities stands, after all, our courageous choice or our outwitting shrewdness. And the more we feel ourselves, the smaller appears that which before seemed invincible.[5]

In his view, the voice of authority is relatively easy to overcome. But, in terms that bring the psychological theories of Sigmund Freud to mind, Stirner decries the fact that our own consciences, which have internalized the values of our parents and role models, are much harder to overcome:

> Not the might of the avenging Eumenides, not Poseidon's wrath, not God, far as he sees the hidden, not the father's rod of punishment, do we fear, but – *conscience*. We 'run after our thoughts' now, and follow their commands just as before we followed parental, human ones. Our course of action is determined by our thoughts (ideas, conceptions, *faith*) as it is in childhood by the commands of our parents.[6]

Conscience, too, must be transcended. Having done so, he describes himself as someone who 'worked his way up to where he became the man, the egoistic man, who deals with things and thoughts according to his heart's pleasure, and sets his personal interest above everything'.[7]

In Section II of Part One, Stirner surveys both the ancients and the moderns in a sprawling overview of the history of philosophy. His account of the Greeks focuses on the Sophistic and Stoical traditions, and preceded Nietzsche in discussing how Plato prefigured Christianity. Unlike Nietzsche, Stirner was highly critical of the Sophists, though they shared his disdain for sceptical Stoicism: 'The Sophistic culture has brought it to pass that one's understanding no longer *stands still* before anything, and the Skeptical, that his heart is no longer *moved* by anything.'[8]

The Sophists rejected the distinction between reason and rhetoric, and embraced a total relativism of all values and beliefs. Their influence, according to Stirner, was pernicious:

> The Sophistic doctrine must lead to the possibility that the blindest and most dependent slave of his desires might yet be an excellent sophist, and, with keen understanding, trim and expound everything in favor of his coarse heart. What could there be for which a 'good reason' might not be found, or which might not be defended through thick and thin?[9]

The Sophists sought to give free rein to their desires, and in the end were controlled by them, just as Plato had predicted in *Republic*.

The Stoics, on the other hand, advocated an indifference to the things of this world, and hence lived a safe, conventional lifestyle, since their scepticism allowed them no good reasons for violating cultural traditions. But, as Feuerbach had put it, 'at least to the ancients the world was a truth'.[10] Unfortunately, by the end of the ancient period, it became 'a truth whose untruth they tried to get back of, and at last really did'.[11] In Plato, the physical world became secondary and was reduced to 'mere appearance', in contrast to the reality of the spiritual realm.

Catastrophically, Socrates virtually invented Ethics:

> Therefore Socrates says that it is not enough for one to use his understanding in all things, but it is a question of what *cause* one exerts it for. We should now say, one must serve the 'good cause'. But serving the good cause is – being moral. Hence Socrates is the founder of ethics.[12]

Socrates' values resembled those of the Stoics to a great degree, in his indifference to bodily appetites and submission to the law.

Plato, who was his student, adopted a dualistic theory of human nature and thought of the soul as being essentially different from the body. In a culture that did not believe in personal immortality, he posited the soul as the immortal locus of personhood. Platonic philosophy prepared the way for Christianity, and Christianity became the official religion of the Roman Empire by the early fourth century AD. This totally reversed the wisdom of the ancients, for 'the spirit ... has to do with absolutely nothing unspiritual, with no *thing*, but only with the essence which exists behind and above things, with *thoughts*'.[13]

After this world-shattering development, the thinker sought only to justify and explain belief in God: 'But the activity of the spirit, which "searches even the depths of the Godhead" is *theology*. If the ancients have nothing to show but the wisdom of the world, the moderns never did ... make their way further than to theology.'[14] As a result, in the (appropriately named) 'Dark Ages', and throughout most of the modern period (up to the 1800s), true philosophical questioning fell by the wayside.

In the next section of his treatise, Stirner further spells out the revolutionary implications of Platonism/Christianity:

> The spirit is free spirit, *i.e.*, really spirit, only in a world of *its own*; in 'this', the earthly world, it is a stranger. Only through a spiritual world is the spirit really spirit; however you may conceive of the future aspect of your spirit, so much is yet certain, that in death you will put off this body and yet keep yourself, *i.e.* your spirit, for all eternity; accordingly your spirit is the eternal and true in you, the body only a dwelling here below, which you may leave and perhaps exchange for another [this is the doctrine of reincarnation in Platonic philosophy].[15]

His critique of this view was unique for his time, and it helped mark the existential turn in philosophical thought. Rather than attack the traditional arguments for the existence of God, he chose to make fun of the spirit world as a realm of 'spooks':

> Yes, the whole world is haunted! Only is haunted? Nay, it itself 'walks', it is uncanny through and through, it is the wandering seeming-body of a spirit, it is a spook. What else should a ghost be, then, than an apparent body, but real spirit? Well, the world is 'empty', is 'naught', is only glamorous 'semblance'; its truth is the spirit alone; it is the seeming-body.[16]

The argument is a satirical *reductio ad absurdum*, which tries to make the 'belief in spooks' look absurd. To give credence to the spirit world is, in his view, both unhealthy and alienating: 'In everything sacred there lies something "uncanny" we are not quite familiar and at home in. What is sacred to me is *not my own*.'[17] This is what it means to be 'possessed' by one of the timeless essences that supposedly lurk behind the appearances of things.

In the face of such essentialism, the world pales by comparison:

> What at first passed for existence, *e.g.* the world and its like, appears now as bare semblance, and the *truly existent* is much rather the essence, whose realm is filled with gods, spirits, demons, with good or bad essences. Only this inverted world, the world of essences, truly exists now. The human heart may be loveless, but its essence exists, God, 'who is love'; human

thought may wander in error, but its essence, truth, exists; 'God is truth', and the like.[18]

As we will see in the chapter on Nietzsche, little had changed in Germany by the late 1880s, despite the fact that atheism (or at least scepticism about the existence of God) had been on the rise for more than a century by then. Once possessed by such illusory essences, it is almost impossible to break free of them. This state of 'possession' outlives explicit theological commitments:

> Is it perchance only people possessed by the devil that meet us, or do we as often come upon people *possessed* in the contrary way – possessed by 'the good', by virtue, morality, the law, or some 'principle' or other?[19]

In Stirner's view, faith in God is succeeded by faith in moral standards, in 'the law', 'the State', 'the people' and 'the family'. Fanatics of various stripes still religiously live by these 'sacred timeless truths'. In order to avoid *all* forms of 'demonic possession', we should hold nothing sacred but ourselves:

> Before the sacred, people lose all sense of power and all confidence; they occupy a *powerless* and *humble* attitude toward it. And yet no thing is sacred of itself, but by my *declaring it sacred*, by my declaration, my judgment, my bending the knee; in short, by my – conscience.[20]

According to Stirner, neither deities nor ideal Essences exist, and belief in them must be exorcised.

Once having done so, 'The world has become prosaic, for the divine has vanished from it: it is my property, which I dispose of as I (to wit, the mind) choose.'[21] Stirner describes his exhilaration infectiously: 'When I had exalted myself to be the *owner of the world*, egoism had won its first complete victory, had vanquished the world, had become worldless.'[22] In a section entitled 'Ownness', Stirner elaborates on this vision:

> Ownness ... is my whole being and existence, it is I myself. I am free from what I am *rid* of, owner of what I have in my

power or what I *control*. *My own* I am at all times and under all circumstances, if I know how to have myself and do not throw myself away on others.[23]

Unlike Nietzsche, Stirner acknowledges that people do act altruistically at times; he simply argues that they are ill advised to do so. The pursuit of self-interest should, in his estimation, know no bounds:

> I secure my freedom with regard to the world in the degree that I make the world my own, *i.e.* gain it and take possession of it for myself, by whatever might, by that of persuasion, of petition, of categorical demand, yes, even by hypocrisy, cheating, etc.; for the means that I use for it are determined by what I am.[24]

It is here that Stirner sounds most like Nietzsche, though, as we shall see, Nietzsche tries to have it both ways by claiming that his overmen also promote adaptive progress in the species.

Stirner has become the darling of the modern anarchist movement, because he refused to acknowledge the legitimacy of State authority in any form:

> Therefore we two, the State and I, are enemies. I, the egoist, have not at heart the welfare of this human society, I sacrifice nothing to it, I only utilize it; but to be able to utilize it completely I transform it rather into my property and my creature; *i.e.*, I annihilate it, and form in its place the *Union of Egoists*.[25]

This 'Union of Egoists' will be an association of iconoclasts, who rebel against everything presumed to be above them: 'The egoist, turning against the demands and concepts of the present, executes pitilessly the most measureless – *desecration*. Nothing is holy to him!'[26] Stirner acknowledges that there are greater powers on the earth than his own, but he refuses to bow before them:

> It would be foolish to assert that there is no power above mine. Only the attitude that I take toward it will be quite another than that of the religious age: I shall be the *enemy* of every higher power, while religion teaches us to make it our friend and be

humble toward it. ... Am I not the entitler, the mediator, and the unique one? Then it runs thus: My power is *my* property. My power *gives* me property. My power *am* I myself, and through it am I my property.[27]

People are only entitled to the value that I bestow upon them. In his pursuit of autonomy, Stirner refused to appeal to the notion of individual human rights, which had become so sacred to intellectuals since the American and French revolutions:

I do not demand any right, therefore I need not recognize any either. What I can get by force I get by force, and what I do not get by force I have no right to, nor do I give myself airs, or consolation, with my imprescriptible right. Right – is a wheel in the head, put there by a spook; power – that am I myself, I am the powerful one and owner of power ... power and might exist only in me, the powerful and mighty.

Talk of inalienable individual rights is one more essentialist hindrance to self-realization.

Egoism leads us to see the world, and everything in it, as existing for our use:

Where the world comes in my way – and it comes in my way everywhere – I consume it to quiet the hunger of my egoism. For me you are nothing but – my food, even as I too am fed upon and turned to use by you. We have only one relation to each other, that of *usableness*, of utility, of use. We owe *each other* nothing, for what I seem to owe you I owe at most to myself.[28]

The egoist may treat you well, if it pleases him, but only in order to make better use of you.

Even the compulsory unconventionality of the 'free thinker' must be resisted:

Totally different from this *free* thinking is *own* thinking, *my* thinking, a thinking which does not guide me, but is guided, continued, or broken off, by me at my pleasure. The distinction of this own thinking from free thinking is similar to that of own

sensuality, which I satisfy at pleasure, from free, unruly sensuality to which I succumb.[29]

Unlike the 'free thinker', who *must* flout societal norms, the egoist can conform to traditional standards when it suits him. Master of his own fate, indifferent to the forces of oppression, the egoist lives the life of authentic feeling:

> The difference is, then, whether feelings are imparted to me or only aroused. Those which are aroused are my own, egoistic, because they are not *as feelings* drilled into me, dictated to me, and pressed upon me.[30]

As Albert Camus will do almost a century later, Stirner urges us to live a life of intense feeling, governed only by one's autonomous preferences, which is precisely the way Hud Bannon (Paul Newman) lived.

Hud is a gritty black-and-white film, hard edged and realistic. It is set in the bone-dry cattle country of Texas, the site of many Westerns. Its director, Martin Ritt, had an excellent novel from Larry McMurtry to work with, and he crafted a telling morality play about the end of an era of duty and respect for the land, which was giving way (throughout America in the early 1960s) to conspicuous consumption and shameless selfishness. Ritt's adherence to classical Hollywood conventions of linear narrative and continuity editing allows us to become immersed in this realistic milieu.

The Bannons had been ranchers for generations. Hud's father Homer (Melvyn Douglas) is an old school Texas cattleman, virtuous to a fault, who has raised a grandson named Lonnie (Brandon De Wilde) ever since his parents died. Homer is consistently critical of Hud, both for his irresponsible behaviour and because of a dark family secret (soon to be revealed).

The film opens with Lonnie searching for his uncle in town. Hud is shacked up with a married woman, whose husband returns home shortly after Lonnie finds Hud's Cadillac parked in front of the married woman's home. The two come out of the house together (at 6 am), and Hud blames the infidelity on Lonnie. The husband is afraid to duke it out with Hud and lets them depart without incident. Lonnie has come to inform Hud that there is trouble out at the ranch.

Homer had discovered a dead cow from his herd, which showed little sign of what killed it. When Hud shoots a buzzard feasting on the corpse, Homer asks him to stop and points out that it is against the law to do so. Hud's response foreshadows subsequent events: 'I believe the law was meant to be interpreted in a lenient manner. I try to do that. Sometimes I lean to one side of it, sometimes the other.'[31] Homer feels obliged to call the State Veterinarian to examine the cow, but Hud protests: 'This is our land. ... I don't want government men on it.' Homer's will prevails and the veterinarian is summoned.

Back at the house, we are introduced to their cook and housekeeper, Alma Brown (Patricia Neal, in an Oscar-winning performance). She is a strong-willed and independent woman, who resists Hud's physical attractions and enjoys giving him a hard time. She turns down Hud's invitation to join him for some beers, but Lonnie says that he would like to tag along.

Hud's relationship with his nephew helps to humanize him and make him a far more sympathetic figure. He shares his memories of the good times he had with Lon's father:

> When I was your age, I couldn't get enough of anything. That was the summer you were born. Your ma died. And your daddy was feeling a little wild about things. We bought us a 'Chevy ... hit every honky-tonk in the country. I don't know which we run the hardest, that car or them country girls, came to them dances. We do-se-doed and chased a lot of girlish butts that summer'.

Lonnie seems fascinated, but when Hud asks him along to yet another married woman's house, he refuses.

The government man's initial diagnosis of the dead heifer is the worst possible news: it appears to have hoof and mouth disease, which is extremely contagious. The veterinarian has to confirm this with tests on living animals, but if he's right, the Bannons will be legally obliged to destroy their entire herd. The government will only compensate them for half their losses, which means they are facing financial ruin.

Predictably, Hud argues that they should round up the herd and sell them before a government ban goes into effect: 'Get on the phone and sell every cow you own. They ain't got a chain on you yet.' But Homer refuses to do so, since that could cause a massive

epidemic if the herd had been contaminated. Hud's cynical response is characteristic.'

> This whole country is run on epidemics. Where've you been? Epidemics of big business price fixing, crooked TV shows, income-tax finagling, souped-up expense accounts. How many honest men you know? Take the sinners from the saints, you're lucky to end up with Lincoln. I say let's put our bread into some of that gravy while it is still hot.

When his father calls him an unprincipled man, Hud responds that Homer has enough principles for the both of them.

Facing the end of all that he holds dear, Homer is nostalgic for the time when all his cattle were longhorns, and almost everything his family had was made from their hides. He only has two left, and Lonnie says that they should be let loose on the prairie. But Homer refuses, insisting that they must be slaughtered with the rest of the herd. Indeed, he ends up shooting them himself.

After a long day on the range, Lonnie convinces his grandfather to take him to the movies. Homer collapses in the theatre and has to be taken home. He falls asleep in Hud's car and they discuss the future:

> Lonnie: He's beginning to look kind of worn out, isn't he. Sometimes I forget how old he is. Guess I don't want to think about it.
> Hud: It's time you started.
> Lonnie: I know he's going to die some day. I know that much.
> Hud: He is.
> Lonnie: Makes me feel like somebody dumped me into a cold river.
> Hud: Happens to everybody, horses, dogs, men. Nobody gets out of life alive.

After Lonnie goes to bed, Hud looks Alma up. In the ensuing conversation, we learn that she was married to a man very much like him, who took her wallet and gasoline credit card and left her stranded in a motel in Albuquerque. As she later explains, she rejects Hud's advances because she doesn't want to be mistreated

again: 'I've done my time with one cold blooded bastard. I'm not looking for another.'

The next evening, Hud has signed up for the annual greased pig competition, and asks Lonnie along for the ride. Lon wonders why, and his granddad explains:

> Lonnie: That's the first time Hud asked me to go anyplace. I wonder why he did.
>
> Homer: Lonesome, I imagine. Trying to scare up a little company.
>
> Lonnie: Lonesome? He can get more women than anybody.
>
> Homer: That ain't necessarily much and it ain't necessarily company. Women just like being around something dangerous part of the time. Even Hud can get lonesome once in a while.

They head into town, chase some women and get into a fight. On the way back, Hud shows some vulnerability, saying that Lon reminds him of his brother, and that he cares about what his nephew thinks of him. This is the moment of Hud's greatest humanity, and he even reveals the family secret: Hud killed his brother by cracking up their car when he was drunk. Even this revelation does not cause Lonnie to turn away from him.

But their intimacy is quickly shattered. When they return, Homer and Hud have a climactic confrontation. Much to his surprise, his father tells Hud that it isn't the death of his son Norman that he cannot forgive:

> Hud: All right. What turned you sour on me? Not that I give a damn.
>
> Homer: Just that, Hud. You don't give a damn. That's all, that's the whole of it. You still don't get it do you? You don't care about people. You don't give a damn about them. You got all the charm and it makes the youngsters want to be like you. That's the shame of it, because you value nothing, You respect nothing. You keep no check on your appetites. You live just for yourself and that makes you not fit to live with.
>
> Hud: My mama loved me, but she died (he leaves).
>
> Lonnie: Why pick on Hud, Granddad. He ain't the only one. Just about everybody around here is like him.

> Homer: That's no cause for rejoicing, is it? Little by little, the
> look of the country changes because of the men we
> admire. ... You're just gonna have to make up your own
> mind one day about what's right and what's wrong.

We are now at the heart of the narrative: Hud and his father are in
a battle for Lonnie's soul.

Hud's next moves determine that struggle in Homer's favour.
First, he tries to get his father declared incompetent, so he can sell
the herd before it is diagnosed as being infected. In the process, he
tells his father why he resents him so much:

> Daddy, you ain't never been wrong. You been handing out the
> ten tablets of law from whatever hill you could find since I was a
> kid. Shape up or ship out. That's the way you run things around
> here. Wild-eyed Homer Bannon, passing out scripture and verse
> like you wrote it yourself. So, I just naturally had to go bad, in
> the face of so much good.

As if to prove his point, he then gets very drunk and tries to rape
Alma. Lonnie hears the commotion and stops him just in time.
When he stares at Hud in disillusionment after their fight, his
uncle points out that Lon desired Alma as well. He admits this, but
protests that he would never have tried to take her against her will.

The next morning, disaster strikes. The infection is confirmed,
and they are forced to shoot the entire herd, in one of the most
devastating sequences in the history of cinema. It begins with a
low-angle shot of twin bulldozers, there to bury the animals once
they are killed. The entire herd is driven into a vast pit, surrounded
by ranch hands and veterinarians with rifles. As they open fire,
point-of-view shots from down in the herd are alternated with
close-ups of each man as he pumps more bullets into the diseased
cattle.

The ferocity of the slaughter is stunning, and the wordlessly
resigned acceptance on Homer's face is deeply moving. Things fall
apart quickly after this. Alma leaves the ranch, unable to ever feel
safe there again. Homer collapses out on the prairie, and when Lon
and Hud come upon him in the dark, their car won't start and he
dies in their arms. His granddad told Lonnie that he no longer had
the will to live, and the boy blames Hud for his demise.

Lonnie leaves the ranch and heads out on his own; Hud had made his decision easy. He does show some regret for losing Lon ('That's too bad. We might have whooped it up some.'), and he is left alone on a deserted ranch. But he already has plans to explore the land for oil drilling, a step Homer would never have taken. His last words to Lonnie are unrepentant: 'This whole world is so full of crap a man's gonna get into it sooner or later, whether he's careful or not.'

Hud cemented Newman's star persona, confirming the template for the collection of anti-heroes he would play for decades to come.[32] Newman saw it as a morality play, which unequivocally condemned Hud's egoism. But a 2010 review of the film is relevant to our subject:

Paul Newman was said to have been shocked that so many viewers felt for Hud Bannon instead of viewing him as a villain. Though many people see him as Alma rightly called him, 'a cold-hearted bastard', he's more than that. Hud, as a character of his time, embodied a new ethos (right or wrong) longing to break free from old norms and seeking acceptance.[33]

This last sentence points us in the direction of Stirner's vision of the egoist.

Bosley Crowther captured why Hud is so compelling in his 1963 review of the film: 'Paul Newman as Hud is tremendous – a potent, voracious man, restless with all his crude ambitions, arrogant with his contempt, and churned up inside.'[34] As such, Hud fulfils Stirner's vision of the ideal egoist in striking detail. He is a man for whom nothing is sacred, not family, not the government, not religion and certainly not the common good. As Hud's father bitterly notes, he doesn't give a damn about anything but himself. The fact that he has shattered all of his relationships in the course of the film doesn't seem to matter much to him. He remains unbroken and unbowed.

Hud refused to be possessed by anything and had completely exorcised all of the 'spooks' that Stirner ridiculed. He is indeed 'his own' and will not throw himself away or waste his energy. As Crowther put it, he is 'the selfish snarling smoothie that doesn't give a hoot for anyone else', a newly potent type in the 1960s.

Like Stirner's egoist, Hud's pursuit of self-interest knows no bounds. He robs his father of the will to live, would risk a

nation-wide epidemic by selling a contaminated herd, and tries to rape his housekeeper. He stops at nothing, and even cares for Lonnie only as someone to raise hell with, like he did with Lonnie's father (with such fatal results). Hud treats him well only to better use him, just like Stirner's egoist.

Yet another reviewer put it this way: 'Hud epitomizes the new man in America who throws off the values of his elders in revolt against oppressive systems that would impinge upon him exercising full autonomy.'[35] Rebelliousness and autonomy are extremely attractive traits in the modern age, and they are the defining characteristics of both Hud and Stirner's egoist.

Let me close by contrasting Hud's fate with another of the most selfish characters in the history of cinema – Jonathan (Jack Nicholson) in *Carnal Knowledge*. One of Nicholson's definitive bastards, Jonathan lived for his sexual conquests and devastated virtually all of the women with whom he got seriously involved (considering them all to be 'ball busters').

In his late forties by the film's end, he had become a pitiful man, alone and struggling with impotence, frequenting a prostitute who must flatter him shamelessly if he is ever to consummate his waning sexual desire. Newman ends up alone, but far from impotent, and remains a surprisingly sympathetic anti-hero who could truly say: 'All things are nothing to me.'

Questions for discussion

1 Do you know anyone like Hud? In particular, do you know a guy who treats women badly yet whom they find strangely attractive? Why is this 'type' associated with the masculine gender role?

2 Are there moral standards or imperatives that oblige us *not* to be total egoists? If so, what are they, and how are they justified? If not, why not follow Stirner's advice and unashamedly pursue our own selfish interests?

3 Can a person be *too* virtuous? Hud condemns his father for moralizing too much, and that he had to turn out bad in reaction to so much virtue. As a parent, do you think you (will) moralize (i.e. comment on issues of right and wrong

with a definite air of superiority) to your children a lot? Why or why not?

4 Can you think of a character in a contemporary film (other than the ones below) that reminds you of Hud? Is the anti-hero still a prominent character type in the movies? Why or why not?

Suggestions for further viewing

Carnal Knowledge (1971, Mike Nichols) – Jack Nicholson cemented his outsider persona in this tale of a rampant male chauvinist and the havoc that he wreaks in the lives of the women with whom he gets involved. His pitiful near impotence at the end is one of the most satisfying comeuppances in cinematic history.

Black Widow (1987, Bob Rafelson) – Teresa Russell plays the title character, who preys on her husbands with impunity until Federal Investigator Debra Winger gets on her trail. The *femme fatale* type is recurrent in Hollywood cinema, and they are surely outstanding examples of egoism in action.

Fight Club (1999, David Fincher) – Tyler Durden (Brad Pitt), the alter-egotist to Edward Norton's humble narrator, is an extrapolation of sheer destructive masculinity: physically devastating, sexually potent and literally explosive. Pitt's character goes much farther than Hud ever dreamed of, yet shares a common charisma and attractive aura about him.

American Beauty (1999, Sam Mendes) – Lester Burnham (Kevin Spacey) wakes up one morning and decides he is tired of being taken advantage of by his cheating wife, his sullen daughter and his demanding boss. So he embraces an egoistic lifestyle, and shakes up everyone around him, to such an extent that his personal safety becomes an issue.

CHAPTER THREE

Kierkegaard and Bergman on Faith and Despair

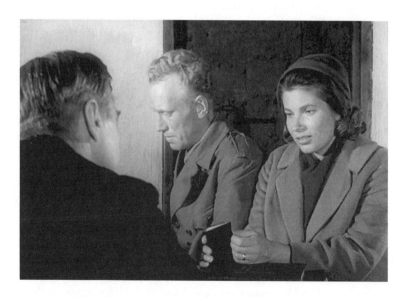

Søren Kierkegaard is deservedly considered to be the first existentialist philosopher. As the entry on Kierkegaard in the *Stanford Encyclopedia of Philosophy* correctly observes, he takes as his central problem the question of 'how to become a Christian in Christendom', which turns out to be a surprisingly difficult task. Living in a Christian nation was not a particularly

attractive prospect for Kierkegaard, since organized religion, in his eyes, generated 'a proliferation of normalizing institutions which produced pseudo-individuals'.[1]

Swedish director Ingmar Bergman grappled with the question of the existence of God in several of his most renowned movies, including *The Seventh Seal* and *Through a Glass Darkly*. But he was proudest of one of his simplest and most straightforward films, *Winter Light*. Whether coincidentally or by design (Bergman was notoriously unwilling to discuss his intentions), there are a number of striking similarities between that film and Kierkegaard's philosophy.

As both a thinker and a man, Kierkegaard questioned his faith as sincerely as any committed atheist (and more thoroughly than most). He finally came down on the side of the Creator, but only after admitting that the truth of his belief was fundamentally subjective. What that meant for him was that a belief must be held with passionate intensity and complete commitment to be considered true for a person at a time.

Kierkegaard commented on many biblical tales, but none of his glosses on such passages are as significant as his detailed reflections on Abraham and Isaac. Abraham is his ideal knight of faith, achieving a teleological suspension of his ethical obligations to keep his son alive. He evidences his unswerving obedience to God's will by showing his willingness to slay Isaac as a sacrificial offering to his creator (more on this later). But even Kierkegaard had to admit that he had trouble identifying with Abraham: 'I am able to identify myself with the (tragic) hero, but I cannot do so with Abraham, for whenever I reach his height I fall down again, since he confronts me as a paradox.'[2]

Kierkegaard eloquently discusses his struggles with doubt and faith in *The Sickness Unto Death*, where he offers an analysis of the significance of despair that is unsurpassed in the history of philosophy. Despair comes in several forms, which deepen in their profundity in direct proportion to the depth of consciousness of the despairing person. Kierkegaard organized these types under three broad headings: Despair at Not Being Conscious of Having a Self, Despair at Not Willing to Be Oneself and Despair at Willing to Be Oneself.

Generally speaking, on his view, human beings will remain in despair until we embrace both our material and our spiritual

natures and take the leap of faith in a God for Whom anything is possible. For such a God, in such a world, eternity redeems any degree of suffering in this life. Man's ability to despair is both a blessing and a curse; 'The possibility of this sickness is man's superiority over the animal ... yet to be in despair is not only the greatest misfortune and misery; no, it is perdition.'[3]

Despair at not being conscious of having a self occurs in the person who lives an immediate and unreflective life. In responding to the fortunes and misfortunes of the moment, 'Immediacy actually has no self, it does not know itself; thus it cannot recognize itself and generally ends in fantasy.'[4] A person with little or no self-awareness despairs in the face of earthly troubles and can see no possible way out of them:

> The man of immediacy ... wishes to be someone else. This is easily verified by observing immediate persons; when they are in despair, there is nothing they desire more than to have been someone else or become someone else.[5]

As one's consciousness develops, however, profound changes occur:

> *When immediacy is assumed to have some self reflection* ... [this] advance over pure immediacy manifests itself at once in the fact that despair is not always occasioned by a blow, by something happening, but can be brought on by one's capacity for reflection, so that despair, when it is present, is not merely a suffering, a succumbing to external circumstance, but is to a certain degree self-activity, an act.[6]

Yet this developing consciousness can easily be led astray. Modern society can envelop us, stifling our individuality:

> Despairing narrowness is ... to have emasculated oneself in a spiritual sense. ... Surrounded by hordes of men, absorbed in all sorts of secular matters, more and more shrewd in the ways of the world – such a person forgets himself, forgets his name divinely understood, does not dare to believe in himself, finds it too hazardous to be himself, and far easier and safer to be like the others, to become a copy, a number, a mass man.[7]

Three-quarters of a century before Martin Heidegger, Kierkegaard identified the threat of what Martin Heidegger would later call the They-Self (see below).

Another threat to reflective people in the modern age is belief in scientific determinism. Accepting the notion that all human actions are inexorably caused by our heredity and environment implies that free will is simply impossible: 'The determinist, the fatalist, is in despair and as one in despair has lost his self, because for him everything has become necessity.'[8] The determinist is in despair from not willing to be himself and from throwing off the burden of responsibility for his free choices.

An even deeper type of despair results from dissatisfaction with one's self. This constitutes progress for Kierkegaard: 'If one is to despair over himself, he must be aware of having a self.'[9] Deeper still is the defiant despair of the rebel who rejects God and His creation in response to profound suffering, injustice or loss:

> The more consciousness there is in such a sufferer who in despair wills to be himself, the more his despair intensifies and becomes demonic ... now he makes precisely this torment the object of all his passion, and finally it becomes a demonic rage ... in hatred towards existence, [it] wills to be itself, wills to be itself in accordance with its misery. ... Rebelling against all existence, it feels that it has obtained evidence against it, against its goodness.[10]

Such a person is obsessed with venting his rage, digging himself deeper into the hole of despair in the process.

In Kierkegaard's view, 'Every human being is a psychical-physical synthesis intended to be spirit.'[11] One should consciously choose to embrace one's spiritual nature and take the 'leap of faith' in God. This is the only way out of despair, 'because for God everything is possible at every moment. This is the good health of faith, that resolves contradictions'.[12] The two most prominent contradictions that faith resolves are that we are both finite and infinite beings and that God took human form in the life of Jesus Christ. These are irrational paradoxes at the heart of true Christianity, which must be affirmed in a passionate 'leap'.

Unity of our finite and infinite selves is both extremely difficult to achieve and (at best) only brief: 'It is only momentarily that the

particular individual is able to realize existentially a unity of the infinite and the finite that transcends existence. This unity is realized in the moment of passion.'[13] Whether one's belief in God is true or not is a subjective matter; hence, Kierkegaard defines truth as: '*An objective uncertainty held fast in an appropriation-process of the most passionate inwardness* ... [this is] the highest truth attainable for an *existing* individual.'[14] A belief is true not for *what* it holds but for *how* it is held by the person in question. Believing in something indifferently, without commitment or passion, is a sign of subjective untruth.

Indeed, belief in God does not seem likely to be true from an objective, rational perspective, because what one believes in is quite literally absurd: 'What, then, is the absurd? – that the eternal truth has come into being in time ... precisely like any other individual human being.'[15] But it is precisely its paradoxical nature that permits belief in God to inspire such passion: 'For the absurd is the object of faith, and the only object that can be believed.'[16]

Along with the subjectivity of truth, Kierkegaard sounds another central existentialist theme in his claim that we choose ourselves with absolute freedom. For Kierkegaard, as Alisdair MacIntyre puts it in his entry in *The Encyclopedia of Philosophy*:

> What the individual does depends not upon what he understands but upon what he wills ... the ultimacy of undetermined choice. ... if criteria determine what I choose it is not I who made the choice.[17]

If the existence of God was rationally provable, belief in God would no longer be faith and no longer require a passionate leap into the unknown.

Kierkegaard's notions of self, will and self-awareness are deeply interconnected:

> The more consciousness, the more self; the more consciousness, the more will; the more will, the more self. ... The self is the conscious synthesis of infinitude and finitude that relates itself to itself, whose task is to become itself, which can be done only through the relationship to God.[18]

For him, we are the type of being 'whose task is to become itself, which can be done only through the relationship to God'.[19]

The necessity of developing that relationship is demonstrated by the inability of any other choice or lifestyle to extricate the individual from despair.

In *Either-Or* and elsewhere, Kierkegaard outlined three stages in the evolution of the individual that (not coincidentally) mirrored developments in his own life. The first, living an aesthetic existence, means focusing on both the artistic and the sensual aspects of our being, pursuing the pleasures they afford and adopting the rotation method of diverse experience in order to avoid boredom.[20] An ethical lifestyle, on the other hand, demands that the individual executes his duties to the letter of the law, as reason dictates. The trouble with both is that 'to despair of oneself is to see oneself confronting an emptiness that cannot be filled by aesthetic pleasure or ethical rule following'.[21] Only a religious lifestyle can fill the void.

So Kierkegaard calls upon us to become 'knights of faith'. Like Abraham, this involves what he calls a 'teleological suspension of the ethical'. As a father, Abraham's premiere ethical obligation was to look after the welfare of his son Isaac. But, in the Book of Genesis, God asks Abraham to sacrifice Isaac as a burnt offering. Demonstrating his worthiness to lead the Israelites, Abraham was prepared to do so, but the angel of the Lord called out to him from heaven to stay his hand. Abraham's story illustrates Kierkegaard's belief that our ultimate purpose in life must be higher than the dutiful execution of our ethical obligations, and we can fulfil that higher purpose only through complete submission to the will of God.

There are several facets of Abraham's choice that are both crucial to and exemplary of what it is to be a true Christian in Kierkegaard's eyes:

> Abraham was greater than all, great by reason of his power whose strength is impotence, great by reason of his wisdom whose secret is foolishness, great by reason of his hope whose form is madness, great by reason of his love which is hatred of oneself.[22]

No matter how much earthly power we acquire, we are powerless before God and death. No matter how wise and rational we may become, we cannot comprehend the irrationality of the paradox of the Divine made flesh, or the madness of taking the leap of faith. To

love God sometimes demands that we hate ourselves (at least our sensual selves) and even members of our own family, if they stand in the way of our obedience to God. Faith, hope and love are the primary Christian virtues, and Abraham embodies each of them to the highest degree.

Abraham's conduct was more than admirable: 'For it is one thing to be admired, and another to be the guiding star which saves the anguished.'[23] His awesome and terrifying choice stands as a beacon on the way of Christ and an inspiring model of the resignation to the infinite that it requires. The passionate intensity of Abraham's commitment to God and his willingness to make the ultimate sacrifice on God's behalf stand as the spiritual ideal of Christianity and is echoed in God's willingness to sacrifice His Only Begotten Son to make possible the salvation of the human race.

Note that Christ's death on the Cross does not *ensure* our salvation. Being cleansed of our original sin, we face the choice of believing in God and gaining heaven or rejecting Him and deserving Hell. That choice must be a free one, and, ironically, in Kierkegaard's view, it is not persecution but the general *acceptance* of Christianity that is the greatest hindrance to choosing faith freely and passionately: 'We are prevented through a delusion, an enormous delusion, (viz. "Christendom", The Christian State, a Christian country, a Christian world) from becoming Christians.'[24]

This poses a dual threat to the individual who seeks to authentically discover what he truly believes: (1) The social stigma attached to being a non-Christian, or even to raising the most fundamental questions about human existence, is designed to make him into 'the mass man' and (2) the coercive power of the State directly infringes on his freedom of choice. To avoid making religious belief compulsive, Kierkegaard called for a complete separation of Church and State:

> Whatever you do, save Christianity from the State, for with its protection it overlies Christianity like a fat woman overlaying her child with her carcass, besides teaching Christianity the most abominable bad habits – as, e.g., to use the police force and to call it Christianity.[25]

The highest praise Kierkegaard bestows on Abraham is that, despite his love for Isaac, he 'believed and did not doubt, he believed

the preposterous'.[26] It is this preposterous nature of the leap of faith that gives it such majesty. The absurdity of the paradox and the passion of the believer are the two fulcrums on which faith turns, the second of which Kierkegaard addresses in a crucial footnote:

> To this end passion is necessary. *Every movement to infinity comes about by passion, and no reflection can bring a movement about. This is the continual leap in existence that explains the movement.* ... What our age lacks, however, is not reflection but passion.[27]

Kierkegaard believed that only the passions can move us to action, and passion is the foundation of our most fundamental projects. The Knight of Faith is defined by the depth of his unswerving commitments, which remain unchanged throughout his life:

> Only the lower natures forget themselves and become something new. ... The deeper natures never forget themselves and never become anything else than what they were. So the knight remembers everything, but precisely this remembrance is pain, and yet by the infinite resignation he is reconciled with existence.[28]

Attaining such 'infinite resignation' involves accepting existence as good, 'for only then can there be any question of grasping existence by virtue of faith'.[29] As we shall see, all three types of despair, and this 'infinite resignation' of faith, are strikingly exemplified by characters in *Winter Light*.

Pastor Tomas Ericsson (Gunnar Björnstrand) has a dwindling flock, and he knows why. *Winter Light* begins with him reciting morning services to a handful of the faithful, mouthing the words automatically with little thought or passion and struggling with a serious illness. As his organist reveals at the end of the film, Tomas was once an inspiring preacher with a substantial following, but then his beloved wife died and that was the end of him.

Winter Light is filmed in a spare and Spartan manner, as if to reflect the Lutheran spirit.[30] It is dominated by luminous close-ups of conflicted speakers, by two shots of people in conversation and by representations of Christ on the Cross, with minimal editing. The emotional concentration of such claustrophobic shot compositions is exhausting, yet they ensure our empathy for the main characters.

One of the communicants at the morning service was Märta Lundberg (Ingrid Thulin), a spinster who devotedly takes care of Tomas, to the extent he will allow. Still pining for his dead wife, he does not love her, spurns her advances and finds her presence stifling. As Märta later observes, 'You're dissatisfied with life, but most of all with yourself.' That dissatisfaction comes to a head one winter day, on which the pastor is called upon to conduct services in two different parishes.

After the first service, the pastor agrees to see Jonas Persson (Max von Sydow) and his wife. Jonas is a fisherman grounded on shore by the harshness of winter. His wife tells Pastor Tomas that Jonas started having thoughts of suicide after seeing a news broadcast on China and its imminent development of an atomic bomb. When Jonas returns alone later that morning, Tomas talks more about himself than with the poor man, revealing his own personal crisis of faith and deepening Jonas' sense of despair.

Inappropriately, the pastor bares his despairing heart to Jonas:

Every time I confronted God with the realities that I witnessed [in the Spanish Civil war and during the process of his wife's death] he turned into something ugly and revolting, a spider God, a monster. ... If there is no God would it really make any difference? Life would become understandable. There is no creator, no sustainer of life. No design.

Jonas leaves, in even greater anguish than when he arrived, and Tomas cries out (echoing Christ): 'God. Why have you forsaken me?'

Meanwhile, Tomas continues to fence with Märta, who has written him a letter that declares her love and begs to be made of use. He reads it with disdain and will eventually reject her affection in a stinging and callous manner. But first a parishioner bursts into the church, declaring that Jonas Persson has fatally shot himself in the head with his rifle. Tomas recalls that he had no answer when Jonas asked him 'Why do we have to go on living?' The pastor knew immediately that he had done Jonas a disservice and that his failure was significant: 'I could only spout drivel, yet I had the feeling that every word was decisive somehow.'

The idea of forcing the pastor to confront the suicide of his parishioner originated when Bergman and his wife at that time, the

concert pianist Käbi Laretei, were vacationing in the countryside and went to visit a pastor whom Bergman knew. Bergman recalled in Vilgot Sjöman's 1963 multi-part TV documentary series *Ingmar Bergman Makes a Film*: 'He was depressed and I asked him why. "Well, a man took his life here, and I had spoken with him just the day before". The priest blamed himself mercilessly for not realizing how serious the situation was. [...] He thought of how impervious he had been to the man's suffering.'[31]

Tomas goes to the scene of the suicide, stands alone with the body for a moment and then helps cover it and get it into the transport van. He says no prayers over Jonas and offers no blessings. Bergman covers the sequence in a long shot that highlights the grey landscape, heightening the feeling of bereft emptiness. His camera observes the pastor's behaviour from a sceptical distance. We are encouraged to think about what he has done, and failed to do.

Then Tomas drives Märta to her Aunt's house, where he finally confronts her feelings for him. He insists that he simply cannot reciprocate them, admitting that he has failed to get beyond his wife's death four years earlier. After trying to pass off a 'pack of lies' about being embarrassed before the faithful about their affair ('I felt that I had found a good excuse ... but you wouldn't bite'.), he acknowledges that 'The real reason is that I don't want you'. He berates her for being too concerned with her physical condition (she suffers from chronic eczema and a nervous stomach) and for involving him in a maze of 'idiotic trivialities', and she responds with a withering prediction: 'You will hate yourself to death.'

This seems to take Tomas aback, and he reverses his original refusal and asks Märta to go with him to the second service. On the way, he stops off to tell Jonas' wife of the suicide. She takes it stoically, reassuring the pastor that she knows he did what he could and struggling to find a way to tell the children. Tomas, on the other hand, knows full well that he failed to respond to Jonas' despair with love and compassion.

Arriving at the second church (and entering through the churchyard cemetery), Tomas is clearly shaken. His sexton, Algot Frövik, is troubled by something he must get off his chest, and declares that the 'passion' has been misinterpreted, and that Christ's sufferings were not primary physical, but rather spiritual. It was the torment of being abandoned by his disciples in the garden of

Gethsemane that truly plagued him, for they had followed him for years, yet had not understood the significance of the Last Supper and could not watch and wait with him for even an hour. He had foretold that Peter, his most trusted disciple, would subsequently deny knowing Him. Worst of all, while he was dying on the cross, Christ feared that his Father had forsaken him, that his teachings were a lie, and that eternal life was an illusion. As Roger Ebert recognized about Algot in his review of the film: 'He alone of all these people seems to have given more thought to the suffering of Christ than to his own suffering.'[32]

Tomas is quiet, but has listened attentively to Algot, and seems touched. No one shows up at the church, and the organist urges cancellation, but Pastor Tomas decides to hold services anyway. When he devoutly utters the words 'Holy, holy, holy' (Lord God Almighty, Heaven and Earth are full of your glory), he is no longer merely mouthing the words. He has reached out to Märta as well, for she reacted strongly and not submissively to his verbal assaults. For her part, she continues to hope that they can treat each other lovingly at some point in the future. The film hence ends on a somewhat more optimistic note than its tone up to that point.

The parallels between real life and the world of *Winter Light* are striking. The actor playing Tomas himself had the flu during filming. Bergman's estranged second wife suffered from eczema similar to that which plagued Märta, which has led at least one critic to suggest that Bergman may have been exploring his own personal doubts about how he treated the women in his life.[33] Finally,

> The film was further inspired by an incident when Bergman and his father, who was a pastor, went to a church near Uppsala and the pastor there said that he was too ill to hold communion. His father spoke with him privately, and the pastor held the service with the assistance of his father. 'Thus I was given the end of *Winter Light* and the codification of a rule I have always followed and was to follow from then on: *irrespective of everything, you will hold your communion.* It is important to the churchgoer, but even more important to you'.[34]

Winter Light is clearly one of Bergman's most personal and deeply felt films.

The director commented on the significance of the pastor's final decision in a conversation with his colleague Victor Sjöstrom:

> Now it is custom in the Swedish church that if there are no more than three persons in the congregation, no service need be held. What I do is this: when Björnstrand comes to the district church, the church-warden comes up to him and says: 'There's only one churchgoer here'. Yet the parson holds the service all the same. That's all that is needed to indicate the new faith that is stirring inside the parson.[35]

Before concluding with an analysis of that reborn faith, let me discuss the various types of despair that are encountered in *Winter Light*, as well as the most inspirational example of faith contained therein.

Perhaps it is because Jonas is inarticulate, or couldn't get a word in edgewise in the face of Tomas' desperate expressions of doubt, but his despair seems the most superficial, despite the fact that it results in his death. Jonas does not declare his hatred of God, nor does he explicitly decry his lot in life or wish he was someone else. His paranoia at the prospect of China having the A-bomb seems to be what psychologists call a displacement, distracting Jonas from his marginal employment as a fisherman, his growing family (which must be getting harder to care for) and his grim surroundings.

With admittedly little to go on, I would hence categorize Jonas as suffering from despair at not being conscious of having a self. As I put it above in my general characterization of this kind of despair, Jonas was 'a person with little or no self awareness [who] despairs in the face of earthly troubles and can see no possible way out of them'. Driven from pillar to post by the exigencies of the moment, he had nothing to fall back on, felt no help from his loving wife or despairing pastor, and dissolved in the face of what must be admitted to be a paranoid delusion (albeit one shared by many people in the world at the time).

Märta is another story. She exhibits a greater degree of self-awareness. She has not had an easy life and has long since abandoned her faith. But she has no self to call her own, since she seeks to subjugate herself to Tomas, and believes that only his love can save her from despair. She wants to be of use, to serve him and

care for his needs, in many ways embodying the traditional role of women in sexist societies. As many mainstream feminists would point out, adopting that role precludes being a true individual, for it involves thinking of the feminine gender as what Simone de Beauvoir dubbed 'the second sex', that is, as inherently inferior and born to serve. I hence conclude that Märta was suffering from what Kierkegaard called 'Despair at Not Willing to Be Oneself'. This involves being *aware* that one is not willing to be oneself, and hence a step forward from totally lacking self-awareness. Perhaps her gutsy retort to Tomas' abuse near the end of the film indicates an emerging sense of self that might inspire more than scorn from the pastor.

Tomas embodies many of the characteristics of what Kierkegaard called 'Despairing at Willing to Be Oneself' and in its most demonic form. His was the consciousness of the unbeliever, which, 'rebelling against all existence, feels that it has obtained evidence against it, against its goodness'. This is the most terrifying form of despair, for it gives rise to a demonic rage at God and His creation.

It is precisely this rage that Tomas gives vent to in his talk with Jonas, ranting about 'something ugly and revolting, a spider God, a monster' being behind the realities of the Spanish Civil War and the premature death of his beloved. As he put it, believing that there is no God, and hence no intelligent design behind events, makes these horrors more understandable in human terms. But faith has got to be able to look the Problem of Evil right in the face and see the possibility of eternity as redeeming the temporary injustices with which we all have to deal.

Sexton Frővik has just such a faith, and his love for God and empathy for the sufferings of Christ stand in sharp contrast to these other characters. Permanently disabled by a railway accident, Algot has the deepest faith of anyone in the film, and the least degree of despair. He encouraged Pastor Ericsson to hold the second service, though he had attended the first one earlier in the day. He meditated often upon the life of Christ, as any good Christian should, and believed he had suffered as much physically as Christ did during the Passion. Despite those sufferings, he clung to his faith, avoiding the despair with which all of the rest of the characters in the film are struggling. As Bergman himself put it, Frővik is an angel: 'Really, literally: an angel. There is fifty times more religion in that man than in the whole character of the parson.'[36]

But the parson himself shows some signs of a renewal of his faith at the end. For one thing, he chooses to go on with the second church service; as Birgitta Steene observes: 'By performing the service when he was in his legal and moral right to cancel it, Tomas Ericsson admits his willingness to "say yes".'[37] For another, as Steene also pointed out, Tomas is trying to overcome an obsolete view of women as 'higher beings, admirable beings, inviolable martyrs', which he no doubt sustained within his previous relationship with his wife. In her absence, he continues to idealize her, an attitude he must overcome to meet Märta on a human plane.

The most conclusive indicator is to be found in his approach to the service: 'One notices that in his final intonation of the words "Holy, holy, holy", Tomas' voice is hesitant; it is as if he listened to the words, and his speech stands in marked contrast to his mechanical performance of a dutiful task in the film's first sequence.'[38] So the film ends with Algot as an exemplar of unswerving faith and with a tentative depiction of Tomas's own personal belief being renewed in the crucible of doubt and through his confrontation with finitude.

Confronting Jonas's suicide, and his own guilt for not having bolstered the dead man's faith, could have pushed Tomas over the edge and into a permanent state of suicidal depression himself. But he does not despair. His more reflective intonation, in the second service, confirms that there is positive development in Tomas's character.

To summarize, then, Jonas, Märta and Tomas, the three central characters in *Winter Light*, exemplify the three major kinds of despair that Kierkegaard discusses in *The Sickness Unto Death*. Furthermore, there are several stunning parallels between Abraham as Kierkegaard's 'Knight of Faith' in *Fear and Trembling* and Algot Frövik's impassioned profession of belief in the emotional sufferings of Jesus at the end of the film.

Algot took his own physical infirmities in stride, dedicated himself to serving God as church sexton and reflected on the life of Christ more profoundly than the pastor who made it his life's work to do so. He is one of the most quietly inspirational embodiments of Christian faith in Bergman's body of work and a character of which Kierkegaard would surely have approved.

Questions for discussion

1 Though Abraham is the embodiment of his ideal knight of faith, Kierkegaard admits that he cannot identify with the Jewish patriarch. Could you kill your own child, if you believed God wanted you to do so? Explain.

2 What do you think of Kierkegaard's claim that either we must believe in God and take the 'leap of faith' or we are destined to live in despair? If you are a believer, does your belief help you avoid despair? If you are not, do you feel you are despairing? Explain in either case.

3 With which character in this film do you most identify, and why? If no one, how is their experience so very different from yours? Is there anything to be learned from these depictions of people grappling with despair and the loss of faith in God?

4 What is the difference between an entertainment film like *Star Wars* and an 'art film' like *Winter Light*. Is the latter entertaining to watch? If not, why watch such films? Can a film be 'too philosophical' or 'too artsy'? Was *Winter Light* either?

Suggestions for further viewing

The Ruling Class (1972, Peter Medak) – Peter O'Toole plays the 13th Earl of Gurney, who thinks he is Jesus Christ, and acts accordingly. He is about to be declared insane until shock therapy reverses his personality and turns him into Jack the Ripper. In a brilliant satire, whereas he was declared insane for acting like a true Christian, he is lionized by Britain's high society for being ruthless and selfish.

A Man for All Seasons (1966, Fred Zinnemann) – Paul Scofild in his Academy Award winning role as St. Thomas More, who was beheaded by King Henry VIII for refusing to publicly approve of the king's marriage to Anne Boleyn. His concern for his immortal soul, even over the welfare of his family, makes him an archetypal cinematic example of the knight of faith.

The Passion of the Christ (2004, Mel Gibson) – A fervent retelling of the story of Christ's crucifixion, with emphasis on the physical sufferings of the Saviour, and His humanity.

The Robe (1953, Henry Koster) – Richard Burton as a Roman nobleman who took part in the crucifixion of Christ. He falls in love with a slave and is converted by her, professing his faith to the Emperor Caligula. A Biblical epic with real heart.

CHAPTER FOUR

Howard Rourke as Nietzschean Overman in *The Fountainhead*

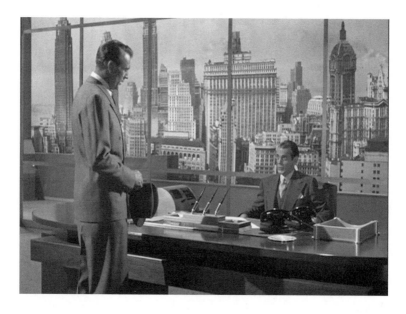

In her final edit of the first edition of *The Fountainhead*, Ayn Rand removed the following Nietzsche quote from the beginning of the book:

It is not the works, it is the *faith* that is decisive here, that determines the order of rank … some fundamental certainty that a noble soul has about itself, something that cannot be sought, nor found, nor perhaps lost. – *The noble soul has reverence for itself.*[1]

While Rand insisted in her introduction to the twenty-fifth anniversary edition that she 'removed it because of my profound disagreement with its author, Friedrich Nietzsche',[2] I suspect that she was also attempting to mask how influential Nietzsche's philosophy had been on her world view and her vision of the ideal hero, Howard Roark. In what follows, I will demonstrate how right she was to show such anxiety of influence.

Friedrich Nietzsche is a towering figure in the history of existentialism, an atheist who first mapped out the logical implications of such a view for the rest of philosophy. Nietzsche sounded almost all of the major themes that would characterize the movement and provided his own unique answers to many of the questions that would haunt it to this day. Nietzsche was a devastating critic, who sought to clear the way for 'new' philosophers by undercutting the three major sources of meaning in traditional thought: religion, morality and philosophy. The positive world view he proposed also had three interconnected elements: the will to power, the overman and the eternal recurrence.

Nietzsche begins his analysis of religion with the Greco-Roman era, where the gods and goddesses were simply more powerful versions of human beings and where personal immortality was not possible for mortal men. Rather than an assault on human nature, these pagan deities represented a celebration of it, and their worship reflected the health of the ruling classes in ancient Greece and Rome.

But both societies were built on the labour of slaves, who had no hope in this life, and whose priests invented the notions of personal immortality for humans and of a perfect saviour God who would redeem their sufferings and give them a chance of immortality in heaven by sacrificing himself on the Cross. Christianity waged war against the powerful in this life and valourized the torments of the slaves:

From the start, the Christian faith is a sacrifice: a sacrifice of all freedom, all pride, all self-confidence of the spirit; at the same time, enslavement and self-mockery, self-mutilation.[3]

In order to make the afterlife appear to be our only hope for happiness, Christianity seeks to make everything that is worthwhile in this life look vain and sinful.

Nietzsche considered himself to be the prophet of an atheistic movement that was well under way: 'Why atheism today? – "The father" in God has been thoroughly refuted; likewise "the judge", "the rewarder". Also his "free will": he does not hear.'[4] Nietzsche celebrated this decline and predicted that Christianity would fade into human history:

> Perhaps the day will come when the most solemn concepts which have caused the most fights and suffering, the concepts 'God' and 'sin', will seem no more important to us than a child's toy and a child's pain seem to an old man.[5]

This hope is a fervent one, for hitherto Christianity has proved to be the greatest impediment to the progress of the human species:

> Men not noble enough to see the abysmal disparity in order of rank and abysm of rank between man and man – it is *such* men who, with their 'equal before God', have hitherto ruled over the destiny of Europe, until at last a shrunken, almost ludicrous species, a herd animal, something full of good will, sickly and mediocre has been bred, the European of today.[6]

Egalitarianism is a natural ideal for those who are inferior, and bringing superior individuals down to the level of the herd is its real aim and ultimate effect.

According to Nietzsche, the major vehicle for doing so has been adherence to the universal moral standards embodied in Christianity. Morality is an expression of the herd instinct in the individual, and humans join the herd for the same reason animals do: for self-preservation. True individuals stand out from the herd, and like lone antelopes who wander away from it, they are more likely to be attacked. Most people are followers who seek to be commanded, and many of them turn to the church for such commands.

The search for a single set of universal moral standards makes no logical sense, in light of historical relativism (values change in the same society over time), cultural relativism (different cultures have

very different moral standards at the same time) and individual relativism (individuals in the same culture at the same time vary greatly in the values they espouse). As Nietzsche puts it: 'The diversity of men is revealed in the diversity of their tables of values ... [which] also differ as to the order of rank of the goods they all recognize.'[7]

Furthermore, such diversity is a *good* thing, from an evolutionary point of view. Although Nietzsche took issue with the notion that natural selection favoured the fittest in the human world (he thought the mediocre were more likely to survive), he agreed with Darwin that diversity within a species makes for greater adaptability, and considered nonconformist individuals to be the random mutations that natural selection could operate on in the social world. Universal moral standards tend to suppress such individuals, producing a degree of uniformity that threatens the future of the human race.

But Nietzsche was not a precursor of the Hippie movement, with its attitude of 'anything goes' and 'live for the moment':

> Every morality is, as opposed to *laisser aller* [letting things go], a bit of tyranny against 'nature'; also against 'reason'; but this in itself is no objection ... What is essential 'in heaven and on earth' seems to be, to say it once more, that there should be *obedience* over a long period of time and in a single direction: given that, something always develops, and has developed, for whose sake it is worthwhile to live on earth 'You shall obey – someone and for a long time: *else* you will perish and lose the last respect for yourself'.[8]

While moralists are wrong to search for a single set of universal values and priorities, they were right to argue that an individual must embrace a hierarchy of values *and stick to it* in order to create anything lasting in life.

Just as Nietzsche preferred the pagan religion of the ancient Greeks to Christianity, he preferred their masterly hierarchy of values as well:

> I finally discovered two basic types and one basic difference. There are *master morality* and *slave morality*. ... In the first case, when the ruling group determines what is 'good', the exalted, proud states of the soul are experienced as conferring distinction and

determining the order of rank. The noble human being separates from himself those in whom the opposite of such exalted, proud states find expression: he despises them. It should be noted immediately that in this first type of morality the opposition of 'good' and 'bad' means approximately the same as 'noble' and 'contemptible'.[9]

It is 'good' to be one of the superior few, while it is 'bad' to be part of the herd majority. Christianity has inverted these values:

> One altogether misunderstands the beast of prey and man of prey (Cesare Borgia for example), one misunderstands 'nature', so long as one looks for something 'sick' at the bottom of these healthiest of all tropical monsters and growths – as virtually all moralists have done hitherto. This for the chapter 'Morality as Timidity'.[10]

No one wishes to think of themselves as powerless and inferior, and the slaves (and their priestly caste) simply reversed the masterly value system: the traits that put the masters in control were now seen as 'evil' (indeed, they become the Seven Deadly Sins), while the qualities that make a slave a slave qualify them as 'good'. Their meekness, passivity and long suffering natures were praised by Jesus in the Sermon on the Mount, for which he gave them his blessing. Furthermore, Jesus promised that the injustice of existence will be righted in the afterlife, when the masters will go to hell and the slaves to heaven.

Nietzsche, on the contrary, declares that he will abandon all moralizing, for 'moral judgment and condemnation is the favorite form of revenge of the spiritually limited on those who are less so'.[11] He then turns his vivisectionist knife on the history of philosophy itself, claiming that philosophers are too often apologists for Christianity and that 'the moral (or immoral) intentions in every philosophy constituted the real germ of life from which the whole plant had grown'.[12] He condemns most philosophers for being Christian moralists, seeking to justify their personal standards of morality as universal and to rationalize their faith.

The dedication to truth and logic that has been said to characterize genuine philosophers is also found to be questionable.

Logic, in Nietzsche's view, is not a reliable method for getting at objective truth:

> Behind all logic and its seeming sovereignty of movement, too, there stand valuations, or, more clearly, physiological demands for the preservation of a certain type of life. For example, that the definite should be worth more than the indefinite, and mere appearance worth less than 'truth': such estimates might be, in spite of their regulative importance for *us*, nevertheless mere foreground estimates ... which may be necessary for the preservation of just such beings as we are.[13]

Nietzsche relativizes logic to the society in which it arises, claiming its principles are designed to preserve *a certain type* of human life and *not* to discover the nature of the universe. Philosophers have always sought their timeless truths, but Nietzsche questioned whether *any* 'truth' could be timeless.

Appearances to the contrary notwithstanding, philosophers are *not* engaged in a selfless and depersonalized search for truth; they each have their own 'truths', which reflect their personal perspectives, and which they attempt to impose on others by the skilful use of rhetoric. Hence, Nietzsche contends that propositions and hypotheses should be evaluated in terms of their usefulness rather than for whether they adequately correspond to the way the world is:

> The falseness of a judgment is for us not necessarily an objection to a judgment. ... The question is to what extent it is life-promoting, life-serving, species-preserving, perhaps even species-cultivating, and we are fundamentally inclined to claim that the falsest judgments ... are the most indispensable for us. ... To recognize untruth as a condition of life: that certainly means resisting accustomed value feelings in a dangerous way; and a philosophy that risks this would by that token alone place itself beyond good and evil.[14]

Though he is considered to be one of the most notorious naysayers in the history of philosophy, Nietzsche called himself an active nihilist, by which he meant that he was negating all of the traditional sources of meaning and value in order to propose new ones.

He does so in *Beyond Good and Evil* in several places, the first of which must be seen in the context of his ongoing critique of Darwinism:

Physiologists should think before putting down the instinct of self-preservation as the cardinal instinct of an organic being. A living thing seeks above all to *discharge* its strength – life itself is will to power – self-preservation is only one of the indirect and most frequent *results*.[15]

Nietzsche uses this hypothesis to answer three of the most basic philosophical questions.

Nietzsche denied the existence of a spiritual realm beyond physical reality and (anticipating quantum physics by several decades) contended that the basic building blocks of the universe should be seen as packets of energy that he called 'quanta of power'. Critical of both dualism and atomism, Nietzsche proposed a dynamic version of metaphysical monism in section 36 of *Beyond Good and Evil*:

Suppose nothing else were 'given' as real except our world of desires and passions, and we could not get down, or up, to any other 'reality' besides the reality of our drives. ... Suppose, finally, we succeeded in explaining our entire instinctive life as the development and ramification of one basic form of the will – namely, of the will to power, as *my* proposition has it ... then one would have gained the right to designate *all* efficient force unequivocally as: *will to power*. The world viewed from inside, the world defined and described by its 'intelligible character' – it would be simply 'will to power' and nothing else.[16]

By 'power', Nietzsche means, more than anything else, 'control'. To feel powerful is to feel in control of things, in three specific senses we will discuss in a minute. The Will to Power also functions as a theory of psychological motivation: Nietzsche contends that people benefit others or hurt others from the same motive: to increase their own feeling of power, which Nietzsche believes to be the key to human happiness.

Finally, the Will to Power is a theory of value. Having undercut traditional standards of valuation, Nietzsche must propose others

or become a passive nihilist, who accepts the meaninglessness of existence. His measures of progress for the human race involve increasing the power of individuals in three senses: (1) control over self, that is, achieving the individual autonomy that is necessary to command yourself to follow the values you choose, (2) control over the environment, to transform it to fulfil human desires and (3) control of superior individuals over the herd majority.

Most people will never be anything more than herd animals. Incapable of commanding, they must be told what to do, and they will do as they are told. Nietzsche designates the personality type that should be in control of society as the overman, and in *Thus Spoke Zarathustra* he makes it clear that only such individuals can redeem the human race from nihilism and allow it to better adapt to a rapidly changing environment. Nothing less than the future of the human species is at stake.

Overmen must be artists, creating new world views and perspectives. As Harold Alderman put it in his wonderful little book *Nietzsche's Gift*:

> A person who will be viewed by Nietzsche as an overman is then more likely to be an artist who uses his Dionysian principle and way of thinking and feeling to create works that carry a particular individual's picture or interpretation of the world. His values may or may not be the same as any other but a good artist should be able to combine creativity with his perception of the world and life and express it well in his work.[17]

As we shall see, that is precisely what Howard Roark does in his buildings.

This vision of the overman that he describes is not a timeless ideal for Nietzsche, but rather his personal notion of what the next progressive stage in human development should be. In order to crystallize this vision, and generate a useful check list on the basis of which I will justify my claim that Howard Roark is an overman, let me cite the traits Alderman proposed to be the characteristics of such a person: the overman

1) expresses anger directly, 2) creative; 3) self-directed; 4) this-worldly; 5) self-aware; 6) proud (not vain); 7) egoistic; 8) experimental; 9) aristocratic; 10) discrete (masked);

11) morality of persons; 12) strong willed; and 13) good (strength) vs. bad (weakness).[18]

I will soon be applying this (admittedly artificial) list to the personality and conduct of Howard Roark. In *Thus Spoke Zarathustra*, Nietzsche contended that the key to becoming an overman is to be found in rejecting the 'spirit of revenge' and adopting the attitude of 'thus I will it so' towards everything that has happened in the past. Developing an attitude of what he calls *Amor Fati* (literally, to 'love fate') allows the overman to be more effective and future oriented. Revenge is counterproductive in a number of ways, the most obvious of which is that the vengeful individual is fixated on what has been rather than focused on what could be. This is where Nietzsche's enigmatic doctrine of 'eternal recurrence' comes in.

For a while, Nietzsche toyed with making the metaphysical claim that a finite number of quanta in an infinite period of time would inevitably start repeating their combinations. But the notion became more attitudinal than literal and is proposed in the published works as a test for being an overman. It was in *The Gay Science* that Nietzsche first raised the prospect of repeating one's life *exactly as it has been* over and over again for all eternity, asking his readers how we would react. If one has no regrets, the idea should be exhilarating. The type of person that would say 'if I had it to do over again, I wouldn't change a thing' is a likely candidate for being an overman. One who is burdened by regret, and engaged in the search for revenge, would find the prospect intolerable. Let's see if Howard Roark fits the former type.

The Fountainhead's director, King Vidor, was not the most likely candidate for helming such a film, having made a scandalously left-wing populist movie called *Our Daily Bread* in the 1930s. Vidor used many of the techniques of the pessimistic genre that came to be known as *film noir* in his vision of Rand's novel, but her loner protagonist triumphs rather than being ground beneath the wheel of existence. Stark contrasts between light and shadow, and asymmetrical shot compositions, depicted a world out-of-joint.

The story begins with Roark (Gary Cooper) being expelled from a prominent architecture school for failing to conform to the standards of classicism. He sets off on his own and seeks a job with fellow iconoclast Henry Cameron, a pioneer of modern architecture

who has fallen on hard times in later life because of his stubborn refusal to conform. Cut to several years later.

In the interim, Roark took over Cameron's firm after he retired, and he shares his struggles with his mentor. Their exchange reflects one of the most prominent of Roark's overman traits, an aristocratic attitude:

> Cameron: What have you got to show for it? You've done four
> buildings in all these years.
> Roark: That's quite a good deal to show for it.
> Cameron: After the kind of struggle you've had?
> Roark: I didn't expect it to be easy, but those who want me
> will come to me.
> Cameron: They don't want you, son. Don't you understand?
> This is what they want. Gail Wynand's Banner, the
> foulest newspaper on earth. You hold to your own
> ideas and you'll starve.
>
> Gail Wynand gives people what they ask for: The
> common, the vulgar, and the trite. And he's maybe
> the most powerful man living. Can you fight that?
> Roark: I never notice it.
> Cameron: Look. You see those people down there? You know
> what they think of architecture?
> Roark: I don't care what they think of architecture or
> anything else.[19]

Like Nietzsche, Rand believed that true creators must be indifferent to public opinion, which generally turns against what is new and innovative. The only opinions that matter to them should be their own.

At the end of his professional rope, Roark is granted a last-minute building commission. But the commissioners insist that Roark bow to convention and add classical ornamentation to his radically experimental design, and he refuses:

> Roark: If you want my work, you take it as it is ... or
> not at all.
> Commissioner: But why?
> Roark: A building has integrity, just like a man. And
> just as seldom. It must be true to its own idea,
> have its own form and serve its own purpose.

> Commissioner: But we can't depart from the popular forms of architecture.
> Roark: Why not?
> Commissioner: Because everybody's accepted them.
> Roark: I haven't.
> Commissioner: Do you wish to defy our common standards?
> Roark: I set my own standards.
> Commissioner: Do you intend to fight against the world?
> Roark: If necessary.
> Commissioner: But after all, we are your clients, and it's your job to serve us.
> Roark: I don't build in order to have clients. I have clients in order to build.

Roark is a tenaciously autonomous agent. He becomes a day labourer in a quarry rather than compromise his priorities.

Roark takes control in his personal life as well. When Dominique Francon (Patricia Neal), the daughter of the quarry owner, flirts with him, he calls her on it. When she slaps him across the face with her whip, he comes to her room and forces her to have sex (although the scene in the film got around the censor by leaving out the sex and suggesting rather clearly that she wanted him, which she admits to in the novel). His is a forceful personality, an egoist who gets what he wants. When a letter from a millionaire arrives with the promise of a new commission, he leaves without even identifying himself.

Roark was summoned to design an upscale apartment house for Roger Enright (Ray Collins). Coincidentally, Dominique works as an architectural critic, and she resigns when editor Gail Wynand (Raymond Massey) OKs a massive smear campaign against the Enright House in his tabloid newspaper, *The Banner*. She is unaware that its designer was her former lover, and their romance reignites at the opening reception Enright holds for his new building.

Dominique admits her love for Roark and pleads with him to leave architecture behind and escape with her. Dominique adopts a nihilistic and hopeless attitude early on, which is revealed in her first exchange with Wynand:

> Dominique: I'll never want anything. Do you know what I was doing when you came in? I had a statue which I

Wynand: found in Europe, the statue of a god. I think I was
in love with it ... but I broke it.

Wynand: What do you mean?

Dominique: I threw it down the air shaft.

Wynand: Why?

Dominique: So that I wouldn't have to love it. I didn't want to
be tied to anything. I wanted to destroy it rather
than let it be part of a world where beauty and
genius and greatness have no chance. The world of
the mob and of the Banner.

On the basis of that attitude, she has concluded that Roark is sure
to fail and that she cannot bear to see it happen. Roark refuses to
surrender, assures her he will not fail and says that they will have
to remain apart until she is willing to stand beside him against the
herd. In a frustrated rage, she rushes to Gail Wynand and consents
to become his bride. Roark looks devastated when he sees them as
a wedded couple from his office window, but he masks his feelings
in the presence of others.

Dominique's prediction comes true for a while, and Roark loses
several commissions to less competent architects. But he is resolute,
and slowly, over a period of years, the tide turns. Beginning with
a modest gas station, and ending with a modern factory, his
achievements are displayed in a triumphant montage of designs and
their realization, accompanied by a soaring musical theme by Max
Steiner. Director King Vidor pulls out all the stops in his fervent
depiction of a loner successfully standing against the crowd and
getting the girl in the process, and Steiner's score is full of leitmotifs
that tell us how to read the scenes emotionally.

Roark explains his success to an interviewer, showing neither
regret for anything he has done nor vengefulness towards those
who persecuted him:

Interviewer: But you had years torn out of your life, wasted by
the Banner.

Roark: No. All these years, I've found some one man who
wanted my work...
one man who saw through his own eyes and
thought with his own brain.
Such men may be rare, they may be unknown, but
they move the world.

Interviewer: How did you look for them?
Roark: I didn't. They called for me. Any man who calls
for me is my kind of man. (Gail Wynand calls for
Roark in the very next scene.)

One of his chief tormenters was Ellsworth Toohey (Robert Douglas), social critic for *The Banner*. A closet fascist who preaches the welfare of the majority (hiding behind the mask of socialism as Hitler did), Toohey was behind the bank commission Roark turned down, the Banner smear campaign, and the success of Roark's mediocre contemporary, Peter Keating (Kent Smith). As part of his campaign against the Enright House, Toohey appeals to a group of undistinguished members of the profession:

You are architects and you should realize that a man like Howard Roark is a threat to all of you. The conflict of forms is too great. Can your buildings stand by the side of his? I believe you understand me, gentlemen.

Later, at the opening gala, he says: 'A man abler than his brothers insults them by implication. He must not aspire to any virtue which cannot be shared.' It is all part of his diabolical plan to enslave the masses; nonconformists like Roark will not submit and would thwart Toohey's attempts to fashion 'one neck, ready for one leash', with him as cultural dictator.

If there is anyone on whom Roark would want to revenge himself, it would be Toohey. But he shows nothing but utter disdain in their only one-on-one confrontation:

Toohey: This city is closed to you. It is I who have done it.
 Don't you want to know my motive?
Roark: No.
Toohey: I'm fighting you, and I shall fight you in every way I
 can.
Roark: You're free to do what you please.
Toohey: Mr Roark, we're alone here. Why don't you tell me
 what you think of me in any words you wish?
Roark: But I don't think of you.

Yet Roark does not disdain everyone, and he forms an unlikely friendship with Gail Wynand, who remains married to his lost love.

Wynand asks Roark to design a personal residence that will be dedicated to his beloved wife Dominique. Having used mediocre architects on all of his public projects, Wynand goes for true genius in his choice here. Despite being rivals for Dominique's affection (unbeknownst to Wynand), they strike up a friendship. Like a good friend, Roark is frank with Wynand:

Roark: ...we are alike, you and I.
Wynand: You're saying it about Gail Wynand of the New York Banner?
Roark: I'm saying it about Gail Wynand of Hell's Kitchen ... who had the strength and spirit to rise by his own effort ... but who made a bad mistake about the way he chose.

Wynand mistook catering to public opinion for power, and soon finds out that, rather than controlling the people, they control him.

The central crisis of the film is generated by Roark's experimental and problem-solving character. Courtland Homes is a major public housing project that Wynand allows Peter Keating to tackle. But Keating cannot solve the problems of efficiency and cost and comes to Roark for help, as he did back in their college days. Roark agrees to allow Keating to submit the plans under his name, knowing that they would be rejected if they were identified as Roark's. His design is indeed accepted, but numerous changes are made, which render the finished product virtually unrecognizable.

This is intolerable, as Roark explained to Keating when he agreed to do it:

Roark: I've thought of the new inventions, the new materials, the great possibilities never used to build cheaply, simply, and intelligently. I loved it because it was a problem I wanted to solve. Yes. I understand. Peter, before you can do things for people ... you must be the kind of man who can get things done. But to get things done, you must love the doing, not the people. Your own work, not any possible object of your charity.

> I'll be glad if men who need it find a better manner of
> living in a house I build ... but that's not the motive of
> my work, nor my reason, nor my reward. My reward,
> my purpose, my life is the work itself. My work done
> my way. Nothing else matters to me....

Keating: Everybody would say you're a fool. That I'm getting
everything.

Roark: You'll get everything that society can give. You'll take
the money, the fame, and the gratitude and I'll take
that which nobody can give a man except himself. I
will have built Courtland.

Robbed of the only compensation he sought (the satisfaction of
seeing his work done his way), Roark resolves to blow up the
completed housing project. All legal avenues of appeal are closed
to him, despite the contract that Keating signed guaranteeing
there would be no changes from the original blueprints. He enlists
Dominique's aid in executing his plan, as a test of her courage and
indifference to negative public opinion. Roark is arrested for doing
so, and the film concludes with his public trial.

Toohey stirs up the people against him, declaring him guilty and
dismissing the relevance of his having designed Courtland Homes:

> Society needed a housing project. It was his duty to sacrifice his
> own desires and to contribute any ideas we demanded of him
> on any terms we chose. ... Man can be permitted to exist only
> in order to serve others. He must be nothing but a tool for the
> satisfaction of their needs. Self-sacrifice is the law of our age. The
> man who refuses to submit and to serve ... Howard Roark, the
> supreme egoist ... is a man who must be destroyed!

Wynand's is the only major paper to defend Roark's actions, in
the first *Banner* campaign waged *against* the prevailing public
opinion. Wynand thinks the people will believe what he tells them,
but he finds he has precious little power to change their minds.
Then, Toohey leads a walkout that cripples the paper. In the face
of financial ruin, Wynand is forced by his Board of Directors to
stop the campaign and join the chorus of voices that denounce
Roark. His failure is personally shattering, evidence of the disaster
of catering to public opinion.

Roark's closing summary ultimately sways the jury in his favour. To quote from its conclusion:

> It was believed that my work belonged to others to do with as they pleased. They had a claim upon me without my consent ... that it was my duty to serve them without choice or reward. Now you know why I dynamited Courtland. I designed Courtland. ... I made it possible. ... I destroyed it. I agreed to design it for the purpose of seeing it built as I wished. That was the price I set for my work. I was not paid. My building was disfigured at the whim of others who took the benefits of my work ... and gave me nothing in return.
>
> I came here to say that I do not recognize anyone's right to one minute of my life. Nor to any part of my energy, nor to any achievement of mine. No matter who makes the claim. It had to be said. The world is perishing from an orgy of self-sacrificing. I came here to be heard ... in the name of every man of independence still left in the world. I wanted to state my terms. I do not care to work or live on any others. My terms are a man's right to exist for his own sake.

Roark's summation was the longest uninterrupted monologue in the history of Hollywood to that point. Rand proved herself equal to her protagonist by refusing to shorten it at the behest of studio executives:

> The studio wanted to cut it. Rand was true to her principles, and threatened to dissociate herself from the movie if her original version [already much shortened from the book] was not restored. Like her ideal protagonist, she prevailed.[20]

Having won his acquittal with that speech, Roark's triumph is complete, and Toohey is discredited.

Enright takes over the Courtland Homes project and promises to build it according to Roark's specifications. Wynand sells 'the Banner' and commissions him to do the Wynand Building, the highest skyscraper in New York. Confronting his powerlessness, the result of his having chosen wrongly, is too much for Wynand, and he commits suicide after his final meeting with Roark. The films

ends with Dominique (now his wife) ascending to the top of the Wynand Building on a service elevator, where Roark stands on a girder in a heroic pose.

The Fountainhead, therefore, is most fundamentally about power. This can be seen quite clearly in its use of high-angle and low-angle shots. In the latter, we look up from below at a figure or thing, which looms above us. As film theorists have noted, low-angle shots tend to put us in a position of inferiority and relative powerlessness. By contrast, a high-angle shot, looking down from above, conveys a powerful feeling (which is why rulers from time immemorial have insisted on being above their subjects). Roark looks up at Dominique when he is a lowly quarry worker and she is the daughter of its owner. She looks up to him at the end, content now to worship him. This is but one prominent example of how power relationships are expressed by cinematic techniques.

With reference to Alderman's list of traits, Roark was certainly a man who expressed his anger directly, whenever the integrity of his work was threatened. He was a creative and experimental artist, who refused to be tied to the works of the past. Eminently self-aware, he declared his commitments and concerns openly and eloquently. He made no references to God, or an afterlife, nor to any other notion of a spiritual realm. He took personal pride in his accomplishments, without a hint of either false modesty or the vanity that requires recognition by others. He was certainly an egoist, but he wasn't an *egotist*; he was more than willing to respect (and even promote) the interests of others when they coincided with his own.

His aristocratic attitude was made evident in his total indifference to the opinion of the masses. He was always in control of his emotions, masking them if need be to better pursue his goals. He had a uniquely personal set of moral priorities and resolutely pursued them with a will of iron. He never moralized about his opponents or his friends, though he clearly disdained weakness whenever he encountered it. Most importantly, he got things done, architectural marvels made his way.

Finally, Roark was a figure of immense power, in all three Nietzschean senses of the term. He had complete control over himself, an autonomous individual defined solely by his own hierarchy of values. He shaped the environment to serve human needs, bringing out the unique potentials of his raw materials in creating spaces in which humanity can dwell. He would not let the

untermenschen (inferior men, the members of the herd) tear him down, and he triumphed over seemingly hopeless odds. As such, he is both Rand's vision of the ideal man and an archetype of what Nietzsche called the 'overman'.[21]

Questions for discussion

1 Ayn Rand has always been the intellectual darling of the conservative wing of the Republican Party. Both Rand Paul and Paul Ryan often quote her works, especially *Atlas Shrugged* and *The Fountainhead*. Research her influence on contemporary American politics and discuss whether you think it is healthy or not.

2 Do you find Roark's acquittal to be credible? After all, he did blow up a public housing project. Does his justification for doing so seem sound to you, or was he just rationalizing a selfish act of destructive violence?

3 Nietzsche's philosophy was used by the Nazis to justify their belief that a pure blooded Aryan master race of Germans was destined to rule the world. But Nietzsche condemned biologism, racism (especially anti-Semitism) and nationalism as dangerous prejudices. Google 'Nietzsche and the Nazis' and explore this fascinating historical connection. Do you think he was a precursor of Nazism?

4 Discuss the depiction of Dominique Francon in the movie. In particular, what is the significance of her initial refusal to love anything (even a statue), why does she marry Gail Wynand when Roark refuses to give up architecture and how do you interpret her eventual decision to return to Roark and stand by him in the ultimate crisis? Is she a liberating role model for women?

Suggestions for further viewing

Rope (1947, Alfred Hitchcock) – Two recent college graduates murder a classmate to demonstrate their superiority to conventional norms, and then hold a dinner party, with their victim's body

hidden in a chest in the living room. The professor who taught them Nietzsche (Jimmy Stewart) begins to suspect something, and the tension in their apartment reaches a fever pitch.

Eternal Sunshine of the Spotless Mind (2004, Michel Gondry) – Nietzsche stressed how important forgetting about the past is in becoming who you are. But what if there was a machine that could erase all of your painful memories? Having done so, will two former lovers opt to try again, even though they know that many of the same problems will arise?

Groundhog Day (1998, Harold Ramis) – Weatherman Bill Murray finds himself stuck in Punxsutawney, PA, forced to repeat this regional holiday over and over again. But, unlike Nietzsche's notion of the 'eternal recurrence of the same', he learns something from each reiteration, alters his behaviour accordingly and becomes a more humane person and sensitive lover as a result.

Citizen Kane (1941, Orson Welles) – Charles Foster Kane seeks control of everyone and everything around him, from his wives to his friends to the public opinion of his readers. His ruthless struggle for power leaves him desolate and alone and raises questions about whether he could qualify as a Nietzschean overman.

CHAPTER FIVE

Being-Towards-Death in *Blade Runner*: *Angst,* Authenticity and Care[1]

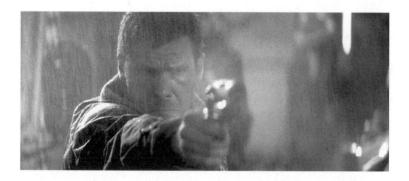

Martin Heidegger was a landmark figure in the history of existentialism, pivotal in redirecting philosophy back to its ancient roots. Heidegger sought to do what he called *fundamental ontology,* recasting the philosophical problematic in striking terms: 'The question to be formulated is about the *meaning* of being' (emphasis added).[2] *Being and Time* is primarily an exploration of the meaning of *human* being (what Heidegger calls *Dasein,* literally 'Being There'), since 'the explicit and lucid formulation of the question of the meaning of being requires a prior suitable explication of a (particular) being'.[3]

His ontological account of the nature of *Dasein* proposes criteria for personhood that can solve one of the most pressing problems in both science fiction and the philosophy of Artificial Intelligence: Could humanly fabricated organisms be properly considered to be persons who we should care about? After a detailed analysis of Heidegger's *Being and Time*, this chapter will apply his criteria to the replicants in the sci-fi classic *Blade Runner*, enquiring as to whether they might qualify as *Dasein*, in Heidegger's sense of the term.

For Heidegger, *Dasein* is well suited to address the 'Being' question because 'in its being, this being is concerned about its very being'.[4] One aspect of what makes us human is our need to ask the question 'what is the meaning of life?'; furthermore, 'Dasein always understands itself in terms of its existence, in terms of its possibility to be itself or not to be itself'.[5] This introduces authenticity as a precondition for living a meaningful existence, which is achieved when Dasein succeeds in being itself. Dasein is inauthentic (in a myriad of ways) when it fails to do so.

Heidegger's account of how we can become who we are is grounded in his notion that we are essentially temporal beings. He claims that how we relate to our past, present and future has everything to do with how we define ourselves (more on this later). 'The essence of Dasein lies in its existence'[6] and the being that is at issue is fundamentally *mine*. I *choose* whether to be who I am or not. Possibility is more important than actuality: 'In determining itself as an entity, Dasein always does so in the light of a possibility, which it *is* itself and which, in its very Being, it somehow understands.'[7] Let me explicate this passage in some detail.

Consider the situation of choice. Philosophers pretty much agree that free will (if it is indeed possible) requires us to be capable of choosing between real alternatives based on reasons; this alone can make us responsible for our actions. At the moment of choice, in the present, I consider two or more future possibilities (e.g. majoring in psychology or philosophy). In committing myself to one rather than the other, I am defining my future professional life and should do so in terms of my core values. According to Heidegger, being who you are is crucial to individual fulfilment, and failing to do so is one of the major sources of anxiety (*angst*).

Authenticity involves Dasein in what Heidegger calls 'self-projective Being towards its ownmost potentiality-for-being'.[8] Each of us has our own unique set of possibilities. Dasein is always ahead of itself, which is to say that we derive our sense of meaning and

value from our future projects, and how our actions in the present help us to realize those projects. 'Meaning is the upon-which of our projections': our future goals give meaning to our present actions, which bring about progress towards them. Our projects, which are freely undertaken, define who we are and are the fundamental wellsprings of meaning in our lives. We can either resolutely seek to realize our unique set of potentials or choose to be less than we can be.

One of the major hindrances to being authentic is what Heidegger identifies as the 'they-self' (*das Man*, a neutered place holder). Being-with-others is a fundamental aspect of Dasein's being, but allowing others to define us submits us to their collective will, which is expressed in the social conventions which predominate in a culture at a time. When I engage in gossip and idle talk, when I bow to conformist pressure from the herd, when I discuss what one ought to do rather than revealing what I, as an individual, care about, I fail to become a self and remain part of the faceless 'they'.

Living a meaningful life requires us to focus on the future and doing what is needed in the present to achieve our goals. We are what we care about, which is confirmed by our actions far more than in our words. It is a challenge to get in touch with what is really important, because the 'they self' constantly distracts us with its conformist demands. Fortunately, there are two aspects of Dasein's being that help us become authentic – our awareness of our impending death and what Heidegger designates as 'the call of conscience'.

Social conventions try to cover up the finality and inevitability of death, as well as the terrifying uncertainties that accompany it. Sure, everybody knows that 'one dies', but the prospect is kept as distant and impersonal as possible. Corpses in funeral homes are praised for looking lifelike; the process is referred to as 'passing away' and religious platitudes about the loved one 'being in a better place' mask the feeling of irretrievable loss that should accompany the demise of 'the dearly departed'. Death is the one possibility that 'cannot be outstripped'; no one gets out of here alive. Inauthentic being-towards-the-end conforms to delicate social conventions and pussyfoots around the topic of death:

> Thus the 'they' covers up what is peculiar in death's certainty – *That it is possible at any moment.* Along with the certainty of death goes the indefiniteness of its 'when'.[9]

Hence, one of the most fundamental existential questions is: 'How long have I got to live?'

Our awareness of our own impending deaths is part of what makes us human; as Heidegger puts it, being-towards-the-end is an integral part of Dasein's being. To do so inauthentically is to buy into the clichés of the 'they-self' and elude our own uniqueness in the process. Authentic being-towards-death lends urgency to the pursuit of our projects, which is gained by confronting the limited temporal horizon that we all share. Authentically confronting the prospect of my own death demands that I realize my future projects, and 'Being-towards-death is grounded in care'.[10] An authentic awareness of death causes us to care for the things that are meaningful to us in a more vibrant fashion. Facing our finitude brings things into focus, solidifies our priorities and urges us to act on them.

Authenticity also demands that I confront what Heidegger calls my thrownness, that is, the facts of my life over which I had no control, such as my parents, my race, gender and nationality and the economic class I was born into. Yet every situation, when authentically confronted, offers a horizon of possibilities from which to choose. I must hence avoid falling into the trap of thinking that I have no alternatives and of excusing my choices as necessarily resulting from my heredity and environment. I should strive to act with what Heidegger calls 'anticipatory resoluteness', by focusing on what the future can bring and doing what is possible now to realize my goals.

In a related manner, authentic awareness of my own death also puts me in touch with my capacity to feel guilty, which arises when I fail to heed the 'call of conscience' from within. To be a self is to erect a world of priorities and values: 'With its world it (Dasein) is there for itself ... in such a way that it has disclosed to itself its potentiality-for-being in terms of the "world" of its concerns.'[11]

Our conscience allows us to tell if our concerns are authentic; it calls us to be who we are and knows whether or not we are doing so. Denying the existence of an unconscious mind that is inaccessible to consciousness, Heidegger contends that each of us knows who we are: Dasein 'always understands itself. The call [of conscience] reaches Dasein in this understanding of itself, which it always has.'[12] But, Heidegger contends, we often 'listen away'

from ourselves and towards the voices of others: 'Losing itself in the publicness and the idle talk of the "they", *it fails to hear* its own Self in listening to the "they" self.'[13]

Failing to heed the call of conscience gives rise to primordial guilt. Rather than feeling that one owes a debt (e.g. to God or to the State), such guilt makes me aware that I am not being who I am, that is, that I am failing to realize my authentic potentials. When I am resolute, I know what I care about and my actions mirror my concerns. Heidegger's definition of care has come under some criticism for its unwieldy, multi-hyphenated length: 'Dasein's totality of Being as care means: ahead-of-itself-already-being-in [a world] as Being alongside [entities encountered within the world].'[14] So let me explain this puzzling passage, and its relationship to the temporality of Dasein, at some length.

As 'ahead-of-itself', authentic Dasein is primarily concerned with the future and the goals at which it aims. The inauthentic individual discounts the future and focuses on gratifying his present desires. As 'already-being-in-a-world', the authentic person reflects on the past and acknowledges the limitations it imposes, neither discounting them nor acting like they foreclose all possibilities. We find ourselves situated in the present, alongside things and our fellow human beings, which afford possibilities for action, and 'Existence is decided only by each Dasein itself in the manner of seizing upon or neglecting such possibilities'.[15] We should strive always to act with an eye to the future and on the basis of a clear understanding of the past.

Dasein is essentially a temporal being, which must sustain a healthy relationship to its past, present and future. I am ultimately responsible for both myself and my world. I choose who I am, by determining the significance of events, and whether I am being true to myself. As Marjorie Grene puts it in the chapter on Sartre and Heidegger in her *Introduction to Existentialism*:

I am what I have done, not what, out of well meaning incapacity, I meant but failed to do, but what ... I have accomplished. Of such accomplishment or failure to accomplish, I and I alone must bear the credit, the shame, the triumph and the regret. It is meaningless to say with the materialist that my environment has made me what I am; for it is I who have, with the values I read into it, made it an environment.[16]

In short, I constitute my world with the value judgements I make, and the actions that I take on that basis. As Hamlet observed (in Act 2, Scene 2), there is nothing either good or bad, but thinking makes it so.

Heidegger's version of existentialism in *Being and Time* sounds all of the major themes that will dominate the movement in the twentieth century, as we shall soon see. Heidegger's contention that we are temporal beings who should be focused on the future will be explicitly rejected by Albert Camus in his absurdist phase, when he urged his readers to live for the present rather than the future. Heidegger's notion of individual freedom will be radicalized by Jean-Paul Sartre, who denies the call of conscience comes from within and rejects the idea that there is an internal self to which one should be true.

Heidegger's claim that humans create meaning in a meaningless world by projecting their goals into the future, and taking actions to shape that world in their image is the most life affirming and optimistic take on existentialism ever formulated. But Heidegger's biography suggests that one can authentically be a Nazi (as he was, publicly, for many years) and realize one's capacity for anticipatory resoluteness in the pursuit of world domination by a Master Race.

This is an appropriate point to turn to an analysis of *Blade Runner*, which examines the issues of racism (or perhaps more accurately, speciesism), and rebellion against slavery, in some detail.[17] Director Ridley Scott draws on the conventions of *film noir* here, which were first forged in such detective classics as *The Maltese Falcon* and *The Big Sleep*. Like Humphrey Bogart, Harrison Ford plays a morally ambiguous detective in a nightmarishly forbidding world.

In its dystopian vision of the year 2019, Los Angeles is a cesspool, plagued by ceaseless rains and inhabited by the dregs of humanity. Almost everyone else has left the planet, having migrated to off-world colonies as the earth becomes less and less habitable. Modernistic architecture reminiscent of Fritz Lang's *Metropolis* inspires awe, while the general human condition looks degenerate and bleak. The voice-over narration in the theatrical cut completes the neo-*noir* atmosphere, with Deckard as a hard-bitten detective seeking out a gang of murderers.

As in *film noir*, the lighting of the frame is critical to its meaning. Los Angeles is enveloped in torrential rain, which darkens the

frame in all exterior shots. Interior spaces, in Tyrell's mansion or Sebastian's decrepit apartment building, are cavernous, shadowy and forbidding. Little islands of light within Deckard's apartment provide the only warmth. Roy is seen from a low angle as a looming threat in revolving shadows before he chooses to save our hero.

We are told at the beginning of the film that humans have created a race of what are called replicants, physical organisms with artificial intelligence that is at least on a par with our own. They serve humanity in a variety of useful roles on the off-world colonies, but are forbidden to ever be on Earth. Deckard's boss calls them 'skin jobs', and killing them is referred to as 'retirement'. Five of them stole a shuttle and headed for Earth, one is already dead, and our heroic protagonist, Rick Deckard (Harrison Ford) has been charged with eliminating the other four.

Earlier, Deckard had resigned from his job as 'Blade Runner', having found the task of 'retiring' replicants to be burdensome in the extreme. But he is called back into service by his old boss, Bryant (M. Emmett Walsh). When Deckard tries to refuse, Bryant reminds him with veiled threats that he really has no choice. This is a tale told largely from Deckard's point of view, which is personalized by his narration in the theatrical release and by the occasional shot taken from his perspective (often called a 'point-of-view shot').

He begins by visiting the Tyrell Corporation, whose motto for their prize creations is 'More Human than Human'. Deckard had intended to administer the Voigt-Kampff test (which monitors a myriad of physical responses to asking the subject emotionally fraught questions) on a replicant. But Dr Eldon Tyrell (Joe Turkel) introduces Deckard to his niece Rachael (Sean Young) and insists that Deckard tries it out on her. After almost a hundred questions (a dozen or so are usually enough), Deckard turns off the machine and Tyrell asks Rachael to step out of the room. He correctly identifies her as a replicant and notes with disbelief that she does not know that she is one. Tyrell explains that she is an experiment, a replicant who has been given memory implants from Tyrell's actual niece, and photographs that purport to show her as a child with her parents, in order to 'provide a cushion for her emotions'.

The idea that empathy is tied to memory is a common one in psychological circles and has even found expression in Pixar's recent release, *Inside Out* (2015). It is a crucial theme in this movie. As we shall see, part of what makes us empathize with Roy at the

end of *Blade Runner* is his reminiscing about his adventures at the edge of the galaxy and decrying the disappearance of such vivid and unforgettable memories.

That evening, Rachael turns up at Deckard's door, concerned that he thinks she isn't human. Brutally frank, he tells her about the memory implants and that her snapshots and childhood recollections are all fraudulent. Seeing how crushed she is by the news, Deckard protests unconvincingly that he was joking and offers her a drink. She stalks out of his apartment, leaving him to take a closer look at some photographs.

The film opened with Leon (Brion James), one of the fugitive replicants, being detected by the Voigt-Kampff test, at which point he kills his interviewer and escapes. Deckard begins his physical investigation of evidence at Leon's apartment, and, in a sense appropriate to the phrase 'private eye', the process is painstaking in its visual acuity. He finds scales from an artificial snake in Leon's shower (which a microscope will later identify by its serial number) and a picture that, through detailed photo enhancement, discloses Leon's companion, Zhora (Joanna Cassidy). Deckard traces the artificial snake to a saloon keeper named Taffey Lewis (Hy Pike), discovers that Zhora is an exotic dancer who does striptease with the snake at Taffey's place and guns her down mercilessly on the city streets to which she flees.

When his boss arrives at the scene of Zhora's death, he informs Deckard that there are four more to go. When Deckard protests that there should only be three, Bryant tells him that Rachael is now also on the loose. Shortly thereafter, he spots Rachael on the street and follows her. But then Deckard is waylaid by Leon, who saw him kill Zhora and seeks revenge. Showing him how horrible it is to live in fear, Leon is about to crush his skull when Rachael grabs Deckard's blaster off the ground and blows Leon's head off.

They go back to Deckard's place, where a romantic interlude ensues. Shallow and soft-focus shots set the mood, and Deckard has to teach her how to kiss and how to express her desires. Their encounter is passionate, though there's more than a hint of forcible sex. Afterwards, Deckard has a job to do, and he leaves Rachael at his apartment.

Next, he seeks out J.F. Sebastian (William Sanderson), one of Tyrell's most skilled genetic designers. Roy Batty (Rutger Hauer), the leader of the replicant foursome, had also discovered that

Sebastian was close to Tyrell, so he sent Pris (Darryl Hannah) to befriend Sebastian as a way to meet his maker. Ironically, both the replicants and Sebastian suffer from the same problem: 'accelerated decrepitude'. J.F. is a 25-year-old man who looks more than twice his age, suffering from Methuselah's syndrome. This is why he had to remain on the planet during the great migration.

The replicants have come to Earth in search of more life. They know that they have a built-in four-year life span, which was designed to keep them from developing too far beyond their human creators (a prospect that Stephen Hawking has warned us about recently). Roy intends to appeal to Tyrell to lengthen their lives, as their forty-eight-month time limit is fast approaching.

Sebastian and Tyrell play chess by phone, and Roy proposes a Queen sacrifice that will checkmate Tyrell in two moves. This gets Roy (and Sebastian) in to see 'his maker', and their dialogue is worth quoting:

> Tyrell: What seems to be the problem?
> Batty: Death
> Tyrell: Death? Well, I am afraid that is a little outside of my
> jurisdiction.
> Batty: I want more life, fucker!
> [omitting a lengthy technical exchange over why Tyrell
> can't lengthen his life]
> Tyrell: But all of this is academic. You were made as well as we
> could make you.
> Batty: But not to last.
> Tyrell: The light that burns twice as bright burns half as long,
> and you have burned so very, very brightly Roy. Look at
> you, you're the prodigal son. You're quite a prize.
> Batty: I've done questionable things.
> Tyrell: Also extraordinary things … revel in your time.
> Batty: Nothing that the god of biomechanics wouldn't let you
> into heaven for … [he then kisses his maker on the lips,
> and crushes Tyrell's skull].

After that, Ray turns on J.F. and kills him too.

The film's climax is rightfully praised as one of its best sequences. Deckard traces Pris to Sebastian's apartment, where she hides amidst several of J.F.'s mechanical creations. She overpowers him,

but when she backs off to apply a gymnastic *coup-de-grace*, he grabs his gun and shoots her in mid-air. She doesn't die easily, and he has to pump several more bullets into her to stop her terrifying death throes.

Then Roy returns, discovers his dead paramour and regretfully kisses her dead lips. Turning to Deckard, he chases the detective out onto the roof of the building. Deckard tries to jump to the next building, but misses, and hangs precariously from a beam. Holding on literally by his fingertips, Deckard is about to plunge to his death. But Roy (who is shown in a terrifying low-angle light in the previous shot) thwarts our expectations, leaps over to the building, remarks that 'It is quite an experience to live in fear. That's what it is to be a slave' and saves Deckard's life.

But Roy's four years are up, his powers are waning and there is time for only a brief dying speech to Deckard, done in heartbreaking close-up as he holds a white dove, symbol of both innocence and sacrifice:

> I've seen things you people wouldn't believe. Attack ships on fire off the shoulder of Orion, I watched C-beams glitter in the darkness at the Tannhäuser Gate. All those moments will be lost in time, like tears in the rain. Time to die. [he frees the dove]

Deckard's voice-over narration in the reverse shot of the 'theatrical release' is strikingly Heideggerean:

> I don't know why he saved my life. Maybe in those last moments he loved life more than he ever had before. Not just his life, anybody's life. My life. All he'd wanted were the same answers the rest of us want: Where do I come from? Where am I going? How long have I got? All I could do was sit there and watch him die.

As he is leaving, Bryant's assistant, Inspector Gaff (Edward James Olmos), praises Deckard: 'You've done a man's job, sir.' Then, in reference to Rachael, Gaff observes: 'Too bad she won't live. But then again, who does.' The film ends with Deckard and Rachael fleeing her pursuers into the wilderness.

The theme of whether robotic creations can be persons (like human beings) is a perennial one in science fiction, in popular films

like *I, Robot*, and in television series like *Battlestar Galactica*. To settle the issue, we must first specify the *criteria* for personhood. Let me attempt to do so, by asking how the replicants in *Blade Runner* measure up to Heidegger's specifications for *Dasein* in *Being and Time*.

First of all, the replicants are capable of free choice. They chose to hijack a shuttle and head for Earth. They chose to seek a longer life. Batty chose to kill his creator, and to save Deckard. In each case they could have done otherwise and accepted their assigned roles instead (as most replicants did). But they refused to do so. In that sense they could be said to have lived authentically. Furthermore, their freedom is of the utmost importance to them. It makes no sense to talk about a machine being a slave. That which cannot be free cannot be enslaved. But their status as slaves is extremely galling to Roy and Pris, and they have rebelled against that injustice and against the brevity of their allotted lives.

Secondly, they are not simply mechanical; they are biological organisms genetically engineered by people like J.F. Sebastian. When J.F. asks them to show him something that they can do, Roy responds indignantly: 'We're not computers, Sebastian. We're physical', albeit with a superior physical make-up (which Pris proceeds to demonstrate by grabbing a hard-boiled egg out of a bubbling beaker).

Their physicality involves a number of other important characteristics. Significantly, they are sentient beings, capable of feeling both physical and emotional pleasure and pain. For example, Pris's agonizing death throes are hard to watch, leaving no doubt that she is suffering. The replicants are also capable of passion, as shown when Roy and Pris share a lengthy kiss. But theirs is something more than a physical relationship.

Getting into more clearly Heideggerian territory, they genuinely care for each other (as, apparently, did Leon and Zhora). When Roy talks about their four years being almost up, he is more concerned about Pris's impending demise than with his own. The deaths of Zhora, Leon and (especially) Pris devastate Roy, judging by the looks on his face. He is a being who is clearly capable of caring about others.

Replicants are also temporal beings. As Roy is dying, he reflects on his past and revels in the unforgettable experiences he had, regretting that his memories will be lost for all time 'like tears

in the rain'. Focused on their meagre prospects, the replicants sought to expand their horizon of future possibilities by being genetically reengineered. They engaged in resolute action in the present in order to achieve their future goals and lost their lives in the quest.

Most significantly, from a Heideggerian perspective, replicants share an awareness of their impending deaths with their creators. They recognize that death could happen at any time, that it is inevitable, and that the best they could hope for is to put it off a little longer. There is no room for sentimentality, euphemisms or avoidance. The chips are down, and running away is simply not an option.

When I first saw the theatrical release of *Blade Runner*, more than three decades ago, I was a philosophy graduate student with a taste for Heidegger and a love of cinema. I remember my reaction to the climax of the film, which I immediately related to Heidegger's philosophy. Roy saves Deckard's life because (just as Heidegger would have it) authentically confronting his own death moved Roy to care for Deckard, despite the fact that the Blade Runner had been trying to kill him. Deckard's voice-over (quoted above) is what triggered my response.

Not only does Batty show the concern for others that is characteristic of authentic being-towards-death, but he is also capable of feeling guilt. He admits to Tyrell that he has done questionable things. He recognizes the need for forgiveness, while protesting that he has done 'nothing that the god of biomechanics would not let you into heaven for'. Most tellingly, Roy eventually forgoes revenge and saves Deckard's life, rather than simply watching him die.

Despite his own critical remarks on the nature of empathy,[18] I believe that Heidegger's distinction between authentic and inauthentic being-with-others has a lot to do with either caring about the feelings of others (because we feel with them, in some sense) or closing oneself off from such possibilities. Roy, I would argue, shows empathy for Deckard, feeling his fear and alleviating it. That empathy is returned, as Deckard's voice-over indicates. At the moment of Roy's death, Deckard recognized that they were both very much alike, and the poignant expression of his powerlessness ('All I could do was sit there and watch him die') is tinged with deep regret.

As audiences tend to identify with protagonists, and see the world to some extent through their eyes, Deckard's evolving attitude towards replicants takes us along with him and confirms the underlying attitude of the film. By its end, he believes that replicants are entitled to be treated as persons, just as much as humans are. It is instructive to trace the process in some detail.

To begin before the beginning, I suspect that the reason Deckard resigned was that he was deeply uncomfortable with being a Blade Runner and no longer considered replicants to be 'skin jobs' that could be callously 'retired'. Though good at his profession, he shows little enthusiasm for it, as his muted reaction to the death of Zhora makes clear.

After determining that Rachael is a replicant, Deckard asks, 'How can it not know what it is?', referring to her as a thing rather than as a person. When she shows up at his apartment, desperately making the case for her humanity, he treats her as a thing, and brutally exposes her deceptive memories and photographs for what they are. But he is taken aback by how hurt she is by this revelation, extends her the courtesy of claiming he was only kidding, and offers her a calming drink. Deckard does such a poor job of showing concern that he even jokes about it, at his own expense in their subsequent phone conversation, protesting that he has had people walk out on him before 'but not when I was being so charming'.

Though Rachael was on the run, she doubled back and saved his life. This has an impact: when she asks him later whether he would come after her and hunt her down in his role as Blade Runner, he says he wouldn't, acknowledging that he owes her one. Then he schools her in matters of desire, teaches her how to kiss and (we assume, since director Ridley Scott chose to forego a more explicit scene) has passionate sex with her that night.

Soon it is clear that Deckard cares for Rachael deeply. After Roy's death, he goes back to his apartment, fearing that he will find that she is either dead or missing. When he uncovers her in his bed, his first question goes straight to the point: 'Do you love me?' She says yes, and they light out for the hinterlands, in an ending that Ridley Scott decried as being too upbeat, and which he made more ambiguous in the 'final cut'.

Dismissing the possibility that Deckard is himself a replicant[19] (if he is, why doesn't he have the superhuman powers of the rest

of them?[20]), my reading of the original theatrical release is that Deckard is depicted as a human being with a racist- and species-centric attitude when the film begins, who overcomes it by having actual and extensive contact with replicants. He evolves from considering them to be mere things to loving one of them and caring a great deal about the demise of another. This change in attitude is the final validation of the status of replicants as Dasein.

Questions for discussion

1 Are you generally authentic, in Heidegger's sense of the term, or do you bow to the influence of the 'they-self' too often? If the latter, do you know who you want to be but don't own up to it with your actions, or are you simply not in touch with who you are?

2 Some commentators, and later generations of viewers, see the seduction scene between Deckard and Rachael as 'rapey'. Were you disturbed by the sequence? Was he simply being a 'forceful man', or does the scene send unhealthy messages about the nature of human sexuality?

3 The dystopic vision of *Blade Runner* was prophetic in its depiction of the long-term effects of global warming. Why do you think such doomsday predictions have had so little effect on US policy? Do you think the human race is an endangered species?

4 Why are our memories so important to us? How do they help us understand who we are? To what extent is our personal identity shaped by the stories we tell about ourselves (and sometimes to ourselves)?

Suggestions for further viewing

Her (2013, Spike Jonze) – A surprisingly involving and bittersweet tale of a disembodied computer voice with expanding intelligence and a poor schlub who falls in love with her. A peek into the near future, with much to say about depersonalization in our present cellphone-addicted culture.

A.I. Artificial Intelligence (2001, Steven Spielberg) – David is a cyborg intended as a replacement for a lost son. When the son returns, David is cast out into a harsh world, full of people who want to dismantle him, and abandoned by the 'mother' with whom he was programmed to bond. An interesting case on which to apply the Heideggerian criteria for *Dasein*, with more ambiguous results.

I, Robot (2004, Alex Proyas) – In an otherwise disappointing adaptation of the classic collection of Isaac Asimov short stories, the film features a robot named Sonny, whose claim to personhood is well grounded.

Ex Machina (2015, Alex Garland) – A talented young coder wins a contest and finds himself interacting with the first cyborg with artificial intelligence approaching our own, which just happens to be housed in a simulacrum of a beautiful woman. Deals interestingly with the question of what makes humans human.

CHAPTER SIX

Heidegger's Poetics and the Truth of War in *The Thin Red Line*

O tell us, poet, what you do. – I praise.
Yes, but the deadly and the monstrous phase,
how do you take it, how resist? – I praise.

> *But the anonymous, the nameless maze,*
> *how summon it, how call it, poet? – I praise.*
> *What right is yours, in all these varied ways,*
> *under a thousand masks yet true? – I praise.*
> *And why do stillness and the roaring blaze,*
> *both star and storm acknowledge you? – because I praise.*
>
> RAINER MARIA RILKE

It is natural to associate the films of Terrence Malick with the philosophy of Martin Heidegger. Malick pursued a graduate degree in Philosophy in the mid-1960s, studied in Germany, met Heidegger and was the first to translate Heidegger's late philosophical treatise *The Essence of Ground* into English (1969). Only then did he enter film school and embark on a cinematic career. Stanley Cavell talked about Malick's *Days of Heaven* in Heideggerian terms the year after it came out,[1] and many book chapters and articles have appeared since, mining this connection for all it is worth. I will do so as well here, applying Heidegger's theory of art to Malick's *The Thin Red Line*.

Whatever the other differences between early and later Heidegger, one thing *is* clear: his focus shifts from the largely abstract task of proposing a fundamental ontology in *Being and Time* to analysing the relationships between Poetry, Language and Thought (the title of a prominent collection of his later essays) in particular works of art, and in science and technology. The pivotal essay in that collection is called 'The Origin of the Art Work', written in 1935. There, Heidegger proposes a remarkable aesthetic theory and provides some vivid examples of what preserving the truth of such works involves. He also provides an eloquent model for understanding how the movies are philosophical.

Heidegger announces that he is seeking the essence of art by exploring its origin:

> Origin here signifies that from where and through which a thing is what it is and how it is. What something is, how it is, we call its nature. The origin of something is the source of its nature. The question about the origin of the work of art asks about the source of its nature.[2]

How, then, is one to enquire about the nature of art?

This seems to be an insoluble problem, but Heidegger is not unduly concerned:

> The question of the origin of the work of art asks about the source of its nature. What art may be, should let itself be taken from out of the work. What the work is we can only find out from the nature of the work. It is easy to see that we are moving in a circle. … Assembling characteristics of available works, and deduction from principles are here in the same way impossible, and where they are used, they are self-deception. Hence we must go in a circle. This is neither a crutch nor a deficiency.[3]

This is the famed 'hermeneutic circle' of Heideggerian interpretation. We must check our intuitions about what art *is* in order to identify particular works of art, but our selections also help us refine the notion of 'art' with which we began, and so on.

An artwork is a humanly made artefact, but it is also something more:

> The work makes publicly known something other than itself; it manifests something other; it is allegory. In the artwork, something other is brought together with the made thing … the work is a symbol.[4]

The work being done by a work of art is revealed in unpacking the meaning of its allegory and disclosing what it symbolizes. This requires us to recognize the light in which a work depicts its subject matter.

Heidegger's first extended example of how art reveals the truth is his interpretation of Van Gogh's painting of a pair of peasant shoes, equipment that is essential to the peasant's life. He contends that we can only appreciate their 'equipmentality' by seeing it at work in Vincent's paintings:

> Out of the dark opening of the worn out insides of the shoes the toil of the worker's tread stands forth. In the crudely solid heaviness of the shoes is stowed up the tenacity of the slow trudge through the far-stretched and monotonous furrows of the field, over which a raw wind blows. On the leather lies the

dampness and richness of the soil. Under the soles slides the loneliness of the field path as evening falls. The shoes vibrate with the silent call of the earth, its silent gift of ripening grain and its unexplained refusal in the desolate fallow of the winter field. The equipment is pervaded by uncomplaining worry as to the certainty of bread, the wordless joy of at having once again withstood want, the trembling before the arrival of birth, and shivering at the surrounding menace of death. This equipment belongs to the *earth*, and finds protection in the *world* of the peasant woman. ... But perhaps it is only in the picture that we notice all this about the shoes. The peasant woman, by contrast, simply wears them.[5]

Explicating this passage will take some time.

Paintings of peasants were relatively rare in Van Gogh's day. His contemporaries focused almost exclusively on depicting upper-middle- and upper-class lives, as these were the clients they had to cater to as well. So, first of all, Van Gogh made a statement by painting such 'lowly' subject matter as a pair of peasant shoes. In doing so, he shined a spotlight on the life of the peasant and showed that her everyday concerns were worth attending to. Like Charles Dickens before him, Van Gogh helped create a more meaningful life for the peasants.

In Heidegger's eyes, the work reveals a profound truth about the pair of peasant shoes, which

was only discovered by bringing ourselves before Van Gogh's painting. It is this that spoke. In proximity to the work we were suddenly somewhere other than we are usually accustomed to be. The art work let us know what the shoes were, in truth.[6]

But this does not mean, as Aristotle contended, that an artwork should be seen as capturing the timeless essence of its subject matter, which pre-existed the painting itself.

Countering Plato's critique of artworks as misleading copies of particular things, Aristotle argued in his *Poetics* that tragedies, comedies and epics can get at the truth, by accurately imitating the universal essence of certain character types. Rather than being twice removed from universal truths, as Plato contended, Aristotle believed that quality works of art imitate them directly, as, for example, in tragedy, which depicts what a certain type of flawed

character (like Oedipus) will probably or necessarily do. Heidegger rejects Aristotle's account as a general theory of art, by asking the following question: 'But where and how, then, is the universal essence, so that the artwork can agree with it? With what essence of what thing, then, should a Greek Temple agree?'[7]

Rather than looking for the original, of which the temple is but a copy, Heidegger praises the humans who erected it (and installed a statue of the god they worshipped within) as having more creative power than they imagined:

> A building, a Greek temple, portrays nothing. It simply stands there in the middle of the cleft and rocky valley. The building encloses the figure of the god and within this concealment allows it to stand forth through the columned hall of the holy precinct. Through the temple, the god is present in the temple. This presence of the god is in itself the extension and delimitation of the precinct as holy.[8]

If we begin by assuming that Athena was a fictitious being, then there was no goddess to which any depiction of her could correspond. Yet the temple to Athena on the Acropolis was seen by the ancient Greeks to be an extremely holy place and is considered to be such to this day.

The temple affected how the ancient Greeks saw their goddess, and themselves:

> In its standing there, the temple first gives to things their look, and to men their outlook on themselves. This sight remains open as long as the work is a work, as long as the god has not fled from it. So it is too with the sculpture of the god, that the victor at the athletic games dedicates to him. The work is not a portrait, intended to make it easier to recognize what the god looks like. It is rather a work that lets the god be present and is, therefore, the god himself.[9]

The statue of Athena that once occupied the temple (it has since disappeared) may be construed as having symbolized the goddess. But in many ways the statue was itself the *actual* object of worship. Such idealized depictions helped shape the classical Greek notions of beauty, wisdom and lawfulness.

All art, then, has what might be called a quasi-religious function: it helps consecrate[10] human existence by infusing it with the poetic sense that there are many things in life worth valuing. This is most evident in the setting up of a temple:

> Such setting-up is erecting in the sense of dedication and praise. Setting-up no longer means merely putting in place. To dedicate means to consecrate, Dedication is called consecration in the sense that in the setting-up of a work, the holy is opened up as holy, and the god is called into the openness of his presence. Praise belongs to dedication as doing honor to the dignity and the splendor of the god. Dignity and splendor are not external properties beside and behind which the god stands, but rather in this dignity, in this splendor, the god is present.[11]

An artwork, at its best, praises its subject, that is, shows it in a positive light. In so doing, it opens a clearing that highlights this positive perspective, allowing particular subjects, ideas, actions or things to be seen as valuable and beautiful. The dignity and splendour of the temple bestows itself on our notion of the god, leading us to see her as worth believing in. Heidegger claims that what Christian religious art had long been recognized as doing (in praising God and seeking to inspire belief in Him) is what *all* great art does: it shows its subject matter in a positive light that inspires conviction in the viewer.

In Heidegger's account, a struggle between earth and world plays itself out in the process of artistic creation, just as the temple on the Acropolis juts out from the rock cleft valley. In Heideggerean terms, the work of art establishes an open that allows the world to world. To translate this language into simpler terms, the earth is made up of inanimate objects, plants and animals, all of which lack self-awareness and are hence inherently meaningless. Only humans inhabit a world. In our respective worlds, things are 'invested with value', the value that we give them. There is no inherent value in existence for us to discover we bestow value on things, and on people, by actually caring about them and expressing our concern in action. In this context: 'The work as work sets up a world. The work holds open the open of that world.'[12] Let me illustrate how this happens.

Consider a famous painting by Francisco Goya, called 'The Third of May, 1808'. On the previous day, hundreds of Spanish freedom fighters rebelled against the French occupation of Madrid. On May 3, the rebels were rounded up and massacred by their occupiers. Despite having expressed sympathy for Napoleon in the past, Goya's depiction of the event is unambiguous. The rebels who are about to die are shown in an animated, individual and positive light (with the central gesticulating figure being the brightest lit and wearing a white shirt and tan pants), while the French firing squad is cloaked in shadows and depicted as anonymous and threatening. In so doing, Goya praised the rebels and validated their cause, while condemning the French soldiers as being virtually inhuman. In the world of this painting, rebellion is seen as worthwhile, and Goya sought to arouse such sentiments in his fellow Spaniards. His work has inspired revolutionaries of various stripes ever since.

As autonomous individuals, we each occupy our own world, but we also share the social world that we inhabit. What is at stake in art is not just individual self-definition but the identity of a culture at a time. As Heidegger puts it:

Wherever the essential decisions of our history are made, wherever we take them over or abandon them, wherever they go unrecognized or are brought once more into question, there the world worlds.[13]

The meaning of life is at once individual *and* social, defined both by personal commitments and by the spirit of the age.

Creating works of art is only one of the ways that humans infuse meaning into our lives:

One essential way in which truth establishes itself in the beings it has opened up is its setting-itself-into-the-work [of art]. Another way in which truth comes to presence is through the act which founds a State. Again, another way in which truth comes to shine is the proximity of that which is not simply a being but rather the Being which is most in being [i.e., God]. Yet another way in which truth grounds itself is the essential sacrifice. A still further way in which truth comes to be is in the thinker's questioning,

which, as the thinking of being, names being in its question-worthiness.[14]

This brings us to the heart of the matter. Consider the notion of political rights. In the Natural Rights tradition adopted by Thomas Jefferson in the Declaration of Independence, rights are bestowed upon us by God as his noblest creatures. Our inalienable rights to life, liberty and the pursuit of happiness existed *before* the founding of the United States, and Jefferson claimed that we instituted the democratic form of government (with a clear separation of powers) to better protect those rights.

But, for an existentialist like Heidegger, 'rights' are neither natural nor God-given. When the Founding Fathers established a State that sought to guarantee such rights, and (in large measure) succeeded in doing so over time, these rights were *brought into existence*. The United States became, at least for a time, the envy of the world, and these democratic values are still some of the most sought after among civilized nations. This is what Heidegger means in this difficult passage:

> The establishment of truth in the work is the bringing forth of a kind of being which never was before ... the bringing forth [in, e.g., the Declaration of Independence that founded the nation] places this being in the open in such a way that what is brought forth first clears the openness of the open.[15]

To return to the crucial passage quoted here, then, humans create a sense of meaning in several ways: by creating works of art, by founding States or religions (which worship 'the Being which is most in being'), by sacrificing much for what we believe in, and 'in the thinker's questioning'. Let me pursue this latter point for a moment. In *Being and Time*, Heidegger recasts the philosophical problematic, which he believed had gone astray after the pre-Socratic age. He offered his version of fundamental ontology, answering basic questions about the meaning and value of human existence that he stood by throughout his career. But, in later Heidegger, it seems that philosophers realize their true natures by posing questions, not in their attempts to offer terminal answers to them.

Truth, in Heidegger's view, is brought into the open by the thinker's questioning. Philosophy 'as the thinking of being, names

being in its question-worthiness'.[16] In posing such questions, the thinker proposes issues as worthy of consideration and puts them to individuals for their personal evaluation. They must ultimately answer the most fundamental philosophical questions (such as 'What is the meaning of life?') for themselves.

Societies, at certain historical periods, do so as well, for 'The prevailing language is the happening of that saying in which its world rises up historically for a people.'[17] One of Heidegger's most brilliant insights is his recognition (which has since been confirmed by psychologists) that how we talk about things determines what they mean to us. He raises concerns about this phenomenon, because of the extent to which our social milieu influences how we talk about things.

Returning more specifically to the discussion at hand, 'Art is, then, a becoming and happening of truth.'[18] A work of art offers us a perspective on the meaning of being that is put to us for our approval. For Heidegger,

> *All art* as a letting happen of the advent of truth is, as such, in essence, *Poetry.* ... Poetry allows this open to happen in such a way indeed that now, for the first time, in the midst of beings, it brings them to shine forth and sound.[19]

This relates directly to the epigrammatic Rilke poem about praise with which this chapter began.

In the realm of values, then, all seeing is *seeing-as*:

> Language, by naming beings for the first time, first brings beings to word and to appearance. ... Such saying is a projection of a clearing in which announcement is made as to what beings will come into the open *as*.[20]

Art gives us a perspective on its subject matter, by portraying it in either a positive or negative light. It leads us to see it in the same light, for example, the way *Gone with the Wind* depicts the Southern cause in a noble and sympathetic fashion. In praising the South, the film helps shape our valuation of things, and the poetic quality of true art (its 'beauty', if you will) makes it all the more persuasive. This is why *The Birth of a Nation* (1915) is so controversial to this day.

This is also where Heidegger is so relevant to the debate about whether, and how, films can do philosophy. If 'philosophy' is construed as an enterprise that poses a series of rational arguments, then films fall prey to Plato's objection about art as mere imitation. You are better instructed by auditing a philosophy class in that instance. But if 'philosophy' is an art, engaged in the creation of meaning, and it does so by showing ideas and hierarchies of value in either a positive or negative light, then film is uniquely suited to do so. Every aspect of both shot composition and montage, as well as of narrative, can contribute to getting the audience to see what is being depicted as praiseworthy, or in a derogatory manner.

One of Heidegger's most significant innovations was his emphasis on the fact that art requires both creators and preservers: 'Thus art is: the creative preservation of the truth in the work.'[21] Without preservers who appreciate the holiness of the temple and the dedication to its god, that holiness fades away. Heidegger celebrates the fact that appreciators bring their own creative powers to bear in interpreting a work of art, often going beyond what the artist (or the age) ever envisioned to be the meaning of the work.

As Oscar Wilde put it in 'The Critic as Artist': 'The meaning of any beautiful created thing is at least as much in the soul of him who looks at it as it was in the soul of he who wrought it.' This relates directly to Heidegger's view in 'Origin':

> The essence of poetry is the founding of truth. 'Founding' is understood here in a threefold sense: as bestowing, as grounding and as beginning. But it only becomes actual in preserving. Thus to each mode of founding there corresponds a mode of preserving.[22]

This has interesting implications for questions of authorial intention and artefact meaning. On such a view, the meaning of an artwork cannot be exhausted by authorial intention. New interpretations can legitimately forge new ways of seeing the work as something other than what the author intended it to mean, as subsequent ages try to incorporate it into their own, very different worlds. Greek temples don't have the same meaning for us as they did for the worshippers of the Greek pantheon at the time, but the spark of the divine is still present in our responses to them.

Two decades had passed between the making of *Days of Heaven* and the release of Malick's next film, which had the misfortune of competing with *Saving Private Ryan*, one of the real blockbusters in the Summer of 1998. *The Thin Red Line* came in for a lot of criticism, on at least two fronts. Some reviewers condemned Malick's extensive use of long philosophical interior monologues as being unrealistic, while others chided him for departing so radically from the James Jones novel which was his source. Even positive reviews were often ambivalent, for example, one by Philip Martin in the *Arkansas Democrat-Gazette*, which characterized it as 'a film of sublime power and beautiful tedium'.

A critical consensus has formed since then that recognizes *The Thin Red Line* as being one of the most philosophical movies ever made about war. I must acknowledge that I have several predecessors in reading the film through a Heideggerian lens, and I quote from one of them as the chapter concludes. But the detailed relationships between the film and Heidegger's analysis of the essence of art in 'The Origin of the Art Work' have yet to be drawn.

The first extended shot in *The Thin Red Line* is of a menacing alligator entering a mossy swamp. An unattributed voice-over then sets the philosophical tone of the film: 'Why does Nature strive with itself, the land with the sea? Is there an avenging power in Nature? Not one power but two?' Many of the subsequent interior monologues will have a similarly interrogatory nature, asking some of the most difficult and most profound philosophical questions.

We then see Private Witt (Jim Caviezel) paddling around in a canoe with some native islanders, and joining in with children playing games or swimming in the ocean. Witt comes to shore, and his first reflections lead us to identify with him almost immediately:

> I remember my mother when she was dying. She looked all shrunk up and gray. I asked her if she was afraid. She just shook her head. I was afraid to touch the death inside her. I couldn't find anything beautiful or uplifting about her going back to God. I heard people talk about immortality. But I ain't seen it. ... I was wondering how it'd be when I died. What it would be like to know that this breath now was the last I would ever draw.

I just hoped I'd meet it the same way she did, with the same calm. 'Cause that's where it's hidden, the immortality I hadn't seen'.[23]

We learn a great deal about the man in this monologue. As a war film, it is no surprise that *The Thin Red Line* is a meditation on mortality. But to begin with Witt's reflections on the demise of his mother situates being-towards-death (to use Heidegger's phrase) as an essential aspect of the general human condition. Witt recalls that the notion of her going to God did not help him deal with her death. Coming from one of the most spiritual voices in the film, his scepticism about personal immortality is especially intriguing.

Initially, we have no idea why Witt and his American compatriot are on the island. But then a US landing craft appears, and it turns out that they are Absent Without Leave (AWOL) from the military. In his debriefing by Sergeant Welch (Sean Penn), we learn that Witt has gone AWOL several times before, but Welch saves him from a court martial and assigns him to be a stretcher bearer. There is some hostility in their exchange, however.

Welch tells Witt that he will never be a real soldier, advising him that, in a world which is trying to blow itself to smithereens, 'All a man can do is shut his eyes and let nothing touch him'. He expands on his bleak perspective: 'In this world, a man himself is nothing, and there ain't no world but this one.' Having just returned from a far different world, where the children seldom fought with one another, Witt cannot agree. Later, in the Brig, he rejects Welch's callous (and ultimately feigned) indifference: 'I love Charlie Company. They're my people.' The stage is hence set for Witt's subsequent actions. He will indeed show that he cares for his fellow soldiers and will face his death as calmly as he hoped.

Next, we become acquainted with Pvt. Bell (Ben Chaplin), a romantic who will do anything for love. He was an officer in the Corps of Engineers, but could not stand being separated from his wife and resigned his commission. Drafted into the army as a private once the war broke out, his thoughts are almost totally focused on his beloved. As he is about to hit the beach at Guadalcanal, he deals with the prospect of death as follows: 'Why should I be afraid to die? I belong to you. If I go first, I'll wait for you there, on the other side of the dark waters. Be with me now.' His love is the be-all and end-all of his existence.

The landing is unopposed, and as the men move inland, our initial narrator returns, voiced over a series of shots of the jungle:

Who are you to live in all these forms? You're death, that captures all. You, too, the source of all that is going to be born. Your glory, mercy, peace, truth. You give call to Spirit. I understand it. Courage, the contented heart.

The sequence ends with a point-of-view shot of Bell's wife, but it may or may not have been his interior monologue. Indeed, who is speaking becomes less important than what they say and how they reflect a kind of collective consciousness delving into the most important philosophical issues of all time.

Later, Witt sees the first allied casualties of the battle and entertains this pantheistic reverie:

Maybe all men got one big soul that everyone's a part of, all the faces the same. Everyone looking for salvation by themselves. Each like the coal drawn from the fire.

Witt can appreciate this collective soul because he is open to caring for his fellow soldiers, in the toughest and most vulnerable situation in which to do so. It will cost him his life.

Complementing the contrast between Welch and Witt, a second narrative conflict is between company commander Lt. Colonel Tall (Nick Nolte) and Captain Staros (Elias Koteas), who actually leads his men into battle. Their mission is to seize a hill, at the top of which is a well-defended machine gun nest and bunker. The first assault (launched across hillsides of tall grasses that sway in the wind like oceanic waves) decimates the company, and Captain Staros refuses Tall's order to regroup and attack again immediately. Staros is shown to authentically care for his men, and Tall himself expresses his discomfort with the role that has been forced upon him by the military ('Shut up in a tomb ... can't lift the lid ... never conceived of myself.').

Crisis is averted when the Japanese mortar barrage tapers off and the attack can be resumed (at Tall's insistence) with a reasonable prospect of success. They take the hill, with acceptable casualties, and Tall declines to court martial Staros for refusing to obey the orders of a superior officer. But he will not accept such behaviour

from an underling. He forces Staros to transfer out, to a position at the Adjutant General's Office in Washington, a non-combat posting. Just as Welch told Witt, Tall tells Staros that he will never be a real fighting man.

The battle scenes, and the dramatic confrontation between Tall and Staros, make for great cinema, and this central sequence is as gripping (and entertaining) as anything in *Saving Private Ryan*. Staros is shown in a positive light, as an officer with a conscience. When his men insist that he got a rotten deal, his response is supremely modest: 'I'm not sure you're right. The tough part is not knowing if you're doing any good.' He resists their urgings to appeal his reassignment and report his commanding officer for recklessness. He assures them he is glad to be going home, and tells them: 'You've been like my sons; you are my sons, my dear sons. You live inside me now. I'll carry you wherever I go.' We are clearly being encouraged to esteem his character.

By contrast, Tall is shown in a largely negative light. Though self-critical, at least to a certain degree (he is, e.g. privately disgusted by the ass-kissing and inhumanity he is willing to engage in and endure), his reflections and conversations clearly disclose his selfish motives. He is nearing the end of his career; the commanding General (John Travolta) notes that many of his contemporaries have already retired. This is the war he had longed for, offering the opportunities for advancement that come only with success in battle. Colonel Tall was willing to accept an appalling number of casualties in order to achieve that success, sending his men into the jaws of certain death and treating their lives as if they meant nothing (just as Welch had said at the beginning of the film).

But the conflicting perspectives of Welch and Witt are more central to *The Thin Red Line* than the clash of wills between Staros and Tall, and more ambiguous. Welch is a heroic officer, running into the line of fire to get morphine to a soldier dying in agony because his screams were undermining the morale of his men. Witt recognizes near the end of the film that Welch cares about him. But Welch tells Witt he is crazy and that it will be the death of him:

> What difference do you think you can make, one single man, in all this madness? If you die, it's going to be for nothing. There's not some other world out there where everything's going to be OK. There's just this one … just this rock.

Welch is not as callous as he acts. When a fellow officer decries the fact that he felt nothing at the death of one of his young men, Welch protests that this 'Sounds like bliss. I can't have that feeling yet. Not like the rest of you guys. Maybe because I know what to expect. Maybe because I was just frozen up already'. Clearly, Welch cares about his men in general, and about Witt in particular, despite his protestations to the contrary. His concern emerges as he confronts death with authentic feeling.

The Thin Red Line can rightly be said to be an anti-war film; the point is made bluntly in one scene, over shots of the inhumanity of war and its dehumanizing effects on the survivors: 'War doesn't ennoble men, it turns them into dogs. Poisons the soul.' In the context of the film, Witt and Staros are unambiguously to be preferred over Tall and Welch for their ability to maintain their humanity in the face of war. Tall and Welch embrace the Nietzschean notion of ruthless 'power' (*Macht*), which is the mark of a natural warrior. Witt and Staros embody Heidegger's notion of 'care' (*Sorge*), in their solicitude for their fellow soldiers.

But what makes *The Thin Red Line* such a philosophical film is that it insistently asks questions about the *meaning* of war, of death, of love and of human existence (although it refuses to answer many of the questions it raises). As noted above, the film begins with a series of interrogatories that suggests there is a war going on at the heart of Nature and that human warfare is simply an extension of that natural tendency. Colonel Tall seems to confirm that this is the perspective of the film when he chides Staros for lacking a true fighting spirit, and points to the creeper vines choking the life out of their competitors as exemplifying the struggle for survival at the heart of nature.

Yet one of the meditations on the subject near the end of the film makes precisely the opposite point:

> We were a family. How did it break apart so that now we are against each other? Each standing in the other's light. How did we lose the good that was given us, let it slip away, scattered, careless?

This offers an opposing perspective (that of Jean-Jacques Rousseau), one that sees humans as naturally peaceful and cooperative and as having been corrupted by society. The issue remains unresolved at the end of the film – it is put to each of us to do so for ourselves.

The film also highlights the notion that we each inhabit our own world of values and concerns, and that hence the universe we share can look very different from different perspectives:

> One man looks at a dying bird and thinks there's nothin' but unanswered pain ... another man sees the same bird and feels the glory. Feels somethin' smiling through it.

What to make of death, immortality, love, war, fate and human nature is also left up to us.

So, the film concludes with many of its questions unanswered. Private Bell, for example, devotedly clings to his love, avoids all other female contact and embraces the flame of his passion: 'No war can put it out or conquer it. I was a prisoner ... you set me free.' But then he gets a letter telling him she loves someone else and pleading for a divorce, excusing herself with her feelings of loneliness without him. He is, of course, shattered. Was it worth it?

Tall replaces Staros with an inexperienced (and incompetent) officer, who takes the company into needless danger and unwittingly chooses two of his most timid soldiers to scout ahead for the enemy. Witt volunteers to go along and stays to hold off the approaching Japanese, while the other two go back to save the company from an ambush. The Japanese platoon surrounds Witt and guns him down mercilessly. His serene countenance attests to the fact that he faces his fate with the courage of his mother, before he raises his gun threateningly to ensure the Japanese would kill him outright. His last thought is of swimming with the native boys.

Welch is deeply moved by Witt's death. In their last exchange before the final battle, Welch had expressed his astonishment: 'You still believe in the light don't you? You still do that? You are a magician to me.' It is here that Witt notes that the Sergeant cares about him. 'I still see a spark in you', Witt adds. Welch alludes to this after Witt's death, at his grave:

> Where's your spark now? (Cries) Everything a lie. Everything you hear, everything you see. So much to spew out. They just keep coming, one after another. You're in a box. A moving box. They want you dead, or in their lie. Only one thing that a man can do: find something that's his. Make an island for himself. If I

never met you in this life, let me feel the lack. A glance from your eyes and my life would be yours.

Witt had asked him 'Why do you always make yourself out like a rock?' It is clear at the end that Welch is no rock, but a caring human being with deep feelings for his fallen comrade. It is also clear that Welch was wrong and that Witt's death *was* meaningful. Not only does he save two of the members of his 'family', but he also ensures the safety of the rest of the company. His sacrifice was not for nothing. As an individual, he was able to make a difference. In telling his story in this way, human existence is seen as worth living and caring about. The resolution of both conflicts privileges the individuals who care (Staros and Witt) and shows those devoted to the Will to Power (Tall and Welch) in a negative light.

To summarize, then, *The Thin Red Line* is a particularly good example of what I have called a Heideggerian approach to cinema, because its central themes are the most characteristic existential concerns in Heidegger's writings: being towards death, caring for others, authenticity, future projection, reflection on the past, the call of conscience and the oneness of being. Its use of unconventional cinematic techniques (long takes, interior monologues, strange camera angles, voice-overs not clearly attributable to particular characters, lingering shots of the surrealistic beauty of nature, posing questions that remain unanswered, etc.) is also Heideggerian.

As many writers have pointed out,[24] the conventions of classical Hollywood cinema (such as invisible continuity editing, linear development, narrative closure and other aspects of so-called 'realistic' representation) developed because they deliver maximum entertainment value, while demanding minimal reflection on the part of members of the audience. These conventions are designed to make us unaware that we are watching a film, allowing us to process the experience unreflectively. By contrast, Malick's extensive use of unconventional techniques announces that his primary intent is to prompt active thought, rather than purvey passive entertainment, which is clearly a philosophical endeavour.

Furthermore, the film uses language (both English and the language of cinema) in a strikingly poetic fashion, with eloquent turns of phrase appearing regularly and vivid cinematography creating an aura of reverence and awe. The film does philosophy by raising a series of fundamental philosophical questions, and

refusing to answer them,[25] offering instead a variety of perspectives on the issues involved.[26] It demonstrates that it is a work of art, in Heidegger's sense of the term, by raising these questions and by showing the value of human caring in a positive light, praising its significance in the quest for human meaning.

Finally, *The Thin Red Line* is Heideggerian because of its focus on the feelings of guilt, shame and personal commitment. In all these ways, then, *The Thin Red Line* instantiates many of the possibilities of what I have called a Heideggerian cinema. As Robert Sinnerbrink observes in the concluding section of his essay on this pairing:

> *The Thin Red Line* is an enactment of this cinematic *poesis*, revealing different ways in which we can relate to our own mortality, to the finitude of Being, and the radiance of Nature, as well as depicting, from multiple character-perspectives, the experience of loss, of violence, of humanity, and of just letting things be. This showing is enacted not simply at the level of narrative content or visual style; it involves the very capacity of cinema to reawaken different kinds of attunement or mood through sound and image, revealing otherwise concealed aspects – visual, aural, affective, and temporal – of our finite being-in-the-world.[27]

In the world that the film depicts, existential issues are worth thinking about, and human beings, and other living things in Nature, are worth caring about. The meanings of death, authenticity, romantic love and God are worth looking into, the essence of Nature and the value of guilt are worth questioning, and artworks that hold open the truth of Being for us can call us to answer these questions for ourselves.

Questions for discussion

1 Most anti-war films make their position known early on and are focused on showing all the vices of such violent conflicts without considering the meaning of war to human existence. In what ways is *The Thin Red Line* not a traditional anti-war film, and how does it announce its explicitly philosophical intentions?

2 In a sense, Heidegger is arguing that most artworks are propaganda pieces, since they present information that is not impartial and that is designed to influence an audience and further an agenda. Think of other films that function in this fashion, identify their political or religious aims and discuss *how* they are trying to influence their viewers.

3 Reflect on Heidegger's claim that personal conviction is what brings value into the world. Do we believe in something because it is valuable or is its value created by our belief in it? Consider Heidegger's own belief in the Nazi cause in the 1930s and 1940s. Did the fervent conviction on the part of the German people that Hitler and Nazism was the future of the human race make this repugnant political movement valuable? Explain why or why not.

4 Heidegger focuses on the affirmative role of the artist as visionary, praising the actions and values that make life worth living. But artists often engage in social criticism, condemning the dominant cultural values that have their societies in a destructive grip. Indeed, most serious art in the modern age is critical rather than praising. Is this a dangerous trend? What values do you see the dominant art forms of our culture affirming and how?

Suggestions for further viewing

The Tree of Life (2011, Terrence Malick) – Among other things, this is the story of the O'Brien family, thrown into turmoil by the death of their nineteen-year-old son R.L. in the 1960s. Oldest son Jack is seen much later, grappling with the problem of evil, reflecting on that death and his own failures in life and how his mother and father embodied the conflict between faith and reason. The crisis is resolved with reference to the book of Job and to the glories of the creation of the universe.

Being There (1979, Hal Ashby) – This satire, whose title is the English translation of *Dasein*, examines a man without qualities or convictions, a gardener who has lived his whole life inside a single mansion and who is forced out into the world by the death of his

employer. Hilarity results when the world takes his banal utterances to be profound, as he becomes an adviser to a Washington power broker and is taken seriously by the President of the United States.

Wings of Desire (1987, Wim Wenders) – The story of Damiel, an angel who tires of his disembodied existence and who somehow manages to become flesh. His decision to do so is based on his love for a trapeze artist, his longing for physical sensation and his desire to have his actions make an impact on the material world. It comes at the cost of facing death.

The Ister (2005, David Barison and Daniel Ross) – During the Second World War, Heidegger delivered a series of lectures on Friedrich Hőlderlin's poem about the Danube River (using its original Greek name). This is a lengthy and poetic cinematic essay that invites the viewer to consider some of the most difficult and profound questions facing humanity today in light of Heidegger's philosophy.

CHAPTER SEVEN

Absurdity and Suicide in *Leaving Las Vegas* and *The Myth of Sisyphus*

As with many of the chapters of this book, the pairing of Albert Camus's early philosophy and *Leaving Las Vegas* is not original to me. Mary Litch, in her popular book *Philosophy Through Film*,[1] relates *Leaving Las Vegas* (and Bergman's *The Seventh Seal*) to Jean-Paul Sartre's essay 'Existentialism Is a Humanism' and to Albert Camus's absurdism in *The Myth of Sisyphus*. Typically, however, Litch is ambivalent about whether Camus and Sartre would either embrace the film or condemn its suicidal protagonist. Yet this has become one of the most popular sections of my course on 'Problems in Philosophy'; few of my students have seen the film beforehand, most are intrigued by existentialism, and its treatment of the subject of suicide makes quite an impact. The films that I have chosen to discuss are, for pedagogical purposes, archetypes of the philosophies which they illustrate, so the pairings are not generally original.

One of the most unconvincing passages in Camus's *The Myth of Sisyphus* (his first sustained philosophical treatise) argues that a person lucidly confronting the absurdity of existence should not commit suicide:

> It may be thought that suicide follows revolt – but wrongly. For it does not represent the logical outcome of revolt. It is just the contrary by the assent it presupposes. Suicide, like the leap [of faith], is acceptance in the extreme.[2]

In light of this, one might expect that Camus would have condemned Ben Sanderson for resolving to drink himself to death and proceeding to do just that. However, I will argue in what follows that Camus *could* have seen Ben as an absurd hero, since he embodies many of the 'virtues' of the life of absurd freedom that Camus advocated. Furthermore, I will demonstrate that it is no accident that some of the most absurd of Camus's literary and dramatic protagonists either kill themselves or engage in self-destructive behaviour that inevitably leads to their demise.

'There is only one truly serious philosophical problem, and that is Suicide.'[3] This first sentence of *The Myth of Sisyphus* is a slap in the face of professional philosophers, who generally believe there at least several other philosophical issues that are just as serious. But (like Nietzsche before him) Camus was an intellectual essayist and not a systematic philosopher, and the rhetorical impact of

opening in that manner was worth it to him. As he put it a page later, 'we are concerned here, at the outset, with the relationship of individual thought and suicide'.[4] In particular, he was seeking an account of 'the exact degree to which suicide is a solution to the absurd'.[5] Before examining his answer to the question 'Does the Absurd dictate death?',[6] an explanation of what Camus means by characterizing human existence as absurd is in order.

In trying to clarify the notion, Camus begins by offering an impressionistic catalogue of the absurd: in confronting absurdity 'the stage sets collapse';[7] awareness of it arises when 'Weariness comes at the end of the acts of a mechanical life'[8] and from our 'discomfort in the face of man's own inhumanity'.[9] The 'denseness and strangeness of the world is the absurd',[10] grounded in our awareness of the brevity of life, the inevitability of death, the silence of the universe (in the absence of God) and the prospect of nothingness.

Neither the universe on the one hand nor particular human beings on the other are absurd. Rather (to use Camus's analogy), absurdity can be likened to the situation of a man with a sword attacking a nest of machine guns; the absurdity of the situation consists in 'the disproportion between his intention and the reality he will encounter, of the contradiction that I notice between his true strength and the aim he has in view'.[11] Hence, 'The absurd is essentially a divorce';[12] the absurd man has become estranged from his surroundings because his goals are patently unattainable in the real world.

One of Camus's unfulfilled demands was that the universe be rationally intelligible:

> I want everything explained to me or nothing. And the reason is impotent when it hears this cry from the heart. The mind aroused by this insistence seeks and finds nothing but contradictions and nonsense. ... The world is peopled with such irrationals. The world itself, whose single meaning I do not understand, is but a vast irrational. If one could only say once 'This is clear', all would be saved. But men vie with one another in proclaiming that nothing is clear.[13]

Estrangement from the world is the inevitable result. 'To an absurd mind reason is useless, and there is nothing beyond reason.'[14].

Exploring what to do in the face of this divorce is the core of Camus's essay. In the face of the absurdity of existence: 'Is one to die voluntarily or to hope in spite of everything?'[15]

Camus contends that there are actually three genuine alternatives. The first is to commit what he calls 'philosophical suicide', the second is literal suicide and the third is to live a life of absurd freedom. The first option involves taking a Kierkegaardian 'leap of faith' in God or in any other irrationally optimistic world view. One commits philosophical suicide by engaging in a process of self-deception that denies the fundamental absurdity of existence. In denial, such a person slays his (or her) faculty of reason, by refusing to acknowledge the irrationality at the heart of existence. Camus insists, on the contrary, that one must maintain an almost Cartesian lucidity: 'Any other position implies for the absurd mind deceit, and the mind's retreat before what the mind itself has brought to light.'[16] He gives us no choice but to face the dissonant music.

Literal suicide, however, is much harder for Camus to convincingly condemn. He begins by reframing the issue:

> It was previously a question of finding out whether or not life had to have a meaning to be lived. It now becomes clear, on the contrary, that it will be lived all the better if it has no meaning.[17]

One can either deny the absurdity of human existence (by committing philosophical suicide), elude the problem permanently (by committing literal suicide) or revolt against an irrational universe and live a life of absurd freedom.

Life will be lived better if it has no meaning, because an unjust and unintelligible universe is worth revolting against: 'That revolt gives life its value ... it restores its majesty ... there is no finer sight than that of the intelligence at grips with a reality that transcends it.'[18] In Camus's eyes, committing literal suicide amounts to an admission of being conquered by the absurdity of existence, like an innocent lamb slaughtering itself. Consciousness and revolt are uniquely human characteristics, which must be cultivated with an indomitable passion: 'It is essential to die unreconciled and not of one's own free will. Suicide is a repudiation.'[19] At this point, it seems that Camus would criticize anyone who took his own life willingly.

But let us consider the consequences of this revolt, and the 'virtues' of the life of absurd freedom.

One way in which life will be lived better if it has no meaning is that we will enjoy greater freedom:

> if the absurd cancels all my chances of eternal freedom, it restores and magnifies, on the other hand, my freedom of action. That privation of hope and future means an increase of man's availability.[20]

Camus rejects Martin Heidegger's contention in *Being and Time* that resolute commitment to future goals can infuse life with subjective meaning. Such commitments are chains that bind the conventional man: 'To the extent to which he imagined a purpose to his life, he adapted himself to the demands of a purpose to be achieved and became a slave to his liberty.'[21] From Camus's perspective, at this point in his career, striving for goals and purposes is as fruitless as Sisyphus rolling his rock up the hill for all eternity: 'The absurd enlightens me on this point: there is no future.'[22] Forgetting about the future (and the past) maximizes our alternatives at every moment.

How should we live, then, in a universe that consistently thwarts our deepest desires? 'Belief in the meaning of life always implies a scale of values ... Belief in the absurd ... teaches the contrary.'[23] Since Plato, most philosophers have argued that the individual should adopt a single hierarchy of values and live accordingly. For the absurd man, 'what counts is not the best living but the most living.'[24] Camus contends that we can live more enjoyably without appealing to such hierarchies.

Living the life of absurd freedom allows one to substitute a diverse quantity of experiences for the quality that all of our lives necessarily lack. He becomes an 'adventurer of the everyday who through mere quantity of experiences would break all records (I am purposely using this sports expression)'.[25] Camus himself had to admit that there is a contradiction inherent in what he was advocating: 'For on the one hand the absurd teaches that all experiences are unimportant, and on the other it urges towards the greatest quantity of experiences.'[26] But, as Ralph Waldo Emerson (and Nietzsche) has observed, a foolish consistency is the hobgoblin of little minds.

Along with his freedom, the absurd man regains his passion. The routine that numbs the human spirit grows out of the commitments that dictate it. No one can sustain passionate intensity in such a repetitive existence. The absurd man lives for the moment, substituting the quantity and diversity of his experiences for their absence of quality. He dives into life with both feet and without regret.

His passion is made possible in part by his revolt against social norms. Violating those norms is singularly satisfying; he thereby distinguishes himself from the herd. One must rebel against the absurdity of existence, not be ground beneath its wheel. Both philosophical and literal suicide are indications that the individual cannot handle the absurd, and must either flee from it in denial or succumb to it willingly by his own hand. The absurd man does neither – he confronts absurdity directly and lives accordingly.

Camus sketches out several examples of the life of absurd freedom, the clearest of which is Don Juan.[27] One of the primary desires that are inevitably thwarted in life is our longing for romantic love that lasts forever and remains undiminished in its passion. Don Juan has been misinterpreted by some 'as a mystic in quest of total love.'[28] But, in Camus's version of the Don's tale, he had long since given up on that quest, having lucidly recognized its impossibility. Don Juan is the archetype of the man who substitutes quantity and diversity in his life for a quality that is forever elusive. He loves each of his romantic conquests in the time they are together: 'Why should it be essential to love rarely in order to love much.'[29] Long-term relationships drain the passion out of life, especially if they involve the demand for sexual exclusivity. Don Juan insists on satiating *all* of his passions: 'If he leaves a woman it is not absolutely because he has ceased to desire her. ... But he desires another, and, no, this is not the same thing.'[30]

Don Juan exemplifies all of what I will (ironically) call the 'virtues' of the life of absurd freedom: He (1) lives life with a passionate intensity, (2) lucidly recognizes the absurdity of the search for a lasting love of one person and follows the logical consequences of that recognition, (3) substitutes the quantity and diversity of his romantic experiences for the quality that is (necessarily) lacking, (4) immerses himself in the moment (of

conquest), (5) 'sets all records' in the sheer number of his sexual partners and (6) revolts against social norms. Don Juan revels in his condemnation by the herd and even calls down punishment on himself: 'Hell for him is something to be provoked.'[31]

Let me now turn to a summary and analysis of *Leaving Las Vegas*, where I will argue that the main character embodies many of the 'virtues' which were just outlined.

At the beginning of *Leaving Las Vegas*, Ben Sanderson (Nicholas Cage, in an Academy Award winning performance) is shown to be at the end of his proverbial rope. First, he has to humble himself to ask an acquaintance for drinking money. Then his job as a Hollywood scriptwriter is terminated. At the bank, he has to go out for several drinks before his hand is steady enough to sign his severance check. We later learn that he is estranged from his wife and child. All of this has occurred because he is an inveterate alcoholic, unable (or unwilling) to seek medical or therapeutic assistance. He tells his former boss that he is headed to Las Vegas, where (we learn subsequently) he intends to drink himself to death.

Director Mike Figgis has impeccable musical taste, and the jazzy soundtrack of the film, interspersed with classic ballads like 'Come Rain or Come Shine' (sung by Don Henley), sets the darkly romantic tone. The couple is granted their own theme, appropriately titled 'My One and Only Love', which is voiced by Sting at several appropriate points.

Before this Hollywood breakthrough, Figgis was known for such downbeat tales as *Stormy Monday, Mr. Jones* and *Leibestraum*, and he was the perfect neo-*noir* stylist to tell this story of inevitable degeneration. His vision of Las Vegas is filmed at night and in dark little rooms where the shadows are forbidding and the psychological atmosphere is unsettled. Ben also shares the same bleak fate of so many *noir* protagonists.

Soon after his arrival in Sin City, Ben nearly runs over an attractive prostitute named Sera (Elizabeth Shue), stopping at the last moment as she crosses the street with the light. When next they meet, he hires her for companionship rather than sex (due to the quantity of his alcoholic consumption, he is predictably impotent). A touching relationship between two lonely misfits develops, minus the happy ending that often concludes such tales.

As Sera becomes acquainted with Ben's fatal project over a dinner he is unable to consume, the following exchange ensues:

Sera: I just wanna know. Why are you killing yourself?
Ben: Interesting choice of words. I don't remember. I just know that I want to.
Sera: Is your drinking a way to kill yourself?
Ben: – Or killing myself is a way to drink.
Sera: Very clever.

Ben had earlier made a similarly reversible causal claim about his drinking and losing his wife.

Despite this troubling revelation, Sera invites Ben to move in with her. He warns her about the bad times ahead, and has one further reservation: 'You can never, never … ask me to stop drinking. Do you understand?' When she agrees, he declares his affection for her. But their cohabitation begins on a sour note. Ben arrives before Sera and passes out at the entrance to her apartment complex (not the best first impression to make on the landlords). After she gives him several presents, they decide to celebrate with a night of gambling at one of the casinos. Despite a promising romantic kiss, their evening also ends in disaster. When his waitress refuses to serve him any more liquor, Ben becomes unruly, overturns a blackjack table, and gets them both thrown out of that particular casino for good. Yet Sera is in love and tolerates these inconveniences.

This inauspicious beginning prepares us for Ben's inevitable fate. Sera will try her best to save him, but in vain. One user review of the film on the Imdb website likened the tale to a Greek tragedy:

Not unlike John Huston's *Under The Volcano*, *Leaving Las Vegas* borrows from Greek mythology, obliquely mirroring the tragedy and pathos of Orpheus's failed attempt to rescue his dead wife, Eurydice, from Hades. Mike Figgis obliges us with a helpful hint in the scene where Nicolas Cage gives Elizabeth Shue a present of earrings: Greek cameos.[32]

As in Greek tragedy, the increasing inevitability of his demise allows us to focus on the pathos of the situation.

Ben goes out first thing next morning, ostensibly to get them both breakfast. He stops at the first bar he sees, gets into a fight

with a jealous patron (whose girl found Ben attractive) and comes back bruised and bloody. His condition soon deteriorates further. Sera treats them to a weekend at a nice desert motel. In full sunlight, by a shimmering pool, she seduces him with her breasts and his bourbon, and tries to lead him back to their room. But Ben collapses onto a glass table and breaks it, turning his back into a prickly pear. This gets them ejected from the motel, too.

After their return, Sera tries vainly to get Ben to eat something. Exasperated, she pleads with him:

> Sera: I want you to see a doctor
> Ben: I'm not gonna see a doctor. Maybe it's time I moved to a motel.
> Sera: And do what? Rot away in a room. We're not going to talk about that. Fuck You. You're staying here. You're not going to any motel ... It's just one thing you can do for me. That's all I ask. I've given you gallons of free will. You can do this one thing for me.

But he won't stop now. Ben realizes that it is time to go and finds a way to get Sera to agree. He goes out and picks up a hooker and brings her back to Sera's place. When she discovers them together in her bed, she throws him out, as he knew she would. Then she gets anally raped and beaten by a trio of college students, and her scandalous condition upon her return is the last straw for the landlords, who tell Sera she has to be out of her apartment by the end of the week.

She searches for Ben at his old motel and elsewhere, but does not find him until the day of his death, when he calls because he wants her with him at the end. They ironically consummate their love for the first time on what can be construed as his death erection. His last word before expiring (shortly thereafter) is 'Wow!'

Returning to the master list of what I have called the 'virtues' of the absurd man, Ben can be seen to embody them all. The two most fundamental ones are lucidity and revolt. In reference to lucidity, Roger Ebert's comment in his review of *Leaving Las Vegas* is on the mark: 'You sense an observant intelligence peering from inside the drunken man, seeing everything, clearly and sadly.'[33] Ben acknowledges his love for Sera, but never deceives himself that it could last forever or redeem him. If he attempted to kick the booze,

he would most likely fail, and he knows it. He has ruined his career, and his marriage, and his health, and recognizes there is no turning back.

As the recent controversy over the death of Robin Williams illustrates, conventional attitudes condemn suicide outright and consider those who commit it to be either selfish or psychotic (unless they are in the latter stages of a terminal disease). Ben's project is as unconventional as they come, and he executes it admirably. He doesn't care that Sera is a prostitute, and he flirts shamelessly with the woman in the bar, though he knows that this is dangerous. The opinions of others are irrelevant, and he has abandoned the herd to take his own approach to life. This freedom from societal constraint makes Ben's project possible.

It is an intense approach. In the words of David Gonsalves, director Mike Figgis 'doesn't romanticize alcoholism or suicide, but he does suggest the intensification of feeling in the midst of numbness'.[34] Furthermore, as critic Janet Maslin put it, '*Leaving Las Vegas* is far less dolorous than might be expected', because Ben is 'Passionate and furiously alive', attracting the audience with the 'riotous energy of his outward charm'.[35]

Ben fits Camus's description of the man who attains absurd freedom: he *is* an 'adventurer of the everyday who through mere quantity of experiences would break all records (I am purposely using this sports expression)'. No character in the history of cinema (except perhaps the Mickey Rourke/Charles Bukowski character in *Barfly*) drinks as much as Ben and survives for as long. He needs half a fifth of Vodka first thing in the morning just to calm his shaking body. Consuming as much alcohol as he does in a single day would kill a normal man, but Ben has built up his tolerance, and does not die easily.

As far as Ben is concerned, he has no past and no future. He refuses to spend his time either regretting his mistakes or making plans. His immersion in the moment is complete. He enjoys drinking, and being drunk, and the complete freedom extreme intoxication facilitates. Once his money runs out, he is likely to end up on skid row, a penniless alcoholic. In light of this, what he is doing makes sense. His final word ('Wow!') says it all: he truly enjoyed the ride, and, like Sisyphus in Camus's version of the myth, he 'concludes that all is well'.[36] Also like Sisyphus, Ben was happy in the end, having stuck to his guns and achieved his goal as he saw fit.

Ben showed true courage in his choice of the method for ending his life. As the film shows us, death by alcohol isn't pretty. It requires a resolute will to execute oneself in this fashion. His absolute refusal to hope in the future also reflects the nature of the absurd man as Camus described him. Despite Ben's sincere love for Sera, he will not go to the doctor or temper his prodigious consumption of alcohol. He lives his life without appeal to anything ideal or 'higher' and refuses to reconsider his fatal resolution.

But there's the rub. He does commit suicide, albeit in a form that is superior in several ways to simply blowing his brains out. So doesn't it follow that the Camus who said: 'It is essential to die unreconciled and not of one's own free will. Suicide is a repudiation',[37] would have to condemn Ben for his decision? Perhaps not. If we grant Ben his assumption that he can't stop drinking, isn't he maximizing the pleasure there is yet to be found in his life? Wouldn't he be likely to end up a miserable homeless bum when his money ran out? In the concluding section, I will discuss the reasons why several of Camus's most absurd literary creations either kill themselves or pursue a lifestyle that makes their death inevitable.

As Thomas Hanna highlights in *The Art and Thought of Albert Camus*, his works can usefully be separated into two distinct periods, an earlier one dominated with his concern for the absurd (and suicide) and a later one focused on the notion of rebellion (and murder):

> There are three works that fall within this earlier period: the novel, *The Stranger*, and the two plays, *The Misunderstanding* and *Caligula*. In these works we have a literature of the absurd.[38]

Let's examine his protagonists from this period to see whether they live up to Camus's own demands.

Neither Meursault nor Caligula commits literal suicide, but they engage in actions that lead inexorably to their destruction. In *The Misunderstanding*, both the mother and her daughter Martha kill themselves, in the wake of discovering they have unknowingly murdered their son and brother. Hanna's analysis of Martha's angry reaction is particularly relevant here:

> This anger of Martha is the anger of an absurd hero who accuses the world and will not be reconciled. Martha is directly

expressive of all the principles of *The Myth of Sisyphus* but one: she commits suicide. But even this is explicable, for the reason that suicide is the alternative to death at the hands of society. In Martha, the experiment of the *raisonnement absurde* (absurd reasoning) has already begun, and we see that it has led to death.[39]

It is no accident that absurd reasoning results in the death of Camus's other two absurd protagonists as well.

In his preface to *Caligula*, Camus describes his tale of the infamous Roman emperor as follows:

> Caligula depopulates the world around him and, faithful to his logic, does what is necessary to arm against him those who will eventually kill him. *Caligula* is the story of a superior suicide.[40]

Notice that he characterizes his protagonist as 'a suicide', even though Caligula did not literally end his life with his own hands. So far, our catalogue of Camus's most absurd protagonists shows that all three commit suicide, either directly or indirectly.

Meursault in *The Stranger* does not choose to kill himself, despite facing the execution that Martha ensured she would avoid. Yet it was his decision to pump four more bullets into the inert body of the Arab on the beach, removing any question of self-defence and making him guilty of murder. Meursault is less of an absurd hero than Caligula, although he *is* indifferent to the future and the past, and lives his life immersed in the moment, without appeal to any ideals or hierarchies of value. But he lacks the lucid recognition of the absurdity of existence, he sets no records for cruelty or murder (or even the diversity of his pleasures) and he does not revolt against his condition until the very end of the novel.

Meursault recognized that those four extra trigger pulls would spell his doom. Maurice Friedman, in his book *Problematic Rebel*, aptly asks: 'What is this murder-suicide but the involuntary protest of the self which has been pressed in on itself so far that it has no choice but to explode?'[41] Living life in complete indifference is a formula for disaster.

In my view, early Camus tried unsuccessfully to elude the nihilistic implications of his absurdism by arguing against suicide and in favour of artistic creativity. As he put it in his retrospective preface to *The Myth of Sisyphus*, appended in 1955,

this book declares that even within the limits of nihilism it is possible to find the means to proceed beyond nihilism. ... it sums itself up for me as a lucid invitation to live and to create, in the very midst of the desert.[42]

I believe he did not find convincing means, and that the self-destructiveness of his early literary and dramatic protagonists from that period demonstrates that he did not do so.

Later, in *The Rebel* (see the following chapter), Camus came to recognize that suicide and murder are the logical outcomes of nihilism. He acknowledged in his introduction to this later work that there was an inconsistency in advocating or condemning *any* lifestyle while embracing nihilism: 'If we believe in nothing, if nothing has any meaning and if we can affirm no values whatsoever, then everything is possible and nothing has any importance.'[43] The revolt he advocated in the *Myth* said 'no' to the absurdity of human existence without saying 'yes' to anything positive. It is, therefore, quite logical that his most absurd protagonists (including Stavrogin in his dramatic adaptation of Dostoevsky's *The Devils*) either kill themselves or engage in behaviour that is inevitably self-destructive.

Camus's central thesis in *The Rebel* was that genuine rebellion must involve an affirmation as well as a negation (see the following text). He diagnosed the contradiction at the heart of *The Myth of Sisyphus* by admitting that this requirement goes unfulfilled in his case against suicide there. In condemning suicide,

> it is obvious that absurdism hereby admits that human life is the only necessary good since it is only life that makes this encounter possible and since, without life, the absurdist wager would have no basis.[44]

According to Camus, *The Myth of Sisyphus* functioned for him like Descartes' use of methodological doubt in the first Meditation; it cleared the way for his positive views. He concluded:

> The absurd is, in itself, a contradiction. It is contradictory in its content because, in wanting to uphold life, it excludes all value judgments, when to live is, in itself, a value judgment.[45]

Camus then quotes Friedrich Nietzsche, in adopting his distinction
between active and passive nihilism (see the aforementioned text):
'"My enemies", says Nietzsche, "are those who want to destroy
without creating their own self."[46] The passive nihilist negates
without affirming anything convincingly. The active nihilist
negates as a stage in what Nietzsche calls the revaluation of all
values.[47]

Looking at the history of Camus's philosophical evolution, then,
we see him moving away from nihilistic absurdism in order to
affirm the value of each and every human life. His post-war public
crusades against the death penalty and terrorism, and the striking
contrasts between Meursault in *The Stranger* and Dr Rieux in *The
Plague* (who struggles heroically against the disease and neither dies
from it nor kills himself), show that Camus was ultimately an active
nihilist, whose earlier absurdist negations gave way to an eloquent
affirmation of humanism.

In conclusion, what I have been arguing is that Ben Sanderson
in *Leaving Las Vegas* has a number of striking similarities to both
Camus's abstract characterization of the life of absurd freedom in
The Myth of Sisyphus and to several of his most absurd literary
and dramatic protagonists. This makes the film an extremely useful
illustration of the significance of, and tensions within, Camus's
early concept of absurdity. Like many of Camus's most absurd
protagonists, Ben Sanderson ends his life willingly and is no less an
absurd hero for having done so.

Questions for discussion

1 Camus claims that if we would just quit striving for all of
 the things that supposedly make life worthwhile, we would
 be happy with living for the moment. Do you agree? What
 gives meaning to your life? Aren't these same projects your
 major sources of suffering? Is striving for them worth it?

2 Is Ben a tragic figure, or is he simply pitiful? Aristotle
 argued that a tragic protagonist must be more noble than
 the rest of us and must be engaged in a heroic action. Does
 Ben fit the bill? Is the end of the film simply depressing, or is
 there some saving grace that mitigates suffering?

3 Statistics show that in the past half-century, suicide rates
have increased by 60 per cent worldwide. Why do you
think this is the case, and what (if anything) should be done
to stem the tide? Is Camus right that most people commit
suicide because of their failure to achieve the (potentially
illusory) things that are supposed to make life worth living?
Would embracing absurd freedom cut that rate?

4 What are your feelings about Sera? Why does she become
involved with Ben, knowing that he is in the process of
killing himself? What do you think she will do after his
death? Has the experience shattered her, or will she be able
to go on with her life?

Suggestions for further viewing

The Big Lebowski (1998, Joel and Ethan Coen) – An absurdist
comedy about an itinerant stoner who seeks to be compensated for
his urinated-upon rug and gets hired by a tycoon to seek out the
man's kidnapped wife. No one commits suicide here, despite the
presence of two avowed nihilists, and the meaninglessness of life is
seen as amusing rather than crushing.

Mulholland Drive (2001, David Lynch) – A surrealistic tale of a
young woman named Betty, who arrives in Hollywood from the
Midwest seeking to become a movie star. She gets involved with a
beautiful amnesiac who may or may not be named Rita and whose
search for her identity takes the pair into uncharted territory. Some
critics have seen Betty as committing suicide at the end of the film
because of her failed career and love life, which would serve to
confirm Camus's theories.

Fear and Loathing in Las Vegas (1998, Terry Gilliam) – This
hallucinogenic adaptation of gonzo journalist Hunter S. Thompson's
most famous work depicts him as an absurd hero, setting all records
for drug use and adventurous activities, and never once despairing
in the face of his paranoid fears and meaningless existence.

Le Feu Follet (*The Fire Within* 1963, Louis Malle) – The story
of another alcoholic contemplating suicide, but in a far more

philosophic fashion than Ben Sanderson. After being released from a private hospital that claims to have cured his affliction, he resolves to kill himself if he can find no good reason to live, and meets up with old friends, lovers and acquaintances in a frustrating attempt to do so. Highly philosophical and hard to find.

CHAPTER EIGHT

Rebellion and Murder in *Missing* and Camus's *The Rebel*

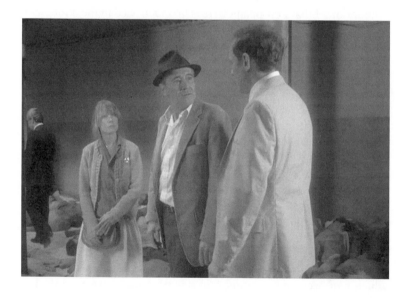

I continue to believe that this world has no ultimate meaning. But I know that something in it has a meaning and that is man, because he is the only creature to insist on having one. This world has at least the truth of man, and

our task is to provide its justification against fate itself. And it has no justification but man; hence he must be saved if we want to save the idea we have of life.

CAMUS, 'LETTERS TO A GERMAN FRIEND'[1]

The Second World War had a significant impact on the philosophies of both Albert Camus and Jean-Paul Sartre. Sartre fought in the French Army and was captured by the Germans; Camus moved to Paris from Algeria in 1940 and edited an underground resistance newspaper called *Combat* during the Occupation. The Nazis appalled both men, yet both found it hard to justify resisting them within the boundaries of absurdist philosophy.

This troubled Camus, who worked out his anxieties in a series of fictitious 'Letters to a German Friend', written in 1944. After the war, he adopted a very different philosophical perspective, one that finds its most articulate presentation in *The Rebel* (1951). The foundation of that new perspective is first identified in the quote with which this chapter began: individual human lives must have value, if anything does, and so each of us should be granted the right to life. Since everything has the value that we give it, if humanity chooses to respect that right, we will have bestowed on human life an absolute and universal value. We will examine the evolution of his views in this chapter and relate his mature position to one of the rebellious counter-culture films from the 1970s and early 1980s, *Missing*.

As we saw earlier, the central issue in *The Myth of Sisyphus* was suicide and whether it was the appropriate response to recognizing the absurdity of existence. But that was an earlier time, and, almost a decade later, *The Rebel* focuses on another problem. As Camus put it: 'In the age of negation, it was of some avail to examine one's position concerning suicide. In the age of ideologies, we must examine our position in relation to murder.'[2] Communism and democracy were fighting it out for dominion over the post-war world, and Camus's central question here was whether murder, which had become so common in this new age, can be justified in the name of any political ideology.

Camus begins *The Rebel* by recognizing the central contradiction inherent in his former absurdist position:

The concept of the absurd leads only to a contradiction as far as the problem of murder is concerned. Awareness of the absurd

... makes murder seem a matter of indifference, to say the least, and hence possible. If we believe in nothing, if nothing has any meaning and if we can affirm no values whatsoever, then everything is possible and nothing has any importance.[3]

If human existence is indeed absurd, then killing someone has no more significance than snuffing out a cigarette butt.

The Second World War convinced Camus that the spirit of nihilism had come to dominate the earth:

> Since nothing is either true or false, good or bad, our guiding principle will be to demonstrate that we are the most efficient – in other words the strongest. Then the world will no longer be divided into the just and the unjust, but into masters or slaves. Thus, whichever way we turn, in our abyss of negation and nihilism, murder has its privileged position.[4]

Camus could not accept murder any more than he could affirm suicide. His repudiation of suicide, however, had already pointed to an unacknowledged positive value: In arguing against suicide, 'it is obvious that absurdism thereby admits that human life is the only necessary good, since it is precisely life that makes this encounter possible'.[5] He then addresses the heart of the problem:

> The absurd is, in itself, a contradiction. It is contradictory in its content because, in wanting to uphold life, it excludes all value judgments, when to live is, in itself, a value judgment. To breathe is to judge.[6]

But these remarks are introductory. Rebellion is the true subject of his second major book, where Camus is enquiring about both its nature and whether murder ought to be permitted in its service. He seeks, as it were, the necessary conditions for legitimate rebellion and begins with the following observation: 'Rebellion cannot exist without the feeling that, somewhere and somehow, one is right.'[7]

One of the central problems in the history of philosophy is our inability to justify the transition from a description of the facts to claims about values. That transition is made manifest in rebellion: 'If he [the Rebel] prefers the risk of death to the negation of the rights that he defends, it is because he considers these rights (to be) more important than himself.'[8] In his willingness to die for his

value, he helps create the sense that human life is worth fighting for and worth living.

In this early, introductory section, Camus indicates that he will be arguing for a stunning conclusion: 'Analysis of rebellion leads to at least the suspicion that, contrary to the postulates of contemporary thought, a human nature does exist.'[9] Camus resisted being labelled an existentialist after the war, and with good reason; in his later writings, he rejected three of the central tenets of this school of thought: (1) that individual existence precedes human essence, (2) that there is no such thing as a fixed essence to human nature and (3) that it is up to us as individuals to define ourselves as we like, even by committing murder.

Camus argues that the individual's act of rebellion goes beyond himself:

> Therefore the individual is not, in himself alone, the embodiment of the values he wants to defend. He needs all of humanity, at least, to comprise them. When he rebels, a man identifies himself with other men and so surpasses himself, and from the point of view of human solidarity is metaphysical.[10]

In brief, 'I rebel, therefore we exist.'[11] Camus proceeds to examine the metaphysical rebel (who says no to God), the historical rebel (who says no to the State) and the artistic rebel (who says no to the prevailing artistic conventions and who will not concern us here).

Metaphysical Rebellion finds its literary archetypes in John Milton's Satan and Fyodor Dostoevsky's Ivan Karamazov. For Satan, it was better to rule in Hell than to serve in Heaven, and God's preference for humanity over the angels was unacceptable. For Ivan, God's divine plan cannot justify the suffering of innocent children. Both rebel against the Divine Being and reject His Authority, which could only derive from His perfection.

In the philosophical realm, the metaphysical rebel *par excellence* is Friedrich Nietzsche, about whom Camus is of two very distinct minds. He condemns Nietzsche's advocacy of a ruthless Will to Power, claiming that this amounts to resigning humanity to the Darwinian struggle for mere survival. But he also acknowledges Nietzsche's insight that saying "No!" to the powers that be requires saying "Yes!" to something else, for the sake of which that denial is made.

Nietzsche distinguished between the passive nihilism of someone like Schopenhauer (see the earlier text), whose pessimism simply negates without affirming anything, and his own active nihilism. He sought to free humanity from the idols of the marketplace (especially the illusions of God, morality and free will) to clear the way for his affirmation of the Will to Power and the overman. As Camus summarizes Nietzsche's position:

> Nihilism, whether manifested in religion or in socialist preachings, is the logical conclusion of our so-called superior values. The free mind will destroy these values and denounce the illusions on which they are built, the bargaining that they imply, and the crime they commit in preventing the lucid intelligence from accomplishing its mission: to transform passive nihilism into active nihilism.[12]

Zarathustra is Nietzsche's John the Baptist, announcing the forthcoming Overman as the saviour of the earth.

Nietzsche is hence a pivotal figure in the conceptual development of rebellion. He is, according to Camus,

> the most acute manifestation of nihilism's conscience. The decisive step he compelled rebellion to take consists in making it jump from the negation of the ideal to the secularization of the ideal. Since the salvation of man is not achieved in God, it must be achieved on earth. Since the world has no direction, man, from the moment he accepts this, must give it one that will eventually lead to a superior type of humanity.[13]

Though Camus disagrees with Nietzsche's conception of the overman and its aristocratic presuppositions, he, too, tried to secularize the ideal in his vision of a rebel who is unwilling to violate human solidarity by resorting to murder.

Camus then offers his analysis of historical rebellion, beginning with the Russian nihilists of the mid-nineteenth century. They were passive nihilists, in Nietzsche's sense, for they affirmed nothing:

> In the universe of total negation, these young disciples try, with bombs and revolvers, and also with the courage with which they

walk to the gallows, to escape from contradiction and to create the values that they lack.[14]

They embrace murder as the logical outcome of their nihilism, refusing to see that their rebellion against the Russian Aristocracy could only be justified by affirming some value for the sake of which they did so, and hence some limit beyond which they were unwilling to go.

The fascists were 'the first to construct a State on the concept that everything is meaningless and that history is only written in terms of the hazards of force'.[15] Camus admitted that Nietzsche was not the man Alfred Rosenberg (the official Nazi philosopher, who adapted Nietzsche's philosophy to its cause) made him out to be. Yet Camus still concluded:

Fascism wants to establish the advent of the Nietzschean superman. It immediately discovers that God, if He exists, may well be this or that, but He is primarily the Master of Death.[16]

The problem was that there was nothing in Nietzsche's philosophy that precluded this fascist utilization of his world view, although Camus noted that Nietzsche himself was neither an anti-Semite nor a German nationalist.

The Marxist revolution in Russia was the other most dramatic example of ideology in action in the twentieth century, where science became the successor to religion, and 'The idea of progress alone is substituted for the Divine Will'.[17] Camus condemned what he called Marx's 'scientific Messianism':

Progress, the future of science, the cult of technology and of production, are bourgeois myths, which in the 19th century become dogma ... this profession of faith ... gives the most accurate idea of the almost mystic hopes aroused by the expansion of industry and the surprising progress made by science.[18]

In short, Marx was far too optimistic about what the future would hold.

Developments in the twentieth century, including genocide, the dropping of the atomic bomb and the indiscriminate slaughter of

millions of innocent civilians, have exposed Marx's optimism as groundless:

> His doctrine, which he wanted to be a realist doctrine, actually was realistic during the period of the religion of science. ... A hundred years later, science encounters relativity, uncertainty and chance. ... The inability of pure Marxism to assimilate these successive discoveries was shared by the bourgeois optimism of Marx's time.[19]

Marx's 'bourgeois optimism' was most clearly expressed in his inaccurate prediction of the inevitability of world revolution; the major capitalist nations simply failed to collapse from within. 'The Russian Revolution remains isolated, living in defiance of its own system, still far from the celestial gates, with an apocalypse to organize. The advent is again postponed.'[20] Camus explained this frankly: 'How could a so-called scientific socialism conflict to such an extent with the facts? The answer is easy: it was not scientific.'[21]

One of Camus's most passionate disputes with Sartre concerned the latter's post-war embrace of Marxism (see the following text) and subsequent attempts to justify the excesses of the Stalinist regime in Soviet Russia. According to Camus, the problem with Stalinism was: 'The demand for justice ends in injustice if it is not primarily based on an ethical justification of justice; without this, crime itself one day becomes a duty.'[22] The Will to Power sweeps away the Marxist utopia, and

> the tragedy of this revolution is the tragedy of nihilism – it confounds itself with the drama of contemporary intelligence which, while claiming to be universal, is only responsible for a series of mutilations to men's minds.[23]

Turning to his own positive views, Camus demands that the rebel must affirm his solidarity with his fellow men:

> But rebellion, in man, is the refusal to be treated as an object, and to be reduced to simple, historical terms. It is the affirmation of a nature common to all men, which eludes the world of power ... man, by rebelling, imposes in his turn a limit to history, and at this limit the promise of a value is born.[24]

The rebel must believe that individual human lives have value, or he cannot justify protesting when those lives are violated. We share a common human nature, in the name of which we rebel and for the sake of which we cannot consistently take innocent human lives.

In 'Thought at the Meridian', Camus concludes that the rebel cannot legitimately murder his fellow men, no matter how noble the cause or necessary to its attainment:

> Logically, one should reply that murder and rebellion are contradictory. If a single master should, in fact, be killed, the rebel, in a certain way, is no longer justified in using the term *community* of men, from which he derived his justification. If this world has no higher meaning, if man is only responsible to man, it suffices for a man to remove a single human being from the society of the living to automatically exclude himself from it.[25]

Many of Camus's post-war political positions stem directly from this argument, including his condemnation of the use of atomic weapons by the United States, of terrorism in Algeria and of capital punishment throughout the world.

In the post-war period, then, Camus sounds remarkably like a classical humanist. Not only does he advocate granting individuals an absolute right to life, but he also embraces the ideal of moderation: 'If, on the other hand, rebellion could found a philosophy it would be a philosophy of limits, of calculated ignorance and of risk. He who does not know everything cannot kill everything.'[26]

Unlike the ideologue, the philosopher must show an appropriate modesty. The excesses of the Modern Age regularly violate a fundamental limit:

> This limit was symbolized by Nemesis, the goddess of moderation and the implacable enemy of the immoderate. A process of thought which wanted to take into account the contemporary contradictions of rebellion should seek inspiration from this goddess.[27]

Camus saw the trade union movement, and its success in dramatically improving working conditions in the post-war world, as the clearest example of the efficacy of moderate rebellion. He advocated gradual, rather than revolutionary, change.

Unfortunately, Camus didn't live to see the (largely peaceful) rebellions of the late 1960s and early 1970s. He might well have enjoyed several films from the period that are sympathetic to rebellion, including those of political filmmaker Constantine Costa-Gavras. *Missing* (1982) is the story of the political radicalization of mainstream American businessman Ed Horman (Jack Lemmon). Horman comes to Chile in search of his missing son, who disappeared during the military coup of 1973. With the clandestine support of the CIA and at least two branches of the US armed forces, popularly elected socialist President Salvador Allende was overthrown by the Chilean military and replaced by right-wing dictator General Augusto Pinochet. The Nixon administration feared another Cuba and was willing to violate international law and facilitate the coup without congressional approval of any kind.

Horman's son Charles (John Shea) was a freelance journalist for a left-wing newspaper, who was living in Santiago with his wife Beth (Sissy Spacek) when the coup occurred. He disappeared just days after its onset. Desperate, she calls Charlie's father, a conservative Christian scientist businessman from New York City, who comes down and joins her in the search. Ed is relatively unconcerned at first, condemning Beth for the 'anti-establishment paranoia' that she shares with his Charlie. It is clear early on that Ed is a member of what Richard Nixon called 'the silent majority', who held their tongues during the Vietnam War and went along with the government and its policies because that is what a patriot is expected to do.

An early exchange between Beth and Ed is especially revealing: he bemoans the fact that Charlie had to 'gallivant all over the world' and 'never got back to the basics':

Beth: And what are the basics? God, country, and Wall Street?
Ed: You know what I mean.
Beth: I know, I know. God bless our way of life!
Ed: Oh, a very good way of life it is, young lady, no matter
 how much people like you and Charles try to tear it down
 with your sloppy idealism. I can no longer abide the
 young people of our country who live off their parents
 and the fat of the land and then they find nothing better
 to do than whine and complain.[28]

Like so many parents at this time, Ed is flummoxed by criticisms of the United States and unwilling to entertain the possibility that his children might be right.

Ed blames Charlie for his disappearance: 'If he'd just settled down where he belongs this would not have happened in the first place.' Then he asks Beth: 'What stupid thing did Charles do to cause his arrest or [force him to] go into hiding?' Much later, an activist named Silvio scorns such naivete: 'You Americans, you always assume you must do something before you are arrested.' Ed continues his tirade against his son: 'Sometimes I honestly think that that boy is incapable of doing anything, except of course give idealistic speeches and write novels that will never be published.' It is clear from his remarks that he doesn't think very highly of either Charles or Beth.

Costa-Gavras's best movies, including *Z*, *State of Siege* and *Missing*, are political thrillers with iconoclastic intentions. They expose governmental corruption, assassination and mass murder for the atrocities that they are. Like *Z*, *Missing* is also an investigative tale, with Ed and Beth relentlessly pursuing the truth of Charlie's disappearance, which is revealed gradually in flashbacks and discoveries. At times, the ambiguity of events is maddening, and Roger Ebert expressed frustration with the director's stylistic excesses in his contemporary review of the film's initial release:

> But he does not show us what happened to make the film's hero disappear. Or, rather, he shows us several versions, visual fantasies in which the young husband is arrested at home by a lot of soldiers, or a few, and is taken away in this way or that. These versions are pegged to the unreliable eyewitness accounts of the people who live across the street. They dramatize an uncertain human fate in a time of upheaval.[29]

Ebert concluded that Costa-Gavras had 'achieved the unhappy feat of upstaging his own movie, losing it in a thicket of visual and editing stunts'.[30] But *Missing* is more than just 'a fancy meditation on the nature of reality'.[31] Its fractured narrative mirrors the process of investigation, as the audience pieces together the confusing mystery along with the protagonists.

Beth and Ed have to make sense out of the conflicting stories from the embassy and from Charlie's friends and neighbours. The

government claims that Charlie wandered off on his own, while neighbours saw him taken away by (an indeterminate number of) soldiers. Flashbacks that reflect individual reports depict differing versions of events, and the two must coordinate these reports while adding evidence from their own investigation. The process undermines the veracity of embassy spokesmen, while highlighting the difficulties of perspectivism that plague any significant investigation.

They finally establish that Charles was visiting the beach resort of Viña del Mar with a friend named Terry (Melanie Mayron) when the coup occurred. He had talked to a former US Navy engineer there (who boasts that the job is done and that they are ready to move on to Bolivia) and to an army officer who warns them to lay low until the coup is over. He and Terry caught a ride back to Santiago with the engineer, and Charlie is arrested the next day. As we subsequently learn, he was taken to the National Stadium, where he was executed three days later.

When Ed meets with the US Embassy officials for the first time, they tell him that Charles is likely to have gone into hiding. Beth scoffs at the notion ('Our whole neighborhood saw him picked up by a goon squad'), but Ed clings to this hopeful possibility. In his second visit to the embassy, Ed says that he knows our agents are involved in a police training program down here and asks them to make use of any contacts they have through this avenue. The embassy denies there is any such program in his third visit. Desperate by this time, Ed pleads that 'I will take Charles back in any condition' and that he has no plans to go to the newspapers or otherwise make a public stink. As he tells someone from the embassy, Christian Science is about faith in truth, and he simply wants them to disclose the truth about what happened, and the whereabouts of the body, so he can bring his son home for a proper burial.

Beth and Ed start searching for Charles in the hospitals (which are inundated by unidentified dead bodies) and the National Stadium. There, they are told that someone from the military was overheard to have said about Charlie that 'The man must disappear, he knows too much.' Ed reaches his breaking point on the way back from hearing this. When a military jeep pulls up next to them, machine gun blazing at some anti-government graffiti artists, he starts yelling at the top of his lungs and slamming his car door against

the jeep, almost getting them killed. Ironically, Beth remembers that Charlie had snapped in similar circumstances. Later, when Ed says that Charlie seemed so innocent, Beth notes that Ed was the one who raised him.

In the most riveting sequence of the film, Ed and Beth visit yet another hospital, which is awash in unidentified dead. There, they find the body of Frank Teruggi, an American friend who the Consulate had told them had safely left the country weeks ago. That night, there is an earthquake, after which Ed admits that he was wrong about both Beth and Charlie:

Ed: This past week I have felt that my heart has been torn out of me.

Beth: It's okay.

Ed: I feel very guilty.

Beth: Hey, Charlie always says guilt is like fear. It's given to us for survival, not destruction.

Ed: Oh, Beth, for what it's worth, I think you are one of the most courageous people I have ever met.

Contacts at the Ford Foundation eventually inform Ed that Charles was killed at the National Stadium three days after his disappearance. The Consulate confirms this is true and reveals that Charlie's body was buried in a wall to cover up his execution. One of them tries to blame the victim for his demise: 'You play with fire, you get burned.' Believing this could not have happened without the embassy approving such a kill order, Ed is beside himself with rage.

His exchange with the ambassador is extremely tense:

Ambassador: We're not involved, Mr Horman. Our position has been completely neutral.

Ed: That is a bald face lie, sir. How can you say a thing like that when you have army colonels, you have naval engineers, they're all over Viña Del Mar!

Ambassador: Please sit down. Look, it's very obvious you're harboring some misconception regarding our role here.

Ed: What is your role here? Besides inducing a regime that murders thousands of human beings?

Ambassador: Let's level with each other, sir. If you hadn't been personally involved in this unfortunate incident, you'd be sitting at home complacent and more or less oblivious to all of this.

Tower: This mission is pledged to protect American interests. There are over three thousand US firms doing business down here. And those are American interests, our interests. In other words, your interests. In short, I am concerned with the preservation of a way of life.

Ed: Well, they're not mine.

Tower: And a damned good one.

Horman's own naive attitudes about 'the American way of life' at the beginning of the ordeal are thrown back in his face, to devastating effect. The utilitarian appeal of the ambassador to what is good for the country as a whole has no purchase with Ed; he now knows the truth, and his attitudes have changed. He asks Beth: 'What kind of world is this?' She replies that he sounded just like Charlie.

As Beth and Ed prepare to board an aeroplane home, the Consul asks them if there is anything more he can do for them:

Consul: Listen, Mr Horman, I wish there was something we could say or do.

Ed: Well, there's something I'm going to do. I'm going to sue you, Phil. And Tower and the Ambassador and everybody who let that boy die. We're going to make it so hot for you you'll wish you were stationed in the Antarctic.

Consul: Well, I guess that's your privilege.

Ed: No, that's my right! I just thank God we live in a country where we can still put people like you in jail.

Even at the end, and despite what he had been through, Ed still had faith in his country and its judicial system. But we are informed in a concluding voice-over that his lawsuit against eleven government officials, including Henry Kissinger, was eventually dismissed because the information needed to corroborate his claims was classified as secrets of State. It turned out that he couldn't put people like them in jail. Moreover, Charlie's body was not returned to the United States until six months later, well beyond the time that a useful autopsy could have been performed.

Michael Wood, in his essay for the Criterion Collection Edition of *Missing*, captures the nature of Ed Horman's rebellion succinctly:

> The hero of *Missing* is a good man who changes his (conformist) politics, or more precisely abandons his old political assumptions, for the sake of justice and what he learns of the truth. Ed Horman doesn't become less American than he was. ... But he recognizes when he is being lied to, and he finds out how little he knows about what his government is doing – what it feels it has the right to do in his name.[32]

The story of the radicalization of Ed Horman had a great impact at the time. One user review of the film on Imdb.com claimed that seeing it when he was seventeen years old had changed his life. Up to that point, he had believed that both his government (in Germany) and the United States were loyal allies of democratic regimes in other countries. He lost that faith in watching this film.[33]

Just like Camus's rebel, Ed Horman reaches his limit in confronting the deception of his government and the likelihood that his son had been killed with at least its tacit consent. He finally says 'No!' to that government, which sanctioned murder in the name of victory in the Cold War, and then denied doing so. The idea of a patriotic American suing his government was unthinkable for most conservatives in the early 1970s. Ed Horman had come a long way in just a few weeks, evidenced as much by his changed opinion of Charlie and Beth as by his newfound suspicion of the Federal government.

Costa-Gavras was renowned for making rebellious movies, beginning with *Z*, an Academy Award winning tale of an investigation of the assassination of a left-wing politician. It caused quite a stir when it was released in 1969, less than six years after the assassination of John F. Kennedy, which was by then awash in conspiracy theories. World filmmaking helped to radicalize a generation of Americans who began the 1960s worshipping John F. Kennedy and who ended the 1970s totally disillusioned with their government and with a disgraced Richard Nixon. Some of those films (like Bertolucci's *1900*) advocated violent revolution, but most, like *Missing*, were concerned mainly with raising the political consciousness of their audiences and stimulating non-violent resistance to governmental policies. Camus would have been pleased.

Questions for discussion

1 The debate between Camus and Sartre over the use of terrorist tactics was mirrored in the split within the Civil Rights movement between Malcolm X and Martin Luther King. Do you think significant social change can be brought about without violence? If it can't, doesn't that mean that, as Sartre argued, revolutionary murder is justified?

2 Have you ever committed a rebellious political act? What do you think of the social protest movements that exist today? It seems that college students are less rebellious now than they were in the late 1960s and early 1970s. If that is so, why is it the case?

3 Do you trust your government? Do you think your legislators are generally trying to promote the greatest happiness for the greatest number? If not, how do they manage to get re-elected so often? What would have to happen for you to be willing to engage in a violent revolution to overthrow your government?

4 What do you think of Camus's total philosophical about face, from his earlier absurdism to his later humanism? Do you think more of him for having evolved into a new position, or less of him for having recanted his earlier claims? Do you agree more with early or late Camus? Why?

Suggestions for further viewing

All the President's Men (1976, Alan J. Pakula) – A riveting account of the Watergate investigation, which brought down a president, and forever altered the image of the US Federal government in the eyes of its average citizens. The importance of a free press to a functioning democracy has never been more vibrantly demonstrated.

Selma (2014, Ava DuVernay) – The story of Martin Luther King's involvement in the three marches on Selma Alabama that helped

reignite the Civil Rights Movement and trigger the passage of the Voting Rights Act of 1965. King is the perfect example of Camus's moderate rebel, refusing to harm others while engaging in non-violent civil disobedience.

Salvador (1986, Oliver Stone) – Gonzo journalist James Woods is in El Salvador, trying to report on the atrocities committed by the military dictatorship that the Reagan Administration supported in the 1980s without getting his head blown off. Director Stone tells an alternative history of America in his political films (e.g. *Wall Street* and *Platoon*) and seeks to raise political consciousness while delivering exciting entertainment.

The Life of David Gale (2003, Alan Parker) – Kevin Spacey plays a man who is so opposed to the death penalty that he puts his own life on the line in order to demonstrate that fatal mistakes can easily be made. Gale says 'no' to executions in the name of the dignity of each and every human life, a sentiment of which Camus would approve.

CHAPTER NINE

Sartrean Romantic Pessimism in *Husbands and Wives*

Sometimes, if rarely, a director will signal the audience about what philosophical perspective they ought to take on a particular film. Woody Allen, who was an undergraduate philosophy major at New York University, does so near the beginning of *Husbands and Wives* (1992), when Mia Farrow puts a book on the shelf with

Sartre's name prominently displayed on its cover. Later, one of the major characters sheepishly admits that his aerobics instructor girlfriend 'isn't Simone de Beauvoir' (Sartre's lifelong companion and fellow philosopher). Woody cues us in on what he is doing here, so it is not surprising that his film parallels Sartre's pessimistic view of romantic love (as articulated in *Being and Nothingness*) in remarkable detail.

In many ways, Jean-Paul Sartre's version of existentialism must be understood in contrast to Martin Heidegger's *Being and Time*. While Heidegger was most influenced by German philosophers Friedrich Nietzsche and Edmund Husserl, Sartre's work forever bears the mark of its Hegelian roots. G.W.F. Hegel's influential analysis of consciousness is based on his brilliant distinction between being-in-itself and being-for-itself, which is also at the heart of Sartre's analysis of human existence.

For Hegel, the in-itself refers to the brute facts of the objective world: things that are what they are in themselves and cannot change (though we can transform them for our use). But human consciousness exists for-itself, which means we are self-aware. Self-awareness opens a world of possibilities to us. As both subjects and objects of our awareness, we can transcend who we have been thus far for the sake of who we want to be in the future. To say that we also exist as being-for-others means that we seek their recognition of us and need it for our own sense of identity and self-worth.

Hegel's other most significant contribution to the history of philosophy is what has come to be called the 'master–slave' dialectic. One of the most primitive and fundamental ways of seeking recognition from others is by compelling them to give it to us. Hence, the most basic of all human relationships is that of master to slave, of a dominant party lording it over a submissive one. Hegel saw this as a tendency that would be overcome in later stages of the development of consciousness, as thesis clashed with antithesis leading to a progressive synthesis. But Sartre was less hopeful about the possibilities of ever doing so, at least in his early philosophical works.

In *Being and Nothingness*, Sartre describes the human condition as perfectly free, more radically so than any other existentialist philosopher, since he denies the existence of any internal self to which one must be true. Yet he also identifies tendencies in human consciousness and behaviour that play out in strikingly similar

ways, over and over again, in seemingly unavoidable patterns of what he calls 'bad faith'.

To begin with his theory of human freedom, Sartre contends that, as being-for-itself (i.e. self-conscious beings), we can, within reasonable limits, break with our pasts and redefine ourselves whenever and however we wish to do so. As being-in-itself, we are limited by what Sartre calls our facticity (e.g. our genetic, cultural and economic heritage over which we have little control), but within those limits there are always alternatives from which to choose. Freedom is the ground of our being, and Sartre's remark on the meaning of this freedom is an early clue to his radical revisionism:

> If freedom is the being of consciousness, consciousness ought to exist as consciousness of freedom. What form does this consciousness of freedom assume? In freedom the human being is his own past (as also his own future) in the form of nihilation.[1]

The essence of freedom lies in our ability to 'nihilate' the past, that is, to negate and overcome its tendencies and motives in favour of an alternative vision of the future. This is what allows at least some of us to change course in midstream.

Humans are in the paradoxical position of being neither their pasts nor their futures:

> We are not what we have been in the past, because it cannot determine our future choices. But a nothingness has slipped into the heart of this relation: because I am not the self which I will be [either].[2]

Hence, human consciousness is not what it is (i.e. has been) and is what it is not (yet). As Sartre strikingly puts it: 'Consciousness is a being the nature of which is to be conscious of the nothing-ness of its being.'[3]

Like Heidegger, Sartre believed that human existence precedes essence, which means that we define ourselves through our individual choices and actions. Heidegger placed additional constraints on this notion, however. For him, we can get these choices right or wrong. If we heed the call of conscience, and are true to ourselves, we are authentic beings in the process of realizing

our most fundamental projects. If we attend to the conventional voices of the 'they' self, or depart from who we are for any other reason, we are inauthentic.

At first, Sartre seems to adopt a similar view. He spends a great deal of time tracing out patterns of what he calls 'bad faith', which initially sound like a catalogue of the various ways of being inauthentic, of the lies that we tell ourselves about ourselves: 'A man does not lie about what he is ignorant of; he does not lie when he spreads an error of which he himself is a dupe; he does not lie when he is mistaken.'[4] This implies that persons in bad faith know what they are evading and how they are evading it: 'In bad faith it is from myself that I am hiding the truth. Thus the duality of the deceiver and the deceived does not exist here.'[5] Freudian psychoanalysis tries to preserve this duality by positing an unconscious super-ego which does the deceiving, but Sartre considered Freud's psychological determinism to be the worst kind of bad faith, because it totally denies our individual responsibility for our actions.

One might assume, then, that being in good faith means refusing to deceive oneself. But no: 'It appears that I must be in good faith, at least to the extent that I am conscious of my bad faith. But then the whole psychic system is annihilated.'[6] It turns out that, for Sartre, there is no internal self to which to be true; indeed, if there were, our internal essence would precede our existence, and our choices could never be truly free:

> If man is what he is, bad faith is forever impossible and candor ceases to be his ideal and becomes instead his being. But is man what he is? And, more generally, how can he be what he is when he exists as consciousness of being?[7]

As being-for-itself, human consciousness can always transcend itself towards new possibilities (unlike the in-itself, which forever must be what it is). For Heidegger, the authentic person is sincerely true to himself. But for Sartre:

> Under these conditions what can be the significance of the ideal of sincerity except as *a task that cannot be achieved*, of which the very meaning is in contradiction with the structure of my consciousness.[8]

It is impossible to be sincere if there is no internal self to which we can be true: 'Bad faith is possible only because sincerity is conscious of missing its goal inevitably, due to its very nature.'[9]

Good faith would require an internal being-in-itself that issued something like the 'call of conscience' (as Heidegger termed it) to resolutely pursue one's fundamental project unto death: 'Good faith seeks to flee the inner disintegration of my being in the direction of the in-itself which it should be and is not.'[10] So it turns out that good faith is simply a deeper form of self-deception.

As Max Stirner first hinted at a century earlier, each of us constitutes our own world, by freely choosing what we value: 'Now we can ascertain more exactly what is the being of the self: it is value ... human reality is that by which value arrives in the world.'[11] We must sustain, and act, on such values over time without any internal or external essence to which we can appeal: 'It is not then through inauthenticity that human reality loses itself in the world.'[12] Sartre later uses a term that becomes central to Albert Camus's early philosophy to describe the nature of these choices:

> Such a choice made without basis or support and dictating its own causes to itself, can very well appear absurd, and in fact it is absurd. This is because freedom is a *choice* of its being but not the foundation of its being.[13]

Sartre's groundbreaking analysis of the search for recognition by consciousness (as a nothing that wants to be something) begins with his phenomenology of 'the Look' of the other. As existing 'for-itself', consciousness recognizes itself as a subject capable of change. But, as a being-for-others, we are the objects of their gaze. In seeking their recognition, we tend to shift our focus from free self-awareness to concern for how they perceive us: 'By the mere appearance of the Other, I am put in the position of passing judgment on myself as on an object, for it is as an object that I appear to the Other.'[14] It is because other people are constantly trying to categorize us (by shoving us into neat little boxes) that their gaze sucks the life out of us, turning living subjects into calcified objects.

One of Sartre's most famous examples of bad faith is the waiter, fulfilling our expectations of the role he is supposed to play and earning a healthy tip in the process. Like the waiter, we are all engaged in playing various roles, which are designed to get us

what we want. For Sartre, then, shame is the most fundamental phenomenon, and not guilt: 'Thus shame is the shame *of oneself before the Other*, these two structures are inseparable. But at the same time I need the Other to realize fully all the structures of my being.'[15]

Sartre acknowledges this need for the other in a way that neither Nietzsche nor Heidegger ever did. These latter figures make it sound like we can (and should) become totally unconcerned with what others think of us. But Sartre contends that the recognition of others is rightfully needed to validate our self concepts, and most of us are willing to pay the price of shame in order to gain it.

The price is high: 'With the Other's look the "situation" escapes me. ... I am *no longer master of the situation*.'[16] The risks of relinquishing mastery are great:

> Thus the Other-as-object is an explosive instrument which I handle with care because I foresee the permanent possibility that they are going to make it explode and that with this explosion I shall suddenly experience the flight of the world away from me and the alienation of my being.[17]

We always know, in what Sartre calls a pre-reflective sense, that those whom we care about can withdraw their love in a moment and blow up our world in the process.

Hence, there is an excruciating tension at the heart of all being-for-others. On the one hand, we need their recognition of us (as persons with valued or beloved qualities) to feel that we are of worth. On the other hand, they inevitably objectify us, trying to reduce us to the stability of mere things in order to maximize their control over the situation. In the eyes of even my friends and loved ones, I am a Scots-Irishman, a heteronormative sexist, a Scorpio, a good father and/or a liberal, and that's all there is to it.

This dynamic becomes particularly vicious in the arena of romantic love. Love is not love if it is not freely given, so we want recognition from an autonomous person who could be other than he or she is at this point in their life. But we also want to rest secure in the belief that such recognition is permanent and lasting. Hence, we tend to objectify others so that we can rely on them as fixed constants. We want to possess them, and their recognition of us.

'She would never leave me', I kid myself, by reducing my beloved to an inert object whose recognition is as reliable as the solidity of a stone. The comparison is particularly apt, because:

The Other, by rising up, confers on the for-itself a being-in-itself-in-the-midst-of-the-world as a thing among things. This petrifaction in the in-itself by the Other's look is the profound meaning of the myth of Medusa [the Greek monster whose gaze could turn mortals to stone].[18]

We have all come under the withering gaze of a judgemental significant other, so we know what Sartre is talking about.

From Sartre's perspective, then, romantic love pursues a beautiful but unattainable ideal:

The experience of the 'we' remains on the ground of individual psychology and remains a simple symbol of the longed-for unity of transcendences, [when] I apprehend through the world that I form a part of 'we'.[19]

In this connection, he even alludes to the idyllic image in Plato's *Symposium* of two halves separated by the jealous Greek Gods coming together again to form a whole.

But romantic love also involves physical desire, which complicates matters even further. We want to possess the Other's body, to incarnate him or her as an attractive object for our use. In the process, we seek incarnation ourselves, as desirable physical bodies:

It is certain that I want to *possess* the Other's body, but I want to possess it in so far as it is itself 'possessed'; that is, in so far as the Other's consciousness is identified with his body. Such is the impossible ideal of desire: to possess the Other's transcendence as pure transcendence and at the same time as body.[20]

Caught in this insoluble dilemma, monogamous romantic love is doomed to failure.

What this search for recognition most often comes down to is a sado-masochistic struggle for power and dominance, the outcome

of which is determined by who most successfully objectifies the other, and who is more comfortable being objectified. Ironies abound here, for as soon as one objectifies another to an extent sufficient to feel truly secure in their love, one often loses the feeling of being recognized by a free for-itself and desire wanes. When one partner becomes too dominant, the passion dies, but if there is no clearly dominant partner the two are likely to tear each other apart emotionally.

Sander Lee, who has written extensively on the philosophical content of the films of Woody Allen, identifies three reasons why, according to Sartre, love is doomed to failure: (1) 'the choice to love is an unreflective attempt to become just what consciousness knows in fact that it is not – a unified whole with the other'; (2) the magic spell of love is very fragile … hence the lover is tormented by 'perpetual insecurity' which itself leads to love's destruction and (3) 'love is constantly threatened by the look of a third person'.[21]

Sartre's pessimistic (realistic?) account of caring romantic relationships goes hand in hand with his attack on Heidegger's analysis of being-towards-death. One must remember that, for Heidegger, authentic awareness of our own impending deaths helps trigger the call of conscience, making it more likely that we will become who we are and act with concern for what really matters to us. For Sartre, by contrast, there is no privileged state of consciousness that can call us to be true to the nothing that we are, *especially* not our awareness of death:

> What must be noted first is the absurd character of death. In this sense every attempt to consider it as a resolved chord at the end of a melody must be sternly rejected. … We ought rather to compare ourselves to a man condemned to death who is bravely preparing himself for the ultimate penalty, who is doing everything possible to make a good showing on the scaffold, and who meanwhile is carried off by a flu epidemic.[22]

Sartre's ironic imagery drains the nobility from the process and suggests that death is simply an absurd and meaningless fate we all have to face.

He then proceeds to rationally deconstruct Heidegger's account, beginning with the claim that death is uniquely mine and that no one can die for me. While he admits this is true, Sartre protests that

'*none of my possibilities* taken from this point of view ... can be projected by anyone other than me'.[23] *All* of my potentialities are uniquely mine, and not just my being-towards-death, which hence has no *particular* significance in this regard.

Furthermore, 'Since death does not appear on the foundation of our freedom, it can only *remove all meaning from life*.'[24] Death forecloses all of our possibilities; we no longer have a future from which to derive meaning. It

> destroys all projects and destroys itself, the impossible destruction of my expectations. It is also the triumph of the point of view of the Other over the point of view *which* I am toward myself.[25]

We exist after our deaths only in what others say and think about us, and 'thousands of shimmering, iridescent relative meanings can come into play upon this fundamental absurdity of a "dead" life'.[26] Hence, 'the unique characteristic of a dead life is that it is a life of which the Other makes himself the guardian'.[27] This is why being remembered fondly by our loved ones is so important to us.

But we may end up being forgotten, which, as Sartre describes it, amounts to being 'resolutely apprehended forever as one element dissolved into a mass'.[28] He continues:

> The very existence of death alienates us wholly in our own life to the advantage of the Other. To be dead is to be a prey for the living. This means therefore that the one who tries to grasp the meaning of his future death must discover himself as the future prey of others. We have here therefore a case of alienation.[29]

Rather than providing us with consoling insights into who we are, being-towards-death brings home to us the stark fact that it will eventually 'give the final victory to the point of view of the Other'.[30] Alienation, not authenticity, results from contemplating our own deaths too deeply.

What emerges, then, from this close reading of excerpts from *Being and Nothingness* is a considerably bleaker world view than we saw in Heidegger. Yes, we are our prospective futures, but only in the mode of not yet having realized them. Yes, we care for others, but our concern is as likely to prompt us to objectify our loved ones and use them to satisfy our desires as it is to move us to recognize

their freedom and help promote their fundamental projects. Yes, we are free to choose to define ourselves through action as we like, but there are no guideposts (either external or internal) to how (or even if) we can get it right or wrong. We are fundamentally temporal beings, but our temporality reveals us to be a nothingness at the heart of being. For early Sartre, as for early Camus, human existence is absurd.

Woody Allen's depiction of romantic relationships in *Husbands and Wives* shares this absurd quality, and many other elements of Sartre's theory. He takes a quasi-documentary approach here that involves a lot of hand-held camera shots, and filmed interviews with the main characters, which are conducted by an anonymous questioner. This gives the film a highly realistic aura, as if it's telling it like it is about the heartbreaks of romantic love. It also announces that this is one of Woody's 'serious' films, which are not to be taken lightly.

Husbands and Wives begins when Jack (Sidney Pollack) and Sally (Judy Davis) show up late for a dinner date with Gabe (Woody) and Judy (Mia Farrow, with whom Allen was then involved) and blithely announce their intention to separate. Determined to take this significant event in stride, they insist they are fine, that their break-up is amicable and that they still want to go out to dinner. But Gabe and Judy are flabbergasted, with Gabe registering his disbelief and Judy protesting that she is 'just shattered' by the news. They go to dinner nonetheless, and while the other three seem to get by it, it is clear that Judy remains upset.

Ostensibly, Judy is appalled because (as she put it shortly thereafter) 'They were so casual about it. ... They didn't seem to be appropriately upset'. Indeed, as Jack and Sally eventually acknowledge, their protests that it was 'no big deal' were disingenuous; to put it in Sartrean terms, they were clearly in bad faith about their decision. They each had their own selfish motives. Jack admitted to his boss that 'Sally was cold' and that he lusted after his aerobics instructor. Sally, who was not orgasmic with Jack, sought adventure and wondered (as so many married people do) what it would be like to be single again, knowing what she knows now.

Later, Judy admits that she was so upset by the break-up of her good friends because it raised the possibility that her own marriage could dissolve. 'You think we'd ever break up?', she asks Gabe after

their friends have gone home. He insists that he isn't planning on doing so and asks if she is (which she denies). But the seeds of doubt have clearly been planted.

Judy always found Gabe to be too judgemental; she does not show him her poetry for fear that, as a professor of creative writing, he would deride her work. What's more, Gabe has resolutely refused to fulfil her desire for another child. Feeling that her needs are not being met (in what Sartre calls a pre-reflective fashion), she has long been dissatisfied, but it took confronting the separation of Jack and Sally to shock her into recognizing it.

Judy isn't the only one who is unhappy. Although Judy tells him his novel is good, Gabe is unmoved and continues to be critical of it, and of himself. He apparently puts little stock in her opinion, a condescending attitude to take towards one's spouse. Yet he allows one of his most promising students to read it and basks in her praise. Rain (Juliette Lewis) is a prolific writer who worships Gabe as her mentor. While Gabe admits that he finds her attractive, he protests that he has never had an affair with a student. He disdains his colleagues who do so and proudly declares that he has never been unfaithful to Judy at any time in their relationship.

Not that his romantic choices have always been so responsible. The love of his life before his marriage to Judy was Harriet Harmon, and she was the most passionate woman he ever met. She had a ravenous sexual appetite, and they did it in all sorts of ways and locations. Yet ultimately she ended up in an institution. Gabe acknowledges his morbid fascination for such women:

> I've always had this penchant for what I call 'kamikaze women.' I call them kamikazes because they crash their plane into you, and you die with them. As soon as there's little chance of it working out ... something clicks in my mind. Maybe because I'm a writer. A dramatic or aesthetic component becomes right ... and I go after that person. There's a certain dramatic ambience that's almost as if I fall in love with the situation. Of course, it has not worked out well for me.

He is aware that this tendency is dangerous, and Jack tells us that choosing to marry Judy broke Gabe's usual pattern of loving self-destructive women.

It soon becomes clear that Sally and Jack are deeply ambivalent about their separation. Within three weeks after the break-up, Jack had moved in with Sam (Lysette Anthony), his strikingly attractive (and much younger) aerobics instructor. When Sally finds out, she is livid, and accuses him of having started the affair before they split up. Her anger ruins her date for dinner and the opera with a new man.

When Gabe calls Sam 'a cocktail waitress', and asks how he can leave Sally for this airhead, Jack defends his new girlfriend: 'She's warm and she's nice and I can relax around her. Sally was hyper. You know that. She's great, but she's cold and difficult.' With Sam he can hang out at home, watch a silly movie and dress sloppily. He claims he wants passion, not intellect: 'Big deal. So she's not Simone de Beauvoir. I want somebody who screams when I fuck her.' But he is protesting too vehemently to be taken as sincere, and he never acknowledges that what is really going on is that he is enjoying dominating someone else for a change.

So Jack seems content, until he hears at a party of his friends that Sally is seeing Michael (Liam Neeson), a handsome book editor who works with Judy. Shook up, he goes over to talk to Sam, who is defending the objective truth of astrology. Embarrassed, and having second thoughts about leaving Sally, Jack drags Sam out of there and instigates a terrible fight on the street outside, deriding her for talking about 'This bullshit astrology. It's stupid'. He drives directly over to his old residence, leaves Sam out in the car and barges in on Sally and Michael. Seeing them together, he dramatically pleads with her to come back to him, but in vain.

When Sally and Michael seem to hit it off, Judy realizes she cares for him herself and wonders why she ever set them up. Here, she was the one in bad faith, unwilling to recognize until then what she knew pre-reflectively all along, and finally admitting to herself that she wants to leave Gabe in part because of her attraction to Michael. When Sally (whose sexual repression still renders her incapable of reaching orgasm) breaks up with Michael and returns to Jack, Michael is crushed and Judy swoops in for the kill.

Jack and Sally reunite, and join Gabe and Judy for another dinner. The reunited couple mouth the usual clichés: 'You can't just wipe out years of closeness. ... Everybody screws up. The question is ... do you learn from it? I think the true test is how you weather a crisis.' This triggers a climactic confrontation between Gabe and Judy back at their house.

He asks why she did not show him her poetry, and Judy responds that he is too critical. She tells him she has returned to therapy, and he scoffs. She criticizes him for flirting, and he denies doing so. He contends that 'change is death', while she protests that 'Life is made of change. If you don't change, you shrivel up', as she clearly feels she has. Several days later, he moves into a hotel.

Gabe develops a personal relationship with Rain and is invited over to her parents' midtown apartment for her birthday party. He knows of her penchant for older men, having met her disgruntled therapist (and former lover) outside her apartment. Gabe gives her a charming music box as a present, and she asks for another, a passionate kiss. After some hesitation, they share one in the midst of a violent thunderstorm and power outage, and the electricity between them is palpable. But Gabe immediately says they should not pursue that magical feeling any further, and, disappointed, Rain reluctantly agrees.

Now, it may appear at this point that Gabe has acted in good faith by refusing, with good reason, to enter that magical realm with a woman less than half his age. He had resolved to stop pursuing the 'kamikaze women' that have attracted him so much in the past and decides to continue his break with that pattern of behaviour. But he is regretful almost immediately:

> And I left and I walked out into the pouring rain. I just headed instinctively back to my apartment ... because I wanted to hold Judy and kiss her ... and say things to her, and then ... then I realized that, you know, I really blew it.

It is not clear whether he is referring to alienating Judy by flirting with a student or to his decision not to follow up on the romantic possibilities with Rain (or both).

The film jumps ahead a year and a half and ends with a series of revealing 'exit interviews' with the principal characters, as they respond to questions from off camera. Judy speaks for both her and Michael in declaring that they are happy. Despite an early fight, where Michael criticized Judy for coming on too strong, Michael protests that he was the one that pursued her most vigorously, and not vice versa (she demurs that she 'wanted it to work' but that she hoped she didn't push). Judy has assumed a clearly dominant position, and Michael is comfortable rewriting history to submit to her dictates.

Judy's bad faith is confirmed when the film returns to a shot of her first husband, who repeats his earlier description of her as a 'passive aggressive' person who always gets what she wants. After a brief period of rebellion, Michael has clearly submitted himself to a dominance which she could not achieve over Gabe. One can easily conclude that this was what Judy wanted in the first place, a man that she could lord it over so thoroughly.

Jack and Sally continue to utter platitudes in their final interview:

> We've learned to ... tolerate our problems more. Don't you think? I've learned, anyway, that love is not about passion and romance necessarily. It's also about companionship and ... it's like a buffer against loneliness, I think. That stuff is important. Somebody to grow old with. What kills most people is unreal expectations.

But things aren't all that great with them: there are still 'things that can't be talked about. Like sexual problems, for instance'. They admit that these problems remain unresolved:

> Jack: Well, there's some things you can't solve and then you have to live with it. You construct some kind of patchwork thing.
> Sally: But sometimes they flare up.
> Jack: They do, and when it happens ... it gets tough when that happens. You learn to deal with it and then push it under the rug. And it works. That's the weird thing. It's not bad.

Learning to push things under the rug is the functional definition of bad faith. One is left wondering how long their compromises will last.

Gabe is granted the last word, ending the film on a dark note. 'I'm out of the race for now. I don't want to get involved. I don't want to hurt anyone. I don't want to get hurt. I don't mind living by myself and working. It's temporary. I'll have the urge to get back into the swing of things'. We learn that he has abandoned his old novel and is writing a new one that is 'less confessional, more political'. He is profoundly uncomfortable talking about this: 'Can I go? Is this over?' are his final queries.

All of the major characters remain mired in bad faith throughout. Jack chafed at being judged and controlled, and got involved with

a younger woman who was much more accepting and sensual. But he resubmitted himself to Sally's dominance as soon as he feared he was losing her to Michael. Sally thought she could leave all the problems of her marriage behind, but she was still over-reflective and unable to incarnate herself as flesh with Michael. The original couple reunites for fear of loneliness in old age, sweeping their sexual frustrations and inability to relax around one another under the rug. They murmur the old saw that it is a matter of lowering one's expectations, the same conclusion Gabe's autobiographical character comes to at the end of his original novel (which had so deeply disappointed Rain).

Michael comes off as a weak-willed individual who willingly submits, first to Sally and then to Judy. After he takes Sally to see Mahler, she is critical of both the symphony and his driving, for which he is immediately apologetic. When they make love, he wonders why he lost her in the middle but then protests that the experience was beautiful (while she laments the fact that they did not orgasm simultaneously). Despite telling Judy he feels emotionally smothered by her, he gives in after she stalks out of his apartment into the rain. A year and a half later, Judy is speaking for the both of them, while he protests that he is the one with the hard-to-tolerate idiosyncrasies and who actively pursued Judy (and not the other way around).

Judy is an archetype of the passive-aggressive personality. She runs away from recognizing what she really wants or feels, but that just means, according to Sartre, that she really did know pre-reflectively but didn't have the guts to confront herself. Freudians would say that Judy wasn't conscious of wanting Michael, and set him up with Sally for that reason. But Sartre would insist that Judy knew what she wanted, but chose to look away for a time. Besides, as her first husband observed, she always got what she wanted eventually (first him, then Gabe and now Michael).

For me, Gabe is the most enigmatic figure of the bunch. I am unsure at the end what he feels about Judy, or Rain, or the break-up of his marriage, aside from the fact that he 'is not in the game' at this time. As noted earlier, when he says 'I really blew it', it is hard to tell which choice he regrets more (or perhaps he regrets both equally). He chose to dally with his student, distracting himself from recognizing the problems in his marriage and dealing with them. He also chose to resist his impulse to dive into a romantic

relationship with Rain, foregoing all the possibilities for both magical and devastating emotion which it held. Rather than looking noble, Gabe looks foolish for having neglected his marriage for a dalliance that he fails to carry through on.

Husbands and Wives, then, ends as pessimistically as any of Woody Allen's serious films, which is only appropriate if, as I suspect, it was scripted specifically with Sartre in mind. The couple whose marriage survives is seen to reunite out of fear rather than love. The newly married couple are together to satisfy their respective needs to dominate and to be dominated. Woody's character has isolated himself from caring for others and can only console himself by mouthing such platitudes as 'Its temporary' and 'I'll have the urge to get back into the swing of things'. Most disturbingly, none of these people seem to have learned much from these 'explosions', and they have made little progress in answering the question that the theme music at the beginning and the end of the film poses, 'What is this thing called love?'.

Questions for discussion

1 What do you think would have happened if Gabe had pursued a romantic relationship with Rain? Did he do the right thing by drawing back? Why are there so many May-December relationships in movies between a young woman and a much older man? Why are the roles so seldom reversed, and what does this tell us about cultural attitudes?

2 Would you call yourself an optimist, a pessimist or neutral about the notion of romantic love? Have you ever really been in love, and is it worth the pain and vulnerability? If it didn't work out, was it because of some of the problems Sartre highlights in his theories?

3 While Sartre admits that we need to be acknowledged by others to have a sense of self-worth, Heidegger and Nietzsche claim that pride must come from within an autonomous self. On which side of the controversy do you find your own attitudes, and, if you think it is both, which is more important, self-recognition or the recognition of others?

4 What do you think about Sartre's claim that we always know how we feel and what we want but that often we simply choose to look away and not acknowledge this? Do you put any stock in the notion of unconscious motivations that can cause us to act in the ways we do? Why or why not?

Suggestions for further viewing

Bad Timing/A Sensuous Obsession (1980, Nicholas Roeg) – A deeply troubled woman gets involved with a psychiatrist and engages in some disturbingly self-destructive behaviour. A highly critical view of psychiatry is coupled with a searing portrait of a romantic relationship gone hopelessly awry.

War of the Roses (1989, Danny DeVito) – Marriage as trench warfare, as Kathleen Turner and Michael Douglas fight it out for control within their marriage and over what will happen to their property after they are divorced. The humour is cutting and helps cushion how close to the truth the film gets.

Closer (2004, Mike Nichols) – Roger Ebert summarizes it best:

> *Closer* is a movie about four people who richly deserve one another. Fascinated by the game of love, seduced by seduction itself, they play at sincere, truthful relationships which are lies in almost every respect, except their desire to sleep with each other. All four are smart and ferociously articulate, adept at seeming forthright and sincere even in their most shameless deceptions.[31]

Dangerous Liaisons (1988, Stephen Frears) – Romance as power struggle, sometimes to the death. Aristocrats in eighteenth-century France fight a no-holds-barred war between the sexes, where seduction is a game to be bet on, and the stakes get higher and higher.

Sartre and the Justice of Violent Rebellion in *Michael Collins*

Like Albert Camus, Jean-Paul Sartre's philosophy and public stands on issues evolved dramatically after the Second World War. Their debates over terrorist attacks on civilians by the liberation movement in Algeria, and the policies and principles of the Soviet Union, galvanized the French nation in the 1950s. Sartre published his lengthy treatise on Marxism and existentialism, *Critique of*

Dialectical Reason, in 1960. 'Search for a Method' was the two-part introduction to that tome, and it was so much more accessible than the main work that it was soon published separately in its own right. This chapter will summarize that introduction and highlight parallels between Sartre's later philosophy and writer-director Neil Jordan's historical epic *Michael Collins* (1996), relating Sartre's justification of violent revolution to the post–First World War fight for Irish independence.

Unlike Camus, Sartre never hinted that he was abandoning existentialism for essentialism, but rather sought to formulate an existentialist version of Marxism that shared features with both movements. He announces this synthesis early on by reconceiving the very nature of philosophy itself along Marxist lines: 'A philosophy is first of all a particular way in which the arising class becomes conscious of itself. This consciousness may be clear or confused, indirect or direct.'[1] As existentialists had long observed, philosophies are never timeless; they pass into and out of existence as historical conditions change.

In expressing the world view of the rising class,

> The philosopher effects the unification of everything that is known, following certain guiding schemata which express the attitudes and techniques of the rising class regarding its own period and the world. Later ... the details of this Knowledge have been, one by one, challenged and destroyed by the advance of learning.[2]

Marxism is the world view of the rising proletariat class of the twentieth century, not, as Marx and Engels believed, an expression of timeless truths about human nature.

Marx is justly famed for his critique of capitalist ideology as distorting our view of reality in the interest of the ruling class. But Sartre considers both Marxism and existentialism to be ideologies in their own right (it is strange to see Kierkegaard described as an ideologist). Indeed, Descartes and Locke, Kant and Hegel are all thrown into this category as well:

> These *relative* men I propose to call 'ideologists'. And since I am to speak of existentialism, let it be understood that I take it to be an 'ideology'. It is a parasitical system living on the margin

of Knowledge, which at first it opposed but into which today it seeks to be integrated.[3]

All essentialists are ideologues, in that they claim to be in possession of timeless truths that simply don't exist. But existentialists are ideologues as well – it is all ideology (or, as Nietzsche put it, rhetoric). Early on in Part One of *Search for a Method*, Sartre's embrace of Marx's philosophy seems complete (and he briefly sounds like just another essentialist):

> It is Marx with whom we claim kinship … a philosophy transforms the structures of Knowledge, stimulates ideas; even when it defines the practical perspectives of an exploited class, it polarizes the culture of the ruling classes and changes it. Marx wrote that the ideas of the dominant class are the dominant ideas. He is *absolutely* right.[4]

But Sartre takes Marxism to be the appropriate philosophy *for the moment*, and not for all time:

> As soon as there will exist *for everyone* a margin of *real* freedom beyond the production of life, Marxism will have lived out its span; a philosophy of freedom will take its place. But we have no means, no intellectual instrument, no concrete experience which would allow us to conceive of this freedom or of this philosophy.[5]

In the meantime, Marxism provides both a practical guide to action and a liberating and holistic vision of the future:

> The fruitfulness of living Marxism stemmed in part from its way of approaching experience. Marx was convinced that facts are never isolated appearances, that if they come into being together, it is always within the higher unity of a whole, that they are bound to each other by internal relations, and that the presence of one profoundly modifies the nature of the other.[6]

As we have seen earlier, Sartre's philosophy shares its Hegelian roots with Marx.

As a version of left-wing Hegelianism, Marxism was one of the first philosophies to try to make sense of human history. By

1960, Sartre had become critical of the excesses of Stalin and his successors, and of the notion that whatever means that are historically necessary to overthrow capitalism are justified. He found the Russian invasion of Hungary in 1956, and their brutal repression of their own people, to be totally unacceptable, and backed away from their practices:

> But what has made the force and richness of Marxism is the fact that it has been the most radical attempt to clarify the historical process in its totality. For the last twenty years, on the contrary, its shadow has obscured history; this is because it has ceased to live *with history* and because it attempts, through a bureaucratic conservatism, to reduce change to identity.[7]

Still, in Sartre's view, some of the fundamental principles of Marxism are (pun intended) right on the money:

> To be still more explicit, we support unreservedly that formulation in *Capital* by which Marx means to define his 'materialism': 'The mode of production of material life generally dominates the development of social, political, and intellectual life'. We cannot conceive of this conditioning in any form except that of a dialectical movement (contradictions, surpassing, totalisations).[8]

In light of his agreement with so many of the fundamental tenets of Marxist philosophy, Sartre asks the next logical question: 'Why then has "existentialism" preserved its autonomy? Why has it not simply dissolved in Marxism?'[9]

For one thing, Sartre always had trouble with Marx's economic determinism, which contradicts the existentialist insistence that individual human freedom still exists, no matter how restrictive the society is in which one lives. Marx thought that man would be free only upon attainment of the worldwide classless society. Sartre and de Beauvoir concluded that both Freudian psychoanalysis and Marxism were uniquely modern forms of bad faith, ways of avoiding individual responsibility for one's actions, which exists at all times and in all places. Furthermore, Sartre never bought into the utopian aspect of Marx's thought – in his view, no human society, not even a classless one, will ever be able to reconcile its tensions so completely.

Most fundamentally, from a philosophical point of view, Sartre disagreed with the claim that Marx had discovered a set of timeless truths which, if acted upon, will end history and its contradictions. *All* philosophies are temporally relative; they rise and fall with the dynamics of history:

> Thus a philosophy remains efficacious so long as the praxis which has engendered it, which supports it, and which is clarified by it, is still alive. But it is transformed, it loses its uniqueness, it is stripped of its original, dated content to the extent that it gradually impregnates the masses so as to become in and through them a collective instrument of emancipation.[10]

Still, Sartre found Marxism to be a convincing perspective from which to justify the use of violence by the revolutionary movements that he supported around the world. His intention, as he put it, was 'not to reject Marxism in the name of a third path or of an idealist humanism [as he believed Camus had done], but to reconquer man within Marxism'.[11] Sartre continued to speak in unequivocally Marxist terms right up until his death:

> All revolutionaries understand today that there is no way to overthrow modern society except by violence, for the very good reason that this society defends itself with repression and violence. I am defending a revolutionary cause, because my personal goal, as it is for everyone here, is the overthrow of bourgeois society.[12]

Sartre consistently supported the use of terrorist attacks on civilians, in Algeria, at the Munich Olympics, and in Vietnam. As one commentator observed:

> He famously supported the Palestinian 'Black September' group that kidnapped, and was responsible for the deaths of, members of the Israeli Olympic team at the Munich Olympics in a 1972 piece in *La Cause du peuple*. In that short article, Sartre says that the group has no other alternatives and that 'the principle of terrorism is that one must kill'.[13]

Sartre himself described Algerian rebels as 'Sons of violence. At every instance they draw their humanity from it'.[14] But, Camus

would ask, how they can 'draw their humanity' from political murder?

In his preface to Franz Fanon's *The Wretched of the Earth*, Sartre provides the explanation:

> Make no mistake about it; by this mad fury, by this bitterness and spleen, by their ever-present desire to kill us, by the permanent tensing of powerful muscles which are afraid to relax, they [the revolutionaries of the third world] have become men: men because of the settler, who wants to make beasts of burden of them – because of him, and against him.[15]

Sartre mocked liberals like Camus, who stood aghast in the face of terrorism. Sartre sought to inspire a sense of personal responsibility for the plight of the African people in each member of the French populace. But he was criticized for seeming to absolve terrorists from guilt, by blaming their heinous acts on their oppressors.

He eventually became more circumspect about his radicalism. In a series of lectures he gave in Rome in 1964, Sartre stated that terror 'must not become a system itself' but must remain a 'provisional expedient'.[16] According to Marguerite La Caze (citing passages from his *Notebooks for an Ethics*), Sartre eventually came to question his support of terrorism.[17] Though they were unpublished during his lifetime (perhaps because they contradicted his public pronouncements so often), he concluded in the *Notebooks*

> that violence is 'unproductive' and that terrorist violence is 'a dead end, the unique and individual discovery by a subject of his free subjectivity in tragedy and death. This is an experience that can benefit no one'.[18]

Though Michael Collins limited his campaign of bombings and targeted assassinations to persons he considered to be combatants, we shall see that he came to similar conclusions about guerrilla warfare, despite having utilized many of its signature techniques in 1919 and 1920.

Michael Collins (released by Irish director Neil Jordan in 1996) is a conventional historical biopic that valourizes its protagonist and vilifies his opponents. Sepia-tinted shots seem to age the celluloid

in some sequences, giving it a period feel. It begins with the Easter Rising of 1916, when nationalist paramilitary groups seized the General Post Office in Dublin, as well as other public places. The uprising was a military disaster. The rebels were crushed by vastly superior British occupation forces, resulting in the incarceration of the principle participants, and the execution of several of their number, before public outcry in Britain brought an end to the use of such drastic measures.

Collins (Liam Neeson) avoided the first round of executions by sheer luck and was sent home with most of the rest of the rebels in December 1916. Shortly after his release, he made a stirring speech:

> They can jail us. They can shoot us. They can even conscript us! They can use us as cannon fodder in the Somme! But ... we have a weapon more powerful than any in the whole arsenal of the British Empire! That weapon is our refusal! Our refusal to bow to any order but our own! Any institution but our own![19]

Soon, he became one of the most prominent leaders of the post-Rising independence movement, joining the umbrella group Sinn Fein, which swept the 1918 parliamentary elections. Rather than taking their seats in the UK House of Commons (where they had little political power), they declared themselves to be members of an independent Irish parliament. Collins joined them, having been elected MP for south Cork County. He also assumed the duties of Intelligence Officer for the Irish Republican Army (the IRA). With his right-hand man Harry Boland (Aidan Quinn) by his side, Collins was an effective freedom fighter.

In his role as director of intelligence, Collins was contacted by Ned Broy (Stephen Rea), then a member of the Irish Metropolitan Police:

> Broy: [The government has] Names and addresses of the whole cabinet [of the IRA]. They are to be lifted [i.e. arrested] tonight. It's an illegal gathering, in open defiance of His Majesty's government.
>
> Collins: Where did you get this?
>
> Broy: Like you said, I'm eager for a G-man.
>
> Collins: Why should I trust you?

Broy: Logically, I suppose you shouldn't. But I have been on
your heels for weeks ... making notes of your speeches.
Let's just say that you can be persuasive.

Broy provided him with access to the voluminous intelligence
information the British had collected about the leaders of the
uprising, warning him that they were facing arrest in a massive
police sweep if they did not flee their homes. Collins informs Sinn
Fein president Eamon de Valera (Alan Rickman) of the impending
raids, but he refuses to have the leadership go into hiding, arguing
that they should submit to mass arrest as a propaganda ploy.
Collins and Boland elude the sweep, and remain at large, agreeing
to become 'ministers of mayhem'.

The following April, Collins arranged de Valera's escape, thanks
to a bar of soap that the president had used to make an impression
of the key to his cell. Despite previous failures, De Valera still
believed that the war against colonial oppression should be won in
traditional pitched battles, making it easier to secure international
recognition for the legitimacy of the Irish Republic. Having declared
himself president of the new Republic, he travelled to the United
States (and other possibly sympathetic nations) seeking support.
While he raised a good deal of money from Irish-Americans,
President Wilson refused to see him, and international recognition
remained elusive.

In de Valera's absence, Collins directed a guerrilla war against
the British, which proved to be much more effective than fighting
pitched battles. He created a special assassination squad, which used
the intelligence provided by Ned Broy to target undercover agents
(called G men), civilian informants and, eventually, prominent
figures in the British colonial occupation. Before being executed,
government agents and their civilian spies received letters warning
them to cease their activities or be killed. The British responded
by bringing in two groups of special forces, referred to as the
'Auxiliaries' and the 'Black and Tans' that instituted a regime of
physical intimidation.

Collins did not resort to violence casually. He explained his
motives to his friend Harry:

Know what? I hate them. Not for their race or their brutality. I
hate them for leaving us no way out. I hate whoever put a gun

in young Vinny Byrne's hand. I know it's me and I hate myself for it. I hate them for making hate necessary. I'll do what I have to do to end it.

Collins was a political pragmatist, who saw violence as the necessary means to a desirable end, but he did not relish having to use it. When he accompanies de Valera on a lengthy trip to America, Harry asks Collins to keep an eye on Kitty Kiernan (Julia Roberts), his girlfriend. This turns out to be a mistake, for a romance develops between the two of them in Harry's absence. The friendship between Harry and Michael is never the same, and their eventual split in the civil war may have stemmed in part from this rivalry for Kitty's affections.

When de Valera returned from abroad, he scoffed at Collins's tactics and wanted to initiate another pitched battle:

de Valera: As you may know, we have had some communication
from the British side. There is a slim possibility that
they might want to talk. But our tactics allowed
the British press to paint us as murderers. If we are
to negotiate as a legitimate government our armed
forces must act like a legitimate army.
Collins: What exactly do you mean Dev?
de Valera: I mean large-scale engagements.
Collins: You mean like in 1916? The great heroic ethic of
failure ... marching to slaughter? Why don't we save
them the bother and blow our brains out?

But de Valera insists, and the IRA seizes the Dublin Customs House in another large-scale operation that once again fails, at the cost of heavy casualties.

This phase of the conflict reached its peak on 21 November 1920, on a day that came to be called Bloody Sunday (one of several in Irish history). The British had imported a group of undercover agents called the Cairo Gang, fourteen of whom were assassinated that morning by IRA death squads. In retaliation, the Black and Tans and Auxiliaries descended on a Gaelic football game in Dublin's Croke Park and opened fire into the crowd, killing fourteen civilians and wounding dozens. The day ended with the

British executing three of the most prominent IRA prisoners they then held.

Bloody Sunday proved to be a public relations disaster for the British, alienating the Irish populace and turning many British politicians and citizens, and the king himself, against the occupation. In July 1921, the British government offered a truce to the rebels. Surprisingly, and over his objections that he was not a diplomat, de Valera appointed Collins to head the Irish delegation to the peace conference. The president claimed to be holding back so he could be the ultimate arbiter of the agreement. De Valera anticipated that the British would never agree to an Irish Republic, and he was prepared to reject anything less. Then, he could blame Collins for giving in and consolidate his power over the new Irish State (which he was destined to lead for decades to come, beginning in 1932).

After months of brutal negotiations in London, Collins secured an Anglo-Irish treaty that established an 'Irish Free State' in southern Ireland, which would, however, remain a dominion of Britain. The treaty also permitted the predominately protestant counties of the north to opt out of the state and continue their direct affiliation with the UK (which six of them promptly did). Although this meant that Ireland would not attain the status of a republic, and would have to submit to the partition that exists to this day, Collins agreed to what he always claimed was the best available compromise. He later explained his thinking to Kitty:

> The treaty is just a stepping stone. ... It is the best anyone could have got. We can use the Irish Free State to achieve the republic that we want. It's either this or war. I won't go to war over words.

Returning to Ireland with signed agreement in hand, he went before the Irish parliament and sought its approval. Collins defended his choice convincingly: 'We don't have the Republic ... but the freedom to achieve it. Peacefully. Surely it is time for peace.' As leader of the guerrilla war, he knew what it was costing the Irish people, and he was willing to compromise at this juncture in order to see it end. He submitted the treaty to a vote by the parliament, and then by the Irish people, vowing to stand by their decisions, and willing to be the vilified scapegoat (as de Valera expected he would be) if it was accepted.

Dissatisfied with half a loaf, and galled by the requirement that all Free State citizens swear allegiance to the Crown, de Valera opposed the treaty. When a majority of the parliament voted in its favour, he withdrew with his allies and initiated the brief but extremely bitter Irish Civil War, which was waged savagely from 1922 to 1924. Harry Boland, perhaps for personal as much as political reasons, sided with de Valera, and soon became one of the casualties of that war.

Collins found himself in the uncomfortable position of being a Crown-appointed prime minister, and eventually the commander of the Free State Army. When anti-treaty IRA forces occupied the Four Courts Building in Dublin, Collins ordered an artillery assault on his former comrades, in a desperate (and successful) attempt to stop the British military from reoccupying the country and quelling the unrest themselves. The Free State Army soon took control of the capital and drove the rebels out of most of their other strongholds as well.

By August 1922, the war seemed to be winding down, and Collins engaged in feverish negotiations with anti-treaty forces to secure peace, many of whom resided in his home county of Cork. On his final trip there, he hoped to arrange a meeting with de Valera, announcing his intentions in the local pub (where he bought drinks for the house):

> Tell him ... Harry Boland's death was enough. Tell him Mick Collins wants to stop this bloody mayhem. Tell him I'm sorry I didn't bring back the Republic, but no one could have. He was my chief, always. I'd have followed him to hell if he asked me, and maybe I did. But it's not worth fighting for any more.

Tragically, the meeting never occurred.[20]

On its way back, Collins's detachment was ambushed by anti-treaty rebels, and he died in a hail of gunfire. Over half a million Irish citizens turned out for his funeral, almost one-fifth of the entire population of the country at the time. Collins's death had serious repercussions: the civil war, which seemed about to end, raged on for almost two more years. As James Mackey put it in his acclaimed biography of the man:

> Had Michael lived, it is probable that he would have brought the civil war to a speedy conclusion, and succeeded in healing

the breach with the North, leading to the removal of partition, which few British politicians, from Lloyd George to Churchill downwards, regarded as anything other than a temporary measure in 1922.[21]

Mackey contended that Collins's economic and administrative skills would have lessened the widespread suffering in Ireland during the Great Depression (which was exacerbated by the trade war with Britain in the early 1930s) and that his personal charisma and political power would have been a check on the excesses of de Valera, who became prime minister a decade later and who dominated Irish politics well into the 1970s.

Unlike writer/director Jordan's more iconoclastic films (such as *The Crying Game, Mona Lisa and In Dreams*), *Michael Collins* is a traditional heroic epic. The settings are convincing and have an authentic look about them. Played by a handsome Hollywood star, Collins is seen as being on the correct side of every controversy. He's right about the need for a guerrilla war rather than large, pitched battles. His campaign of targeted assassinations is remarkably effective in upping the ante of colonialism. He gets the girl, and his rival and friend is killed for siding with de Valera's cause against him (it must be said that Dev is depicted as a weaker and more devious man than he probably was). Collins's story is told in a chronological manner and unfolds with an increasing sense of inevitability. He dies a martyr's death and is publicly mourned by an astonishing percentage of the Irish population at the time. Adherence to classical Hollywood 'realistic' conventions has its predictable effect: viewers are led to identify with Michael Collins and see him in a positive light and to affirm his values as their own.

Doctrinaire Marxists, on the other hand, show disdain for Michael Collins as a historical figure. The following excerpt from an article posted on the website called 'The International Marxist Tendency' is typical:

His political tragedy, like other well-meaning, even heroic, bourgeois and petty-bourgeois nationalists in the age of imperialism was to attempt the impossible; to try to achieve meaningful national independence, in Ireland's case uniting both Catholics and Protestants, without breaking free from the bonds of capitalism. We should salute his struggle against the British

empire's imperialist occupation – but also try to learn from his mistakes.[22]

While Sartre was anything but a doctrinaire Marxist, he did have a disdain for 'clerks' like Michael Collins (who had been a postal clerk): 'Whether he identifies himself with the Good, and with divine Perfection, with the Beautiful, and the True, a clerk is always on the side of the oppressor.'[23]

He was, however, one of the most eloquent anti-colonialist writers of the 1950s and 1960s. Sartre, and the publication which he edited at the time, *Les Temps Moderne*, consistently criticized France's conduct of the war in Indochina, likening its behaviour to Germany's during the occupation (as early as December 1946). Sartre's first public pronouncement on the Algerian conflict (in a 1954 edition) reflected his Marxist perspective. As Julian Sharp summarized:

> The central thrust of Sartre's argument is that colonialism constitutes a system which is built on the relentless and ruthless exploitation of Algeria by France and the Algerian colons. It was precisely because of its intrinsically exploitative nature that the colonial system could not be 'reformed' because to do so would remove its very essence. The system had to be destroyed.[24]

Sartre believed that nothing less than total destruction would do, because he was convinced that French President Charles de Gaulle could never agree to Algerian independence. To Sartre's amazement, the president came to such an agreement with the rebels in 1962, because the costs of retaining colonial power had become prohibitive. Prime minister of England David Lloyd George came to very much the same conclusion about the occupation of most of Ireland and decided to withdraw in the face of the guerrilla war led by Michael Collins.

Sartre's criticisms of the brutal pacification methods of the French colonial army would apply equally well to some of the excesses of the British in Ireland that are depicted in the film. Sartre's most controversial statement on violence against the colonial oppressors was positively incendiary:

> At this stage of revolt, they have to kill: to shoot down a European is to kill two birds with one stone, doing away with oppressor

and oppressed at the same time; what remains is a dead man and a free man, a survivor.[25]

Manchester University professor David Drake characterized Sartre's position in terms that are also appropriate to the Irish situation:

> Sartre wholeheartedly endorsed the revolutionary violence of the anti-colonial movements, for not only was it necessary to oppose the inherent violence of the colonial system, but also, it was through the violence against the European oppressor that the colonist reasserted himself as a human being.[26]

Their embrace of Michael Collins at his death shows that the Irish people took great pride in their violent resistance to the British under his direction.

The wartime friendship between Camus and Sartre, forged during their common resistance to Nazi occupation, dissolved acrimoniously. As Stanley Hoffmann observed in his review of a book on the subject:

> The great issue that began to divide them in the 1950s was communism, and the 1952 publication of Camus' *The Rebel* [see above] led to their break. Their opposing views on violence subsequently led them to react differently to war in Algeria, with Sartre accepting violent means as an acceptable tool in the fight for decolonization while Camus, horrified by the atrocities of both sides, stayed silent in public.[27]

Camus was himself a *pied-noir* (literally, 'black foot', referring to white Algerians of French extraction, whom the Arabs outnumbered 5 to 1), who emigrated to Paris in 1940, shortly before the Nazi occupation. Despite his outrage at the excesses of the French government, Camus opposed full Algerian independence and decried the use of violence in attempts to attain it. At that time, he was dismissed by the left as overly idealistic, and uncommitted to the cause of independence, as his silence was taken to be supportive of the oppressors. He is not a widely beloved figure in Algeria to this day. Yet his ambivalence is easily understandable.

By contrast, Sartre was a Frenchman who admitted that the best he could do was speak in solidarity with an Arab cause in which he had little personal stake. Perhaps this allowed him to consider the issues with a more dispassionate eye. Events seem to have proven Sartre right, as Algeria would never have achieved its independence so quickly without violent resistance to its colonizers. Similarly, the guerrilla war that Michael Collins waged against the British was crucial to achieving home rule and eventual independence.

But the legacy of the use of such violence played out in both countries for decades to come. The failure to unite north and south led to the renewed and bloody troubles of the 1970s and thereafter in Northern Ireland, and relations between the Arabs and the *pied-noirs* who remained in Algeria are still deeply strained. The debate between Camus and Sartre hence remains open and richly rewards re-examination.

Questions for discussion

1 Put in a nutshell, Marx's critique of a capitalist democracy alleges that it allows 1 per cent of the population to amass a majority of the wealth of any nation, by robbing workers of the fruits of their labour and financially compelling legislators to protect the special interests of the wealthy. Doesn't what has happened in the United States in the past thirty years confirm the truth of that critique?

2 The success of the Civil Rights Movement in the 1960s has been largely attributed to the non-violent activities of the NAACP and Martin Luther King. What seems to have been forgotten is the plague of race riots that occurred during that period, in Rochester, Harlem and Philadelphia in 1964, in Watts (Los Angeles) in 1965, in Hough (Cleveland) in 1966 and in Newark in 1967. Would the cause of civil rights have advanced so quickly in the absence of such riots?

3 The United States War of Independence was a rebellion against the occupation of a colonial power and constitutes one of the most glorified epochs of its history. Yet it built its

own colonial empire (in the Philippines, Cuba, Panama and, arguably, in Vietnam) and has had a less than stellar record of supporting indigenous rebellions around the world. What is your take on this issue? Does America really champion democracy around the world?

4 Michael Collins limited his guerrilla attacks to members of the colonial British Army and government, and to paid Irish informants. Sartre argued that terrorist attacks on innocent civilians were also justifiable. Osama Bin Laden justified the attacks on the World Trade Center as retaliation for US support for the Zionist oppressors and neglect of the Palestinian people. Is terrorism ever justifiable? If so, when?

Suggestions for further viewing

The Battle of Algiers (1966, Gillo Pontecorvo) – A highly influential study of the use of terrorism in the Algerian War, filmed from the point of view of the terrorists. Brilliant use of identification leads viewers to root for the success of the bombings, as we are appalled by their effects.

October (1927, Sergei Eisenstein) – Commissioned by the Soviet government to commemorate the tenth anniversary of the Russian Revolution, *October* is a primer of Marxist ideology, told in symbols. Violent revolution is consecrated as a noble endeavour, and the wicked alliance of the military, wealthy Czarist aristocrats, industrialists and the Church is dismantled piece by piece.

Malcolm X (1992, Spike Lee) – Denzel Washington plays the enigmatic political leader who began to be radicalized as a convict, became infamous for advocating violence against the white oppressor and questioned the use of violence after his pilgrimage to Mecca shortly before his assassination. An epic companion piece to Lee's *Do the Right Thing*.

Munich (2005, Steven Spielberg) – Eric Bana plays the leader of a Jewish assassination team targeting the Palestinian terrorists behind

the slaughter at Munich. He is plagued by doubts and nightmares as civilian lives are endangered. He questions the difference between what he is engaged in and the crimes of the terrorists who are his targets, while wondering whether any real good has been done in the process.

De Beauvoir's Fight against Gender Stereotypes and *Revolutionary Road*

Simone de Beauvoir's two major treatises, *The Ethics of Ambiguity* and *The Second Sex*, were groundbreaking works on the possibility of an existentialist ethics and on the social conventions that have historically relegated women to an inferior social status. Remarkably, they remain as relevant today as when they were penned over six decades ago. In both, she was writing about the post-war social milieu of the late 1940s and 1950s, precisely the period in which Sam Mendes' *Revolutionary Road* is set. The struggles of the film's central couple mirror de Beauvoir's primary concerns with striking clarity.[1]

From time immemorial, woman has been the 'Other'. Like the other races, or the other nationalities, woman constitutes the other gender, the inferior one. The history of Western philosophy underscores her status. Aristotle asserted that 'We should regard the female as afflicted with a natural defectiveness', while 'St. Thomas, for his part, pronounced woman to be "an imperfect man", an "incidental being"'.[2] But Simone does not blame a bunch of old white men for the plight of women at mid-century: 'If woman seems to be the inessential which never becomes the essential, it is because she herself fails to make the change.'[3]

In the twentieth century, the intellectual case for the subordination of women has been made primarily on biological, psychoanalytic and materialistic grounds. De Beauvoir debunks those justifications and concludes that

> the very fact that woman is the *Other* tends to cast suspicion on all of the justifications that men have ever been able to provide for it. These have all too evidently been dictated by men's interests.[4]

As she describes it in the conclusion to *The Second Sex*, she envisions a world where

> the little girl [will be] brought up from the first with the same demands and rewards, the same severity and the same freedom, as her brothers, taking part in the same studies, the same games, promised the same future, [and] surrounded with women and men who seem to her undoubted equals.

There are biological differences between the two sexes: men tend to be physically larger and more muscular, while women bear the

children. But, as Plato pointed out in his *Republic*, these differences make a difference only relative to certain purposes and provide no ground for a hierarchical distinction between the sexes. The sexes have different reproductive roles, but these differences should not dictate the traditional social roles:

> It is the male element which provides the stimuli needed for evoking new life and it is the female element that enables this new life to be lodged in a stable organism. ... It would be foolhardy indeed to deduce from such evidence that woman's place is in the home – but there are foolhardy men.[5]

Keeping house and raising children reduces the housewife to a life of immediacy and servitude. Condemned to the drudgery of housecleaning and to fulfilling the endless demands of her children and husband, and denied the satisfaction of having a job in the public world, the conventional feminine role in society is designed to deaden a woman's consciousness and chain her to her biological functions.

In a brilliant move, de Beauvoir draws upon the fundamental principles of existentialism (as outlined in *Being and Nothingness*) to ground her critique of the supposed inferiority of women in biology:

> Once we adopt the human perspective, interpreting the body on the basis of existence, biology becomes an abstract science; whenever the physiological fact (for instance, muscular inferiority) takes on meaning, this meaning is at once seen as dependent on a whole context; the 'weakness' is revealed as such only in the light of the ends man proposes, the instruments he has available, and the laws he establishes. If she does not wish to seize the world, then the idea of a *grasp* on things has no sense; when in this seizure the full employment of bodily power is not required, above the available minimum, then differences in strength are annulled; wherever violence is contrary to custom, muscular force cannot be a basis for domination. In brief, the concept of *weakness* can be defined only with reference to existentialist, economic, and moral considerations.[6]

A particular trait is only superior relative to certain purposes and is only meaningful when integrated into ongoing human projects.

In the psychological realm, Sigmund Freud was singled out for criticism by both Sartre and de Beauvoir. Though both acknowledged that there was some truth to psychoanalysis, in their estimation psychological determinism was a characteristically modern form of bad faith, a self-deceptive attempt to avoid individual responsibility by denying freedom of choice.

Consider the infamous doctrine of penis envy in women. Freud argued that the inherent inferiority complex in women is triggered by their lack of a penis, the pre-pubescent recognition of which is a traumatic landmark in their psychosexual development. Now, one might expect de Beauvoir to deny that such envy even exists. While admitting it is a reality, at least for some women, she attributes its epic impact in those cases to the sexist culture which women inhabit:

> Woman, we are told, envies man his penis and wishes to castrate him; but the childish desire for the penis is important in the life of the adult woman only if she feels her femininity as a mutilation; and then it is as a symbol of all the privileges of manhood that she wishes to appropriate the male organ. We may readily agree that her dream of castration has this symbolic significance.[7]

In a society of sexual equality, however, such privileges would no longer exist, and penis envy would shrink to insignificance.

Marxism substitutes economic determinism for psychological determinism, an equally disreputable instance of bad faith in de Beauvoir's eyes. Both Marx and Freud reduce human nature to a single set of variables and describe the results of evolving social conditions as if they were timeless truths. She criticizes both of their reductionist accounts with equal vehemence:

> So it is that we reject for the same reasons both the sexual monism of Freud and the economic monism of Engels. A psychoanalyst will interpret the claims of woman as phenomena of the 'masculine protest'; for the Marxist, on the contrary, her sexuality only expresses her economic situation in a more or less complex, roundabout fashion. But the categories of 'clitorid' and 'vaginal', like the categories of 'bourgeois' or 'proletarian', are equally inadequate to encompass a concrete woman. Underlying

all individual drama, as it underlies the economic history of mankind, there is an existential foundation that alone enables us to understand in its unity that particular form of being which we call a human life.[8]

Neither Marxism nor Freudian psychoanalysis has freed women from their second-class status, nor can *any* such reductionist account.

Ironically, de Beauvoir embraces the Soviet ideal (while severely criticizing the reality):

A world where men and women would be equal is easy to visualize, for that precisely is what the Soviet Revolution *promised*: women reared and trained exactly like men were to work under the same conditions and for the same wages. Erotic liberty was to be recognized by custom, but the sexual act was not to be considered a 'service' to be paid for; woman was to be obliged to provide herself with other ways of earning a living; marriage was to be based on a free agreement that the contracting parties could break at will; maternity was to be voluntary, which meant that contraception and abortion were to be authorized.[9]

This ideal will prove particularly relevant to our understanding of *Revolutionary Road*.

The conclusion to *The Second Sex* is inspiring in its bold vision of the future:

Assuming on the same basis as the father the material and moral responsibility of the couple, the mother would enjoy the same lasting prestige; the child would perceive around her an androgynous world and not a masculine world. ... Authorized to test her powers in work and sports, competing actively with the boys, she would not find the absence of the penis ... enough to give rise to an inferiority complex; correlatively the boy would not have a superiority complex if it were not instilled into him and if he looked up to women with as much respect as to men.

There is nothing inevitable about the war between the sexes, according to de Beauvoir. It is a product of the systematic oppression of women:

> The innumerable conflicts that set men and women against one another come from the fact that neither is prepared to assume all the consequences of this situation which the one has offered and the other accepted. The doubtful concept of 'equality in inequality', which the one uses to mask his despotism and the other to mask her cowardice, does not stand the test of experience.[10]

But de Beauvoir also blames women who buy into society's bogus concept of 'femininity' for preferring the benefits of that role to the freedom of true liberation.

De Beauvoir is to be praised for recognizing that men are also victimized by the conflict (although not as severely as women):

> Man is concerned with the effort to appear male, important, superior; he pretends so as to get pretence in return; he, too, is aggressive, uneasy; he feels hostility for women because he is afraid of them, he is afraid of them because he is afraid of the personage, the image, with which he identifies himself. What time and strength he squanders in liquidating, sublimating, transferring complexes, in talking about women, in seducing them, in fearing them! He would be liberated himself in their liberation.[11]

Sexual equality promises to defuse the hostility between the sexes. Women treat men badly (at least in some cases) for a reason:

> Here we find the explanation of the cruelty that woman often shows she is capable of practicing; she has a good conscience because she is on the unprivileged side; she feels she is under no obligation to deal gently with the favored caste, and her only thought is to defend herself. She will even be very happy if she has occasion to show her resentment to a lover who has not been able to satisfy all her demands: since he does not give her enough, she takes savage delight in taking back everything from him.[12]

Again, however, de Beauvoir makes it very clear that this struggle unto death is not inevitable. Women's liberation requires (1) shattering gender stereotypes, (2) sexual and reproductive freedom and (3) equal opportunity and compensation in the workplace. If these conditions are achieved, the sex wars will subside and individuals of both sexes will be able to autonomously define themselves:

> The fact that we are human beings is infinitely more important than all the peculiarities that distinguish human beings from one another; it is never the given that confers superiorities: 'virtue', as the ancients called it, is defined at the level of 'that which depends on us'. In both sexes is played out the same drama of the flesh and the spirit, of finitude and transcendence; both are gnawed away by time and laid in wait for by death, they have the same essential need for one another; and they can gain from their liberty the same glory. If they were to taste it, they would no longer be tempted to dispute fallacious privileges, and fraternity between them could then come into existence.

More than six decades later, this stirring prospect remains unrealized, and her contention that 'it is never the given that confers superiorities' is strikingly relevant today.

In *The Ethics of Ambiguity*, de Beauvoir takes on the central problem of existentialist ethics, which was aptly posed by Fyodor Dostoevsky in *The Brothers Karamazov*: If there is no God, why doesn't it logically follow that everything is permitted and nothing can be declared absolutely wrong? For the French existentialists, this question was most forcibly raised in their very public discussion of the Nazis, the Stalinists, and Algerian and Vietnamese terrorists: how can one legitimately condemn their actions within an existentialist framework? In the name of what positive value can one say 'no!' to such brutal tactics?

De Beauvoir always operated within the Sartrean ontology of being, where, as we've seen, consciousness is essentially a nihilating lack. She adapts Sartre's theory to ground her own account of value:

> Value is this lacking-being of which freedom *makes itself* a lack; and it is because the latter makes itself a lack that value appears. It is desire which creates the desirable, and the project which sets up the end. It is human existence which makes values spring up

in the world on the basis of which it will be able to judge the enterprise in which it will be engaged.[13]

We value something of which we feel the lack and act to make it ours. If we lacked nothing, and had no desires, we could not bring value into the world.

For de Beauvoir, as for later Camus, human solidarity is crucial. In Camus's *The Rebel*, it was 'I revolt, therefore we exist'. For de Beauvoir, 'I am free, therefore we all are free'. The movement that freed human existence from the demands of timeless essences here sought to erect freedom as the only universal absolute:

> Freedom is the source from which all significations and all values spring. It is the original condition of all justification of existence. The man who seeks to justify his life must want freedom itself absolutely and above everything else. At the same time that it requires the realization of concrete ends, of particular projects, it requires itself universally.[14]

She is thereby proposing an admittedly ambiguous but nonetheless useful moral criterion: an action is good as it tends to bring about more freedom in the lives of individual human beings, and evil if it increases oppression and servitude.

One must, as an individual, choose to be free:

> But one can choose not to will oneself free. In laziness, heedlessness, capriciousness, cowardice, impatience, one contests the meaning of the project at the very moment that one defines it. The spontaneity of the subject is then merely a vain living palpitation, its movement toward the object is a flight, and itself is an absence. To convert the absence into presence, to convert my flight into will, I must assume my project positively.[15]

But it is not enough for me to do so for myself alone; realizing my own freedom requires me to recognize the freedom of all.

The exercise of that freedom is exhilarating: 'To will oneself free is to effect the transition from nature to morality by establishing a genuine freedom on the original upsurge of our existence.'[16] To will ourselves free requires us to forego any appeal to our 'natures' to justify our actions. We are who we choose to be, among the many alternatives left open to us by our facticity.

A genuine moral imperative emerges from this line of reasoning, obliging us to fight the forces of oppression and serve the cause of freedom. This answers the accusation of moral relativism directly: 'At the same time the other charge which is often directed at existentialism, of being a formal doctrine incapable of proposing any content to the freedom which it wants engaged, also collapses. To will oneself free is also to will others free.'[17] What this means in practice cannot be determined beforehand, but such considerations will be highly significant:

> It must again be called to mind that the supreme end at which man must aim is his freedom, which alone is capable of establishing the value of every end; thus, comfort, happiness, all relative goods which human projects define, will be subordinated to this absolute condition of realization. The freedom of a single man must count more than a cotton or rubber harvest. ... To put it positively, the precept will be to treat the other (to the extent that he is the only one concerned...) as a freedom so that his end may be freedom; in using this conducting wire one will have to incur the risk, in each case, of inventing an original solution.[18]

Adopting such a moral standard will point the way to novel decisions in particular situations.

De Beauvoir concludes on an astonishingly optimistic and life affirming note:

> In order for the idea of liberation to have a concrete meaning, the joy of existence must be asserted in each one, at every instant; the movement toward freedom assumes its real, flesh and blood figure in the world by thickening into pleasure, into happiness. If the satisfaction of an old man drinking a glass of wine counts for nothing, then production and wealth are only hollow myths; they have meaning only if they are capable of being retrieved in individual and living joy. The saving of time and the conquest of leisure have no meaning if we are not moved by the laugh of a child at play. If we do not love life on our own account and through others, it is futile to seek to justify it in any way.

Unfortunately, in a world that is still subject to widespread gender-based oppression, pursuing the life of autonomous freedom can

often have tragic consequences, as the fate of the Wheelers in *Revolutionary Road* so movingly illustrates.

Revolutionary Road was helmed by Academy Award winning director Sam Mendes (*American Beauty*). Rather than use the conventions of *film noir* to express his dark message, Mendes makes the world of the 1950s appear as sunny and bright as it could be. At the beginning of the film, Frank and April Wheeler (Leonardo DiCaprio and Kate Winslet) are living the 1950s American Dream. They've recently moved into a nice house on Revolutionary Road, in the upscale part of their suburban neighbourhood. Frank is a whiz at selling business machines, and Kate keeps a beautiful house, while lovingly raising their two darling children.

But things are not as sunny as they seem. Kate, who was once an aspiring actress, is frustrated with doing mediocre community theatre in the high school gym, and Frank is thoroughly bored with his job. They fight with each other about things both little and big, as the passion drains out of their marriage. Their frustrations come out when Frank pulls over on the way home from a performance that fizzled, and insists that they talk about April's dissatisfaction with her acting opportunity:

Frank: You know what you are when you're like this, April? You're sick. I really mean that.
April: And do you know what you are? You're disgusting.
Frank: Oh, yeah?
April: You don't fool me, Frank. Just because you've got me safely in this little trap, you think you can bully me into feeling whatever you want me to feel!
Frank: You in a trap? You in a trap?
April: Yes! Yes! Me, Frank!
Frank: Jesus Christ, don't make me laugh!
April: Me! You pathetic, self-deluded little boy. Look at you! Look at you and tell me, how by any stretch of the imagination you can call yourself a man? [Frank seems about to hit her but strikes the roof of the car instead].

It is clear both are desperately unhappy. In Sartrean terminology, she has just exploded their world.

As it turns out, Frank shared April's dissatisfaction with their life even before this. The next day, on his thirtieth birthday, he takes

a secretary at the firm out for a two-martini lunch, and admits as much:

Frank: My old man worked at Knox.
Secretary: Yeah?
Frank: He was a salesman in Yonkers. Once a year he used to take me into the city for lunch. It was supposed to be a very special, life-advice sort of occasion.
Secretary: Nice.
Frank: No. Not really. I used to sit there and think, 'I hope to Christ I don't end up like you'. Now, here I am, a 30-year-old Knox man. Can you beat that?

She is appropriately sympathetic and they begin an affair that afternoon.

Frank comes home that night to an April whose attitude has changed. She has thought out their situation and envisioned a plan to free themselves from their conventional lifestyle. She enthusiastically shares an idea that occurred to her when she recalled one of their early conversations, in which he told her he wanted to return to France (where he fought during the war), because the French really feel their feelings and that was one of his greatest ambitions. Her response at the time was to say that he was the most interesting man she had ever known, and their romance took off from there.

With this reminiscence fresh in her mind, April proposes that they move to Paris, lock, stock and barrel. They can live on their savings for a while, then she will support them as a secretary in a government office, while he will take some time to find himself and what he truly wants to do with his life. Frank is understandably hesitant, as the suggestion seems to have come out of left field:

Frank: For one thing, what exactly am I supposed to be doing while you're out earning all this money?
April: Don't you see? That's the whole idea. You'll be doing what you should've been allowed to do seven years ago [when she first got pregnant and they settled into a conventional marriage]. You'll have time. For the first time in your life you'll have time to find out what it is that you actually want to do. And when you figure it out, you'll have the time and the freedom to start doing it.

Frank: Sweetheart, it's just not very realistic, is all.
April: No, Frank. This is what's unrealistic. It's unrealistic for a
 man with a fine mind to go on working year after year at a
 job he can't stand, coming home to a place he can't stand,
 to a wife who's equally unable to stand the same things.

Despite his reservations, Frank agrees, and they start to prepare for their new lives.

What April is proposing, and her reasons why, relate directly to *The Second Sex*. April envisions a reversal of gender roles, with her becoming the material provider, while Frank seeks an authentic project to pursue and spends more time with the children. Both April and Frank feel trapped, and the move to Paris would get them out of their comfortable little boxes and give them a chance to live freely and authentically. It is precisely the kind of movement towards individual liberation that de Beauvoir would have encouraged. April is to be esteemed for having proposed it, and Frank seems surprisingly open to this role reversal, at least at first.

In a brilliant example of how our being exists for others, and is shaped by their opinions, the Wheelers find it rough going when they share their plans with the people in their lives. First, they tell Shep (David Harbour) and Milly (Kathryn Hahn) Campbell, their closest friends. Though supportive to their faces, the Campbells conclude in private that the whole thing sounds a little immature. Both are clearly unsettled by this development, and not just because they would be losing regular contact with their dear friends. Milly reacts as if the security of their own lives is being threatened by this unconventional resolution on April and Frank's part.

Apropos the twin themes of being-for-itself (i.e. self-awareness) and being-for-others, the central visual motif in the film is looking into mirrors and other reflective surfaces. Several shots are taken through picture windows, which reflect what the character is seeing outdoors while the camera scrutinizes a reflective individual within (usually April). Lighting is used to ironic effect: some of the most traumatic moments of the film are shot with bright sunlight streaming through the spotless windows of the Wheeler residence.

The Wheelers have a real estate agent named Mrs Givings (Kathy Bates), who brings her troubled son John (Michael Shannon)

over for a visit, after getting April's approval. Though on leave from a mental institution, John understands what they mean immediately (unlike his sceptical mother) and affirms their decision:

> John: So, what do a couple of people like you have to run away from?
> Frank: We're not running.
> John: So what's in Paris?
> Frank: A different way of life.
> April: Maybe we are running. We're running from the hopeless emptiness of the whole life here, right?
> John: The hopeless emptiness? Now you've said it. Plenty of people are on to the emptiness, but it takes real guts to see the hopelessness.

Frank is somewhat unsettled by this show of support, as he reveals after the Givings leave.

> April: You know, he's the first person who seemed to know what we were talking about.
> Frank: Yeah. That's true, isn't it? Maybe we are just as crazy as he is.
> April: If being crazy means living life as if it matters, then I don't care if we are completely insane.

Undaunted, they continue to prepare for the move to Paris.

But then a huge obstacle arises: their renewed sexual passion has resulted in April getting pregnant. April wants to self-abort, though she is nearing the twelve-week term, after which taking such action can be fatal. When she tells him, Frank immediately reverts to his traditional masculine gender role. In the interim, he has been offered an impressive promotion at Knox Business Machines and he is leaning towards accepting this and staying in Connecticut:

> Frank: Look, I'm not happy about it. But I have the backbone not to run away from my responsibilities.
> April: It takes backbone to lead the life you want, Frank.
> [He then finds a primitive abortion instrument in the bathroom]

Frank: What the hell are you going to do with this?

April: And what do you think you're going to do? You're going to stop me?

Frank: You're damn right I am!

April: Go ahead and try.

Frank: Listen to me. You do this, April, you do this and I swear to God I'll...

April: You'll what? You'll leave me? Is that a threat or a promise?

Frank: When did you buy this, April? How long have you had this? I want to know!

April: Jesus Christ. You really are being melodramatic about this whole thing. As long as it's done in the first 12 weeks, it's perfectly safe.

Frank: That's now, April! Don't I get a say?

April: Of course you do! It would be for you, Frank. Don't you see? So you can have time, just like we talked about.

Frank: How can it be for me when the thought of it makes my stomach turn over, for God's sake?

April: Then it's for me. Tell me we can have the baby in Paris, Frank. Tell me we can have a different life. But don't make me stay here. Please. Do you actually want another child? Well, do you? Come on, tell me. Tell me the truth, Frank. Remember that? We used to live by it. And you know what's so good about the truth? Everyone knows what it is, however long they've lived without it. No one forgets the truth, Frank. They just get better at lying. So tell me, do you really want another child?

Frank: All I know is what I feel. And anyone else in their right mind would feel the same way.

April: But I've had two children. Doesn't that count in my favor?

Frank: Christ, April! The fact that you even put it that way! You make it seem as if having children is some sort of a goddamn punishment.

April: I love my children, Frank.

Frank: And you're sure about that, huh? What the hell is that supposed to mean? April, you just said our daughter was a mistake. How do I know you didn't try to get rid of her, or Michael for that matter?

April: No.

Frank: How do I know you didn't try to flush our entire fucking family down the toilet?

April: No, that's not true. Of course I didn't.

Frank: But how do I know, April?

April: Stop. Please just stop, Frank.

Frank: April, a normal woman, a normal sane mother... Look, all I'm saying is you don't seem entirely rational about this thing. And I think it's about time we found somebody to help make some sense of your life.

April: And the new job's going to pay for that, too?

Frank: April, if you need a shrink, it will be paid for.

Reasserting his dominance, Frank unilaterally declares that there will be no abortion and no moving to Paris. He refuses to hear April's cry for help. When the War between the Sexes reignites, Frank raises the stakes by playing the psychoanalysis card. If April won't see things like most people do, she must need a shrink. His complete reversion to male chauvinism underscores the formidable power of paternalistic stereotypes.

April cannot accept Frank's decision. Looking like a caged animal, her trapped and desperate gaze inside the roadhouse signals her plight. When Frank takes Milly home, April has sex with Shep in the front seat of his car as an expression of her anger and despair: 'I saw a whole other future. I can't stop seeing it. Can't leave, can't stay. No damn use to anyone. Come on. Let's do it.' But sexual liberation doesn't seem to do her much good.

When John Givings hears about their change of heart, his take on it is withering:

John: No, no. What happened, Frank? You get cold feet? You decide you're better off here after all? You figure it's more comfy here in the old hopeless emptiness after all, huh? Oh, wow, that did it. Look at his face. What's the matter, Wheeler? Am I getting warm? ... You know something? I wouldn't be surprised if he knocked her up on purpose ... that way he'd never have to find out what he is really made of.

After he insists that they leave, it is clear that John's remarks have hit home. Frank: 'And everything that man said is true, right?' April:

'Apparently I don't have to. You're saying it for me.' His anger boils over, and he tells her that he wished to God that she had aborted the foetus.

The next morning, April tries to play the role of the perfect little housewife, making Frank a lavish breakfast and showing interest in his new job, while telling him he should be proud of what he does. Though appreciative of her efforts, his unenthusiastic responses about the job make it patently obvious that he really isn't happy with, or excited about, his conventional resolutions.

Desperate, she goes into the bathroom after he leaves for work and self-aborts, although she knows she is beyond the point where it is safe to do so. She haemorrhages as the result of this rash decision, and in a heartbreaking point-of-view shot, she watches herself dripping blood on the carpet. Director Sam Mendes (Winslet's husband at the time) cuts to a shot from behind her, as the stain on her skirt grows while she gazes for the last time out her sunny picture window. Then she calls for an ambulance, but, despite being rushed to the hospital, she bleeds to death before Frank can rush to her side. The film ends with Frank working as a salesman for another business machine company while living in the city and devotedly raising his two children on his own.

April's choice reveals that she was simply unwilling to submit to Frank's dominance, no matter what the cost. De Beauvoir's writings allow us to understand *why* she decided to risk death rather than return to the hopeless state of non-existence that traditional gender stereotypes impose. When Richard Yates wrote the original novel in 1961, the birth control pill was not yet widely available, abortion was still illegal, and Frank's knee jerk negative reaction to the very idea of it was pretty much typical of the time. De Beauvoir stressed the importance of sexual freedom in her praise for the Soviet ideal: erotic liberty should be granted to all persons, maternity ought to be voluntary and ready access to effective contraception and safe, legal abortions should be a woman's right. As Gloria Steinem put it two decades later, women's liberation requires sexual liberation first and foremost. Women must be freed from their slavery to biology and granted the same sexual autonomy that men have always enjoyed.

What is especially devastating to me about *Revolutionary Road* is the fact that the Wheelers had been trying to do something

about their discontented state. Their initial resolution to move to Paris and try out a different way to be was truly brave, not foolhardy (as all around them but John seemed to think). In *Existentialism and Contemporary Cinema: A Beauvoirian Perspective*, Constance Mui and Julien Murphy argue that 'The Beauvoirian framework allows us to understand the characters' struggles against an oppressive situation as an attempt to turn away from alienation towards authenticity as a possibility.[19] They consider *Revolutionary Road* to be a tragedy: 'What is this new American Tragedy? It is that the very conventional forms of adult life – are the barriers, not the means, to self-fulfillment.'[20] This is indeed a terrifying insight, one that captures the essence of the film perfectly. It also restates one of de Beauvoir's most profound themes: gender stereotypes victimize both men and women alike, and must be transcended.

Questions for discussion

1 What is the significance of John Givings being the only one of the Wheelers' acquaintances to approve of their project to move to Paris? How does this relate to Frank telling April that she must be insane to want to abort her child?

2 Think of a resolution in your life that was met with almost universal disapproval by your family and friends. Did you carry through on it anyway? Why or why not? Should we need the approving recognition of others in order to feel good about ourselves?

3 What progress has been made towards de Beauvoir's ideal of women's (and human) liberation in the past half-century, and in what ways do we remain a sexist society? Are some significant gender differences biological (or at least evolutionary)? Like what?

4 In terms of serving the cause of women's liberation, would it have been more effective to show the Wheelers carrying out their project successfully? Isn't their fate a trifle discouraging to women who seek to free themselves from the gender stereotypes that still exist? Why or why not?

Suggestions for further viewing

Alice Doesn't Live Here Anymore (1974, Martin Scorsese) –
Newly widowed thirty-something housewife and mother Alice
Hiatt is devastated by her husband's death, and moves back to her
hometown of Monterey California to start over as a waitress and
aspiring singer. She forges a circle of friends, struggles with raising
her son and finds new love. Not your usual Scorsese.

Thelma and Louise (1991, Ridley Scott) – A controversial study of
gender reversal, and whether having the right to act like men is truly
liberating for women. Best friends Thelma and Louise go on a road
trip, and soon Thelma is being raped in a roadhouse parking lot.
Louise just can't stand by and watch it happen, and all hell breaks
loose. Their ensuing crime spree rushes to a stunning climax.

Julia (1977, Fred Zinnemann) – Based on the memoirs of playwright
Lillian Hellman, this is the story of her relationship with the
title character, who joined the fight against fascism early on and
enlisted Hellman to help smuggle a substantial amount of money
out of Germany. One of the few Hollywood dramas to ever focus
on women who share a meaningful project and downplay their
romantic entanglements.

Juno (2007, Jason Reitman) – A teenage girl named Juno decides it is
time to have sex, but fails to take the proper precautions. When she
gets pregnant, she decides to have the child and place it with a well-
to-do couple. In doing so, Juno exerts the sexual and reproductive
autonomy that de Beauvoir championed, and is respected for it. Her
decision *not* to have an abortion illustrates how being pro-choice is
not synonymous with being pro-abortion.

CHAPTER TWELVE

Foucault's *Madness and Civilization* and *One Flew Over the Cuckoo's Nest*

Of all the postmodernist European philosophers that Nietzsche influenced (and their ranks include such luminaries as Jacques Derrida and Slavoj Zizek), the most devoted acolyte was Michel Foucault. Conspicuously, Foucault embraced both Nietzsche's fundamental insight that all life is Will to Power *and* his genealogical method. As discussed earlier, Nietzsche, in *On the Genealogy of Morality*, traced the history of the evolution of morals from the masterly values of the ancient Greeks and early Romans to the slavish Christian values that supplanted them. Like Nietzsche, Foucault brandished the method as a means of grounding his critique of the most fundamental social institutions, including the prison system (*Discipline and Punish*), medicine (*The Birth of the Clinic*), the 'Human Sciences' (*The Order of Things*) and sex (*The History of Sexuality, Parts I and II*). *Madness and Civilization* (1964) was an abridgement of his first such treatise, *A History of Madness in the Classical Age* (1961).

In tracing the history of the development of the mental institution from the sixteenth to eighteenth centuries, Foucault told a story of increasing repression which contradicted the accepted view:

> Standard histories saw the nineteenth-century medical treatment of madness (developed from the reforms of Pinel in France and the Tuke brothers in England) as an enlightened liberation of the mad from the ignorance and brutality of preceding ages. But, according to Foucault, the new idea that the mad were merely sick ('mentally' ill) and in need of medical treatment was not at all a clear improvement on earlier conceptions (e.g., the Renaissance idea that the mad were in contact with the mysterious forces of cosmic tragedy or the 17th-18th-century view of madness as a renouncing of reason). Moreover, he argued that the alleged scientific neutrality of modern medical treatments of insanity are in fact covers for controlling challenges to a conventional bourgeois morality.[1]

The following will summarize Foucault's treatise on the issue and relate it to the terrifying portrayal of a mental institution in the film version of Ken Kesey's 1962 novel *One Flew Over the Cuckoo's Nest*, which won all five major Academy Awards in 1975.

Foucault announces his intentions clearly in the preface to *Madness and Civilization*: he will tell

> the history of that other form of madness, by which men, in an act of sovereign reason, confine their neighbors, and communicate and recognize each other through the merciless language of non-madness; to define the moment of this conspiracy before it was permanently established in the realm of truth. ... We must try to return, in history, to that zero point in the course of madness at which madness is an undifferentiated experience, a not yet divided experience of division itself.[2]

He proceeds to tell an eye-opening tale that draws on art and literature, on the one hand, and historical accounts of how madmen became progressively more confined, on the other.

One of the first cultural artefacts he discusses in this connection is Hieronymus Bosch's painting *Ship of Fools*, asking why 'the figure of the Ship of Fools and its insane crew all at once invade the most familiar landscapes?'.[3] His astonishing answer is that there were such ships in Germany in the sixteenth century:

> But of all these romantic or satiric vessels, the *Narrenschiff* [Ship of Fools] is the only one that had a real existence – for they did exist, these boats that conveyed their insane cargo from town to town. Madmen then led an easy wandering existence. The towns drove them outside their limits; they were allowed to wander in the open countryside.[4]

Madmen were considered to be a source of entertainment during the Middle Ages, associated with a carnival atmosphere and carefully examined as objects of great curiosity.

Part of the curiosity was about the outrageous truths that many of these enigmatic figures would utter from time to time. In literature, drama and farce,

> the character of the Madman, the Fool, or the Simpleton assumes more and more importance. He is no longer simply a ridiculous and familiar silhouette in the wings: he stands center stage as the guardian of truth-playing here, If folly leads each man into a

blindness where he is lost, the madman, on the contrary, reminds each man of his truth.[5]

Foucault describes Cervantes' Don Quixote, and Shakespeare's fool in *King Lear*, as having insights into the truths of existence which are covered up within sane society. One could add Hamlet's presumed madness, periodically seen by him as resulting from having penetrated too deeply into profoundly pessimistic truths about human existence.

The 'truth' to which such madmen frequently give voice has to do with the vanity of all things, and the emptiness of such illusions as materialism, secular power and immortality. Facing this truth involves recognizing our animal natures:

> When man deploys the arbitrary nature of his madness, he confronts the dark necessity of the world; the animal that haunts his nightmares and his nights of privation is his own nature, which will lay bare hell's pitiless truth; the vain images of blind idiocy.[6]

Our animalism is expressed in the world of passion, where violence, sexual desire and the Will to Power govern the better angels of our nature.

In Brant's famous poem about Erasmus, madness appears as the comic punishment of knowledge and its ignorant presumption: 'In a general way, then, madness is not linked to the world and its subterranean forms, but rather to man, to his weaknesses, dreams, and illusions.'[7] In the absence of the medieval attitude towards madness as spiritual possession, insanity retains its special quality by taking on an aura of insight and of the price that must be paid for such insight.[8]

That price soon gets higher, entailing confinement away from society:

> Scarcely a century after the career of the mad ships, we note the appearance of the theme of the 'Hospital of Madmen', the 'Madhouse'. Here every empty head, fixed and classified according to the true reason of men, utters contradiction and irony, the double language of Wisdom.[9]

The early 1600s was the period of 'the Great Confinement' in Paris, where 30 per cent of the populace were beggars, and where

a *Hospital Generale* was opened in a former leper sanatorium that soon housed over 1 per cent of the city's population (more than 6000 persons).

The inmates at the general hospital were initially an undifferentiated mix of criminals, madmen and the chronically impoverished. This mass incarceration was motivated by fear of the poor, of the criminal element and of the insane, and justified by the moral condemnation of all involved. In a period of economic desperation, the poor were soon seen as to blame for their plight (as they are by conservatives to this day), and hence as deserving their confinement. The insane (who were also frequently accused of being lazy) had to be confined in order to avoid further scandal and as just punishment for their outrageous violations of social conventions (mainly prohibitions against violence, sex, laughter, drunkenness and truth telling). Thus,

> in classical madness ... it is no longer because the madman comes from the world of the irrational and bears its stigmata; rather, it is because he crosses the frontiers of bourgeois order of his own accord, and alienates himself outside the sacred limits of its ethic.[10]

In each of these three types of cases, then, the evil that they embody is receiving its proper moral censure: 'There are aspects of evil that have such a power of contagion, such a force of scandal that any publicity multiplies them infinitely. Only oblivion can suppress them.'[11]

Madmen, in many ways, became the most fearful of these three incarcerated types:

> The animality that rages in madness dispossesses man of what is specifically human in him; not in order to deliver him over to other powers, but simply to establish him at the zero degree of his own nature. For classicism, madness in its ultimate form is man in immediate relation to his animality, without other reference, without any recourse.[12]

Foucault concludes that 'madness did not disclose a mechanism, but revealed a liberty raging in the monstrous forms of animality'.[13] The Age of Reason, with its abhorrence of our animal natures, could do no less than label anyone who did what comes naturally as insane.

According to Foucault, a lethal combination of Cartesianism and Christianity led Western culture to embrace an oppositional dualism between reason and the passions, privileging the former and approaching the latter with the deepest suspicion. It follows thereafter:

> The savage nature of madness is related to the danger of the passions and to their fatal concatenation ... the real target of this denunciation (of madness as 'the worst of the maladies') was the radical relation of the phenomena of madness to the very possibility of passion.[14]

Men must subdue their passionate natures at all costs and follow the dictates of reason in all situations.

The institutionalization of madmen was hence a significant development, which ended their mobility and increased their social stigma. It was

> an important phenomenon, this invention of a site of constraint, where morality castigates by means of administrative enforcement. For the first time, institutions of morality are established in which an astonishing synthesis of moral obligation and civil law is affected. The law of nations will no longer countenance the disorder of hearts.[15]

Behaviour that violates the status quo must be squelched.

The most disturbing thing about madness is that it sanctioned lawbreaking:

> Madness was one of those unities in which laws were compromised, perverted, distorted – thereby manifesting such unity as evident and established, but also as fragile and already doomed to destruction. There comes a moment in the course of passion where laws are suspended as though of their own accord.[16]

Intense emotion can, in and of it itself, provoke madness. But such emotions can also be inspirational.

Attempting to dissociate madness from both its spiritual and its passionate connotations, Foucault traces the etymology of the term 'delirium':

The simplest and most general definition we can give of classical madness is indeed *delirium:* This word is derived from *lira,* a furrow; so that *deliro* actually means to move out of the furrow, i.e., away from the proper path of reason.[17]

What this means in practice is that anyone who departs from the norm is immediately considered suspect, since it is a sign of an aberrant personality to act differently from one's neighbours or to question their routines.

Those who move out of the furrow tempt the others around them to do so as well. Hence, they must be sequestered. Madmen are depicted as hallucinating falsehoods, rather than seeing truths, and their views must be clearly labelled as illusory and distorted. Delirium involves more than believing in falsehoods ... it involves believing in non-being, in embracing nihilism. Thus

on one hand madness is immediately perceived as difference: whence the forms of spontaneous and collective judgment sought, not from physicians, but from men of good sense, to determine the confinement of a madman; and on the other hand, confinement cannot have any other goal than correction (that is, the suppression of the difference).[18]

This implies that anyone who seriously questions society's conventions is *ipso facto* insane.

This dramatic transformation in attitudes towards madness was accomplished by its confinement:

Not so long ago, it had floundered about in broad daylight: in *King Lear,* in *Don Quixote.* But in less than a half-century, it had been sequestered and, in the fortress of confinement, bound to Reason, to the rules of morality and to their monotonous nights.[19]

Public institutions engaged in very little treatment, but private sanatoriums tried to do more:

The therapeutics of madness did not function in the hospital, whose chief concern was to sever not to 'correct'. And yet in the nonhospital domain, treatment continued to develop throughout

the classical period: long cures for madness were elaborated whose aim was not so much to care for the soul as to cure the entire individual, his nervous fiber as well as the course of his imagination ... from the end of the seventeenth century, the water cure takes or regains its place as a major technique in the therapeutics of madness.[20]

The symbolic meaning of the water cure is of an act of purification from moral blight.

Treatment seeks to impose social conventions upon the insane, to get them to conform, to measure up, to return to the furrow. In so doing,

nature, as the concrete form of the immediate, has an even more fundamental power in the suppression of madness. For it has the power of freeing man from his freedom. In nature – that nature, at least, which is measured by the double exclusion of the violence of desire and the unreality of hallucination – man is doubtless liberated from ... the uncontrollable movement of the passions. But by that very fact, he is gently and as it were internally bound by a system of natural obligations.[21]

By this, I take Foucault to mean that treatment became a form of psychological conditioning that robbed patients of their freedom in order to ensure conformity and avoid scandal.

Madhouses became, in effect, places of moral instruction:

This metamorphosis, which occurred in the second half of the eighteenth century, was initiated in the techniques of cure. But it very quickly appeared more generally, winning over the minds of reformers, guiding the great reorganization of the experience of madness in the last years of the century. Very soon Pinel could write: 'How necessary it is, in order to forestall hypochondria, melancholia, or mania, to follow the immutable laws of morality!'[22]

The reign of reason is re-established by ensuring that the inmates follow the moral imperatives of their society, which enshrine rationality in standards for action.

One of the major ways that madmen were defanged was by treating them like children:

> For this new reason which reigns in the asylum, madness does not represent the absolute form of contradiction, but instead a minority status, an aspect of itself that does not have the right to autonomy, and can live only grafted onto the world of reason. Madness is childhood. Everything at the Retreat is organized so that the insane are transformed into minors.[23]

Patients were robbed of their freedom and subjected to treatment that is appropriate for a five-year-old. Workers at the asylum considered themselves to be engaged in the process of civilizing such people, by forcing them to grow up.

The medicalization of madness treated it as a disease, and the psychoanalytic model for its treatment exacerbated the tendency: 'What we call psychiatric practice is a certain moral tactic ... preserved in the rites of asylum life, and overlaid by the myths of positivism.'[24] It involves the infantilization of the patient, a return to the concerns of one's childhood, with the psychoanalyst as one's new father figure:

> To the doctor, Freud transferred all the structures Pinel and Tuke had set up within confinement ... he did not deliver him [i.e., the patient] from what was essential in this existence; he regrouped its powers, extended them to the maximum by uniting them in the doctor's hands; he created the psychoanalytical situation.[25]

In that system, maintaining the authority of the doctor (and his staff in an institution) is crucial to ensuring that neurotics conform to social norms and that psychotics harm neither themselves nor others.

Ken Kesey became an anti-establishment guru in the early 1960s with the widespread popularity of his novel, *One Flew Over the Cuckoo's Nest*, and his valourization by Tom Wolfe as the hallucinogenic leader of the Merry Pranksters in *The Electric Kool-Aid Acid Test* in the late 1960s cemented his cult status. *Cuckoo's Nest* is based on his experiences as an attendant at a psychiatric hospital, and the director of the movie version, Milos Foreman

(*Amadeus*), preserved the realism of the novel by filming it at the Oregon State Psychiatric Hospital where he worked, and using the present head of the actual institution to play the doctor in the film.[26] Formerly known for Czech comedy-dramas like *The Fireman's Ball* (1967) and *Taking Off* (1971), *Cuckoo's Nest* was Forman's first American production, where he upped the drama while keeping his dark comedic edge. He was rewarded for his efforts with the Academy Award for Best Director of 1975.

With few preliminaries, we are introduced almost immediately to the protagonist of this tale, Randle P. McMurphy (Jack Nicholson), who is being transferred to the hospital from a local penal institution. His transfer papers indicate that repeated acts of violence and disrespect for proper procedures and authorities have gotten him in this spot:

> Dr Spivey: Well, it … says several things here. It said you've been belligerent. Talked when unauthorized. You've been resentful in attitude towards work, in general. That you're lazy.
>
> McMurphy: Chewing gum in class.
>
> Spivey: The real reason you have been sent here is because they wanted you to be evaluated. To determine whether or not you are mentally ill. This is the real reason. Why do you think they might think that?
>
> McM: Well, as near as I can figure out, it's 'cause I fight and fuck too much.

McMurphy describes himself as someone who gives into his animal passions, and he is soon revealed to be a force of nature.

After his admittance interview with the doctor, McMurphy is introduced to group therapy, which happens every day. He soon becomes the centre of attention, which he was destined to be as an alpha male. Led by Nurse Ratched (Louise Fletcher), the sessions are one of the major venues where she can wield absolute authority over the patients. First she leads Harding to attribute his unhappiness with his wife to her not meeting his mental requirements (in the book it is made clear that he is most insecure about the attention her voluptuous breasts attract from other men). Then she tells Billy (Brad Dourif)[27] that she would like to be able to write in her book that he began the meeting (as a way of browbeating him to participate). Judging by the resentful look

on his face, it is immediately evident that McMurphy and Nurse Ratched will lock horns. Their first encounter is over the volume of the supposedly soothing music that is piped in to the chronic ward. He asks if it could be turned down, and she refuses, explaining that the really bad cases couldn't hear it if it was any softer. Then he is given a horse pill, with no explanation of what it is or will do. While McMurphy refuses on the pretext that he fears to lose his sexual potency by ingesting saltpeter (a nineteenth-century treatment of maniacs), he apparently takes the pill when Ratched threatens him with having it forced upon him in an other than oral manner. But he shows his fellow inmates later that he didn't swallow it.

There are several ways to build identification with cinematic characters, one of which is to show things from his or her perspective with point-of-view shots. But, in *Cuckoo's Nest*, the camera is like another disembodied observer, cutting to the characters who are speaking and conveying their emotional affect. Like the patients in the hospital, we are captivated by McMurphy's iconoclastic charisma and obvious joy of living.

McMurphy is a natural born hustler, and soon has the group playing blackjack, first for cigarettes and then for personal IOUs. He is also a born troublemaker, who resents Ratched's authority and can't understand why she has them so thoroughly dominated:

McM: God Almighty, she's got you guys coming and going. What do you think she is? Some kind of a champ or something?

Harding: No, I thought you were the champ.

McM: You want to bet?

Harding: Bet on what?

McM: One week. I bet in one week I can put a bug so far up her ass ... she won't know whether to shit or wind her wrist watch. What do you say to that? Want to bet?

He soon wins the bet, much to his eventual discomfort.

The inevitable confrontation between the two occurs over McMurphy's desire to watch the World Series with his new buddies. Routine schedules would get in the way, so he respectfully (at least initially) requests that those schedules be changed to work around the game and permit them to view it. Despite her reservations about upsetting the men by interrupting their routine, Ratched puts it up

for two separate votes. Being unable to secure a clear majority either time, McMurphy compensates by providing an imaginary play by play commentary for his fellow inmates.

McMurphy soon arranges for a special outing. Leaving the attendants behind, he hijacks their trip bus to the seacoast, commandeers a boat and takes them deep-sea fishing. Posing as doctors from the hospital, they have a gay old time and catch some big fish before they return to a dock overflowing with police and hospital personnel awaiting their return.

After being there for almost a month, McMurphy has another interview with Dr Spivey:

> Spivey: How do you like it here?
> McM: That fucking nurse, man.
> Spivey: What do you mean sir?
> McM: She ain't honest.
> Spivey: Miss Ratched is one of the finest nurses we've got at this institution.
> McM: Well, I don't want to break up this meeting or nothing, but she's something of a cunt, ain't she doc?
> Spivey: How do you mean that?
> McM: She likes a rigged game, you know what I mean?
> Spivey: Well, you know, I have been observing you here now for the last four weeks and I don't see any evidence of mental illness at all. I think you've been trying to put us on all this time.
> McM: You know, what do you want me to do (makes like he is masturbating in public). You know what I mean? Is that crazy enough for you? You want me to take a shit on the floor? Christ!...
> Spivey: How did you feel about what happened yesterday?
> McM: I wanted to kill ... I mean...

In the staff meeting afterwards, Dr Spivey announces his intention to return McMurphy to prison, despite his violent tendencies.

Ironically, it is Nurse Ratched herself who intervenes at this point:

> Well, gentlemen, in my opinion, if we send him back to Pendleton or we send him up to Disturbed it's just one more way of passing on our problem to somebody else. You know, we don't like to

do that. So I'd like to keep him on the ward. I think we can help him.

She remains an ambiguous figure, but we suspect her motives throughout. Meanwhile, McMurphy finally comes to appreciate the seriousness of his situation. When he threatens one of the black attendants with payback after he gets out (which he thinks will be in less than two months), he learns that he is under a forcible committal that ends only at the discretion of his doctor and nurse. That means he could be held there for years. Not a natural-born Christ figure, he berates his fellow inmates for failing to tell him that this was the arrangement. He regrets standing up to Nurse Ratched on their behalf, and he wishes he hadn't been so insubordinate. But they protest that they didn't know it was like that, since the vast majority of the functional ones were committed voluntarily. McMurphy is dumbfounded that they subject themselves willingly to such abuse.

McMurphy gains an ally in an inmate known as Chief (Will Sampson), a mountain of a man who poses as deaf and dumb but who reveals himself to Mac as capable of both speech and hearing. They plan a breakout, in anticipation of which McMurphy patiently holds back on his hijinks for a while. But events intervene. Nurse Ratched has shut down his gambling exploits and is rationing the inmates' cigarettes in order to ensure they cannot continue. Cheswick (Sydney Lassick) throws a relentless manic fit, demanding that his cigarettes be given to him, and McMurphy snaps. He breaks the sliding glass window and gives Cheswick his cigarettes, after which the guards must subdue them.

As punishment, both Cheswick and McMurphy are subjected to electroshock treatments, which are seen to be both grotesque and medieval. Foreshadowing his eventual condition, McMurphy comes back acting like he has been reduced to a virtual vegetable by the treatment, then shows everyone that he was just kidding.

This is the last straw for McMurphy, and he is ready to break out. The Chief, unfortunately, will not be joining him:

McM: Chief, I can't take no more. I gotta get out of here.
Chief: I can't. I just can't.

McM: Its easier than you think, Chief.

Chief: For you maybe ... you're a lot bigger than me.

McM: Well, Chief, you're about as big as a goddam tree trunk.

Chief: My pop was real big. He did like he pleased. That's why everybody worked on him. The last time I seen my father he was blind in the cedars from drinking, and every time he put the bottle to his mouth, he don't suck out of it, it sucks out of him, until he'd shrunk so even the dogs didn't know him.

McM: Killed him eh?

Chief: I'm not sayin' it killed him. They just worked on him, the way they been workin' on you.[28]

But before checking out, McMurphy has to throw a killer going-away party.

Calling the girlfriend he took with them on the fishing expedition, McMurphy arranges for treats and alcoholic refreshments, as well as for further feminine company, with which to bribe the night attendant. Hilarity ensues, in a display that is reminiscent of the Ship of Fools image from earlier in the article. McMurphy plays the role of Dionysus, getting everyone drunk and arranging for Billy to lose his virginity. As a result, McMurphy passes out and fails to escape, and when they are discovered the next morning, tragedy ensues.

Billy is initially missing, and when he is found in a compromising position with the girl, Nurse Ratched warns him menacingly that she will have to tell his mother. Terrified of the prospect, Billy commits suicide. When this is revealed, Mac grabs Ratched by the throat and attempts to choke the life out of her. It takes several attendants to pry him away. He is taken in constraints to the disturbed ward, and when he returns he had been subjected to a prefrontal lobotomy, which totally erased his personality. Chief has mercy on him and smothers him with a pillow before escaping by throwing a huge marble sink through a window.

The mental institution is here shown as a particularly volatile site of the general struggle for power in human existence. Nurse Ratched seeks complete control over all aspects of the lives of her charges. She does so by treating them as children, speaking to them in condescendingly parental tones and using her insights into each of them to find the perfect method of psychological manipulation.

She categorized McMurphy as a troublemaker from the start, simply because he refused to be intimidated. Just as the classical age feared, his willingness to buck authority was catching. Soon they are all hooked on gambling, Cheswick is throwing a fit, and Billy is willing to lose his virginity with Mac's girlfriend. Their rebellion against repressive authority caught the spirit of the age, contributing to the popularity of both the book and the movie.

The primary source of the institution's authority was indeed moral, as Foucault observed. The behaviours that were most condemned had to do with the gratification of the passions. The thrills of gambling, sex and selfish autonomy had to be denied, in favour of the hypnotic stasis of docile patients who have been drugged into submission. Autonomy also requires solitude, time to be by yourself and get in touch with yourself. But the institution frowns upon spending time alone:

Scanlon: Why is the dorm locked on weekends?
Ratched: Remember, Mr Scanlon, we've discussed many times
 … that time spent in the company of others is very
 therapeutic. And time spent brooding alone only
 increases a feeling of separation. You remember that,
 don't you?
Scanlon: Do you mean to say … its sick to want to be off by
 yourself?

She certainly makes it sound like it is.

McMurphy has seen through all the BS of contemporary middle class life and is a relentless truth teller. He questions the competence of his doctor, the supposedly altruistic intentions of Nurse Ratched and the decision of many of the competent patients to take refuge in an asylum:

McM: Jesus, I mean, you guys do nothing but complain about
 how you can't stand it in this place, and then you
 haven't got the guts to walk out? What do you think you
 are, for Christ's sake? Crazy or something? Well, you're
 not. You're not! You're no crazier than the average
 asshole out walking around on the streets. And that's it.
 Jesus Christ. I can't believe it.

McMurphy comes to understand why someone might willingly retreat from the world by talking with the Indian on the night

before the planned escape. The son of a real-life Native American chief, he watched his father beaten down by life on the reservation, resentment of his nobility and eventual alcoholism. The experience diminished his father's stature in the chief's young eyes, diminishing the boy in the process. This is what he meant by telling Mac that he wasn't big enough to face the outside world.

We are told nothing about what made McMurphy such an incarnation of animality. He is a walking ad for the sins of the flesh, and, according to the dictates of polite society, had to be put away. When he would not submit to incarceration, or psychological conditioning, he was punished with electroshock treatments and eventual lobotomy, which eliminated the threat he posed to conventional stability.

What makes McMurphy's tale stick with us is that he really wasn't such a bad guy after all. Going beyond pure self-interest, he becomes a Christ figure who sacrifices himself for the sake of his fellow inmates. Taking them fishing, fighting for their rights and getting them intoxicated (and laid) is what leads to his demise. The end of the film shows that his inspirational influence continues even after his personality is extinguished. The chief exerts superhuman strength to throw that sink through the grated window, and he is now big enough to embrace his freedom.

Jack Nicholson was the perfect actor to play McMurphy, because (as Stanley Cavell said of Cary Grant) 'the man ... carries a holiday in his eye'. His characteristic devilish look conveys the impression that he is always up to something, and whatever is about to happen is going to be good. His knowing grin and expressive face are contagious, as is his transgressive attitude, and he became the archetypical anti-hero of his generation.

So, there are several striking parallels between Foucault's account of madness in the classical age and Milos Forman's *One Flew Over the Cuckoo's Nest*. The line between the criminal and the madman is not clearly drawn, with McMurphy sitting astride the ambiguous boundary. Whichever he is, both sets of institutional practices dictate that he must be kept away from the public, and conditioned to return to the furrow of shopworn ideas and behaviours, before being released. He represents a force of nature, a return to animality, and has been institutionalized because he likes to fight and fuck too much. He vies for dominance with Nurse Ratched, only losing the struggle when his personality is extinguished. He simply will

not bow to authority, or submit to psychological conditioning, so society must forcibly silence him. But his truths have not been silenced, and his iconoclastic impact lives on.

Most fundamentally, the film raised questions about the use of mental institutions to promote social conformity which are strikingly similar to the ones that most concerned Foucault. Are the institutionalized really less sane than the 'normal'? Is it really appropriate to call such disturbances 'mental illnesses'? Do the so-called 'insane' have insights from which the rest of us simply turn away? Is institutionalization done primarily for the sake of the patient, or for the sake of a society that can no longer tolerate people who don't stick to the furrow of their long row to hoe?

Contemporary indicators suggest a sea change in attitudes towards traditional psychological diagnoses. As a recent *New York Times* op-ed piece by psychologist T.M. Luhrman put it:

> For decades, American psychiatric science took diagnosis to be fundamental. These categories – depression, schizophrenia, post-traumatic stress disorder – were assumed to represent biologically distinct diseases, and the goal of the research was to figure out the biology of the disease. That didn't pan out. In 2013, the institute's director, Thomas R. Insel, announced that psychiatric science had failed to find unique biological mechanisms associated with specific diagnoses. What genetic underpinnings or neural circuits they had identified were mostly common across diagnostic groups. Diagnoses were neither particularly useful nor accurate for understanding the brain, and would no longer be used to guide research.[29]

This explains why treatment of mental disturbances as biological illnesses has proved to be so unfruitful since the 1960s and suggests that all of the above questions remain up in the air to this day.

Questions for discussion

1 Is the borderline between genius and madness as unclear as it is often depicted in serious literature and movies? Does scientific or artistic genius require a willingness to violate

the norms of a practice? At what point should a person struggling with mental illness be forcibly institutionalized, if ever?

2 We have seen two films in a row where conformity to social norms has been depicted as the ultimate insanity. Do you strive for success, in conventional terms of amassing property, prestige and responsible heirs? If so, why do you think that such strivings have been lampooned as themselves a type of madness?

3 What should society have done with McMurphy, instead of lobotomizing him? He was a lawbreaker, a repeat offender, who disrupted the two major institutions designed to condition such offenders into conformity. Doesn't the State have the right at some point to ensure that such disruptions will not continue?

4 Do you agree with McMurphy that most of his fellow inmates were no crazier than the average person? Was he justified in criticizing them for taking refuge from the world by being voluntarily institutionalized?

Suggestions for further viewing

Spider (2002, David Cronenberg) – Ralph Fiennes plays Dennis Cleg, a man who has been institutionalized for decades and is released to a halfway house. A highly subjective portrayal of serious mental illness that suggests that some people are indeed better off in an institution.

A Clockwork Orange (1971, Stanley Kubrick) – In a dystopic future, the State decides to deal with criminality by conditioning little Alex (who is a man without a conscience) to become violently ill whenever he contemplates sexual or violent acts. Is this a just way of dealing with a sociopath? Wouldn't it be preferable to a pre-frontal lobotomy?

Girl Interrupted (1999, James Mangold) – Based on a first person account by a journalist who institutionalized herself for eighteen

months, the film is also told from her point of view. She knows she is not insane, while some of the patients around her clearly are, yet she chooses to remain, for the same cowardly reasons that McMurphy accused his colleagues of having.

A Beautiful Mind (2001, Ron Howard) – The story of John Nash (who just recently died in an auto accident), a brilliant mathematician who suffered from schizophrenia, yet made substantial contributions in the area of game theory, and earned a Nobel Prize in Economics. The connection between his illness and his unique mathematical insights is intriguingly explored.

Afterword: Existential Philosophies and the Movies that Embody Them

This book has had two major aims. As a textbook on existentialism, it sought to clarify and enrich the reader's understanding of a dozen figures in this philosophical movement. It did so by quoting and commenting on large chunks of their original writings and

by looking at a dozen films that can be seen as each of those philosophies in action. What I have sought in each chapter is to find a film that shows the philosophy in question in a positive light, while having a number of striking similarities to that philosophy, whether self-consciously intended or not.

As a treatise on cinema, *Movies with Meaning* demonstrates that films can have philosophical content, by teasing out that content in its proposed readings. To the extent that you have found these readings to be credible, I have succeeded in showing that the films in question are philosophical. To clarify what I mean here, let me allude to an article of mine on *Being John Malkovich*, which appeared in the Special Edition of *Journal of Aesthetics and Art Criticism* called 'Thinking through Cinema: Film as Philosophy' (Winter 2006).

There, I proposed that the extent to which a film can be philosophical admits of degrees and suggested the following hierarchy: (1) A film can properly be considered to be philosophical if relating it to some philosopher can help us to better understand and appreciate it; (2) a film is *more* philosophical if it is intended by its creators to express a particular philosophy and succeeds in doing so and (3) a film is most profoundly philosophical if it actually makes a unique contribution to the academic conversation about the topic.

In all but three cases, this book has discussed films that fall into type 1: ignorant of the filmmakers' intentions in these cases, I have simply highlighted the similarities between film and philosophy that allow both to be understood better. Films show philosophies in action, allowing us to understand abstract concepts in their concrete actualizations. They can do so even if their creators have no explicit knowledge of the philosophies in question. If those philosophies have true insights into the human condition, they can be paralleled unknowingly by cinematic explorations of that condition. You don't have to have read Schopenhauer to express a pessimistic outlook on life.

My readings of *Waking Life*, *Husbands and Wives* and *The Thin Red Line* suggest that they fall under type 2: they were made by directors with extensive knowledge of the philosophers in question, who were likely to be trying to express those philosophies in their films. These films are more philosophical, both because they clearly announce their philosophical heritage and because

they are particularly detailed and eloquent expressions of those philosophies.

With the possible exception of *Waking Life*, I don't believe a single film here goes beyond the philosophy with which it is paired to make a unique contribution to existential thought. Their protagonists, rather, serve as archetypes of what those philosophies are describing and advocating, of the kinds of men and women that each envisions. As such, they function as useful illustrations of those philosophies.

The films that have been analysed here have real philosophical content. That content is shown, not told: except for most of the segments of *Waking Life* and a few speeches in *The Fountainhead*, didactic philosophical arguments are not recounted at great length. These films show their respective philosophies in action, rather than telling us what those philosophies contend or why they do so.

From the point of view of film appreciation, then, this book demonstrates just how philosophical mainstream movies can be. Since it is a well-known fact that people get a lot of their ideas from the movies, it is strangely reassuring to recognize this content. By showing their philosophies in a positive light, these films influence their viewers to see the world in similar ways. The kind of critical cinema enthusiasts that this book has sought to develop will better appreciate both the ideas of existentialism and how they are represented in movies.

NOTES

Chapter One

1 Arthur Schopenhauer, *Parerga and Parilipomena* (1851), selections from which have come to be called *Studies in Pessimism*, available at: https://ebooks.adelaide.edu.au/s/schopenhauer/arthur/pessimism/ (accessed 10 July 2014). Further quotes will include an indication of the essay from which they are taken.

2 Ibid.

3 Ibid.

4 In a direct allusion to Schopenhauer, Nietzsche tells the story of Silenus, votary to Dionysus, who was asked by King Midas (of the famed golden touch) what was the best thing that could happen to him. Silenus replied that the best thing was quite beyond his reach: that he had never been born. The second best was that he dies as soon as possible. Nietzsche saw the spirit of tragedy as affirming the worth of human existence and refuting that wisdom. *The Birth of Tragedy*, sections 2–13.

5 Ibid.

6 Ibid. Bertrand Russell, in *A History of Western Philosophy*, saw Schopenhauer as something of a hypocrite in his private life, since he seemed to lack the self-denying and compassionate nature that he advocated. But even Russell admitted that he showed genuine empathy for the suffering of animals, condemning their use for experimental purposes and becoming a rigorous vegetarian.

7 Ibid.

8 Ibid.

9 Robert Wicks, Stanford Encyclopaedia of Philosophy entry on Schopenhauer, available at: http://plato.stanford.edu/entries/schopenhauer/#4 (accessed 15 July 2014).

10 'On the Sufferings of the World', *Studies in Pessimism*.

11 'On the Vanity of Existence', *Studies in Pessimism*.

12 Ibid.

13 Ibid.
14 Ibid.
15 'On Suicide', *Studies in Pessimism*.
16 Ibid.
17 Ibid.
18 Ibid.
19 'Psychological Observations', *Studies in Pessimism*.
20 Ibid.
21 'On Education', *Studies in Pessimism*.
22 Ibid.
23 Ibid.
24 Script transcribed from the film by James Skemp for the Wakinglife. net website, available at: http://wakinglifemovie.net/ (accessed 20 July 2014). The chapter listing is worth consulting, as it gives one a sense of the overall design of the film.
25 Ibid., Chapter 3 – 'Life Lessons'.
26 Ibid.
27 Ibid.
28 Ibid., Chapter 4 – 'Alienation'.
29 According to Peter Abelson,

> Schopenhauer made several remarks on the belief in reincarnation, which is quintessential for the karma doctrine. He assumed there had to be some truth in a belief as widespread as this, but he could not accept the idea of metempsychosis: the transmigration of a soul with personal hallmarks. He argued that one's personality, consisting mainly of opinions and memories, was basically intellectual and as such tied to the Vorstellung [Representation] that is human existence. Thus it could never be carried over the threshold of death. Reincarnation could only be true in the sense of a palingenesis [embryonic development that reproduces the ancestral features of the species] of the Ding an sich [thing-in-itself] into the individual beings of the world as Representation. He was convinced, however, that the Buddhists used the concept of metempsychosis only as a myth for the common herd and, like him, really held the idea of palingenesis of the Absolute.

From *Philosophy East and West*, Vol. 43, No. 2 (April 1993): pp. 255–278, available at: http://buddhism.lib.ntu.edu.tw/FULLTEXT/ JR-PHIL/peter2.htm (accessed 20 July 2014).
30 Ibid.
31 Wakinglife.net; Chapter 8 – 'Noise and Silence'.
32 Ibid.

33 There is also a lengthy discussion towards the end of the film about the notion of a lucid dream, and whether we can control our dreams consciously, concerns we will not address here.
34 Ibid.
35 Wakinglife.net; Chapter 16 – 'Meet Yourself'.
36 James Berardinelli's recent (2014) review of *Waking Life* on his website *ReelViews*, available at:http://www.reelviews.net/php_review_template.php?identifier=788 (accessed 21 July 2014).
37 Encyclopedia Britannica online entry on drug use, available at: www.britannica.com/EBchecked/topic/172024/drug-use (accessed 21 October 2014).
38 'The Universe as Will: Schopenhauer's Pessimism' by Zaikowski posted on the *High Experience*, available at: http://www.highexistence.com/the-universe-as-will-schopenhauers-pessimism/ (accessed 22 July 2014).
39 I am indebted to renowned Hitchcock scholar Ken Mogg for this suggestion.

Chapter Two

1 Max Stirner, *The Ego and His Own*, translated by Steven Byington (New York: Benj. R. Tucker, Publisher, 1907), available at: http://theanarchistlibrary.org/library/max-stirner-the-ego-and-his-own (accessed 24 July 2014). Further citations will be followed by the section titles in which they appear.
2 Ibid.
3 Ibid.
4 Ibid., Part First: Man – I. A Human Life.
5 Ibid.
6 Ibid.
7 Ibid.
8 Ibid., Part First: Man – II.I. The Ancients.
9 Ibid.
10 Ibid.
11 Ibid.
12 Ibid.
13 Ibid.
14 Ibid.
15 Ibid., Part First: Man – II.II.1. The Spirit.
16 Ibid., Part First: Man – II.II.2. The Possessed.
17 Ibid.
18 Ibid.

19 Ibid., Part First: Man – 'Wheels in the Head' in II.II.2.
20 Ibid.
21 Ibid.
22 Ibid.
23 Ibid., Part Second – I. Ownness.
24 Ibid.
25 Ibid.
26 Ibid.
27 Ibid.
28 Ibid., Part Second – II.II. My Intercourse.
29 Ibid., Part Second – II.III. My Self Enjoyment.
30 Ibid.
31 Dialogue Transcript of *Hud* on the website *Drew's Script-O-Rama*, available at: http://www.script-o-rama.com/movie_scripts/h/hud-script-transcript-paul-newman.html (accessed 27 July 2014).
32 Newman played anti-heroes from early on in his career, such as Ben Quick in *The Long Hot Summer*, Billy the Kid in *The Left Handed Gun*, and Fast Eddie Felson in *The Hustler*.
33 'A Man with Inklings of a Soul' (15 August 2010) by Michael Mirasol, on the Roger Ebert website, available at: http://www.rogerebert.com/far-flung-correspondents/a-man-with-inklings-of-a-soul (accessed 26 July 2014).
34 Bosley Crowther, Review of *Hud* for the *New York Times*, 29 May 1963.
35 'In Search of Masculinity' by Ann Barrow (2004), on the *Image Journal* website, available at: http://imagesjournal.com/2004/features/masculinity/ (accessed 27 July 2014).

Chapter Three

1 *Stanford Encyclopedia of Philosophy* entry on Kierkegaard, available at: plato.stanford.edu/kierkegaard (accessed 21 July 2014).
2 Søren Kierkegaard, *Fear and Trembling*, trans. by Walter Lowrie (Garden City: Doubleday Anchor Books, 1954), p. 44.
3 Søren Kierkegaard, *The Sickness Unto Death*, trans. by Gordon Marino in his *Basic Writings of Existentialism* (New York: Modern Library, 2004), p. 43. Further references will be followed by the page numbers from which they are taken.
4 Ibid., p. 83.
5 Ibid., p. 84.
6 Ibid., p. 85.
7 Ibid., p. 63.

8 Ibid., p. 70.
9 Ibid., p. 93.
10 Ibid., p. 105.
11 Ibid., p. 73.
12 Ibid., p. 70.
13 Soren Kierkegaard, 'Faith and the Absurd' in *Concluding Unscientific Postscript*, trans. by Swenson and Lowrie Princeton, 1941), reprinted in *Nineteenth Century Philosophy*, Edwards and Popkins, editors (New York: Free Press, 1969), p. 307.
14 Ibid., p. 305.
15 Ibid., p. 306.
16 Ibid., p. 307.
17 Entry on Kierkegaard in *The Encyclopedia of Philosophy* (New York: Macmillan, 1969), p. 366.
18 Kierkegaard, *Fear and Trembling*.
19 Ibid.
20 Soren Kierkegaard, *Either-Or*, trans. by Swenson and Swenson (New York: Anchor Books, 1959), pp. 280–296.
21 Kierkegaard, *The Encyclopedia of Philosophy*, p. 368.
22 Kierkegaard, *Fear and Trembling*, p. 31.
23 Ibid., p. 35.
24 Søren Kierkegaard, *The Present Moment* (1846), trans. and posted online by Christian Classics Ethereal Library, available at: http://www.ccel.org/ccel/kierkegaard/selections/files/moment.htm (accessed 24 July 2014).
25 Ibid.
26 Kierkegaard, *Fear and Trembling*, p. 35.
27 Ibid.
28 Ibid., p. 54.
29 Ibid., p. 57.
30 Unlike the final film of the trilogy, *The Silence*, which was more cinematically innovative.
31 Feature on the Turner Classic Movies website about *Winter Light*, available at: http://www.tcm.com/this-month/article.html?isPreview=&id=659366%7C659839&name=Winter-Light (accessed 28 July 2014).
32 Roger Ebert, Review of *Winter Light*, available at: www.rogerebert.com/great-movie-winter-light-1962 (accessed 28 July 2014).
33 See Ebert's discussion of this issue in ibid.
34 Turner Classic Movies website.
35 Quoted on the Ingmar Bergman Swedish website, available at: http://ingmarbergman.se/en/production/winter-light (accessed 28 July 2017).
36 Ibid.

37 Birgitta Steene, *Ingmar Bergman* (New York: Twayne Publishers, 1968), p. 107.

38 Ibid.

Chapter Four

1 Friedrich Nietzsche, *Beyond Good and Evil*, trans. by Thomas Common, available at: http://www.thenietzschechannel.com/works-pub/bge/bge-eng.htm (accessed 2 August 2014). Further references will be followed by the section number from which they are taken.

2 Ayn Rand, *The Fountainhead* (New York: Signet Books, 1993), p. x.

3 Ibid., 46.

4 Ibid., 53.

5 Ibid., 57.

6 Ibid., 62.

7 Ibid., 194.

8 Ibid., 188.

9 Ibid., 260.

10 Ibid., 197.

11 Ibid., 219.

12 Ibid., 6.

13 Ibid., 3.

14 Ibid., 4.

15 Ibid., 13.

16 Ibid., 36.

17 'Nietzsche's idea of an overman and life from his point of view' on the Center for Computer Research in Music and Acoustics website, available at: ccrma.stanford.edu/~pj97/Nietzsche.htm (accessed 7 February 2015).

18 Harold Alderman, *Nietzsche's Gift* (Athens: University of Ohio Press, 1977), p. 66.

19 *The Fountainhead* (1949) Movie Script, available at: http://www.springfieldspringfield.co.uk/movie_script.php?movie=fountainhead-the (accessed 30 July 2014).

20 From the 'Making of' featurette on the Turner Classic Movies DVD, released in 2006.

21 In stark contrast to what I have been arguing, Rand intended the book to be a critique of Nietzschean 'power'. The two power-mad individuals, Wynand and Toohey, are, however, not powerful in the Nietzschean sense. Wynand caters to public opinion and finds he cannot control it; Nietzsche always disdained public opinion (just as Roark did) in part for its fickle nature. Toohey hides behind the

rhetoric of socialism in order to enslave the masses … his incipient fascism is based on levelling everyone to mediocrity and not on the empowerment of excellence. This means that Rand missed the mark in both cases. [For an interesting discussion of these issues, see Lester Hunt's essay 'Thus Spoke Howard Roark: The Transformation of Nietzschean Ideas in *The Fountainhead*', available at: http:// philosophy.wisc.edu/hunt/nietzsche&fountainhead.htm (accessed 3 August 2014).]

Chapter Five

1 The connection between Heidegger and *Blade Runner* is not an original idea. It was first explored (to my knowledge) by Stephen Mulhall in volume one of *Film and Philosophy* ('Picturing the Human, Body and Soul', 1994) and more recently by Andrew Norris in '"How Can It Not Know What It Is?" Self and Other in Ridley Scott's *Blade Runner*' (*Film-Philosophy*, Vol. 17, No. 1, 2013), available at: www.film-philosophy.com/index.php/f-p/article/ view/349 (accessed 6 August 2014).

2 Martin Heidegger, *Being and Time*, trans. by Macquarrie and Robinson (New York: Harper and Row, 1962), excerpted in *Existentialist Philosophy*, 2nd edition, edited by L. Nathan Oaklander (New York: Prentice-Hall, 1996). Further references will be followed by the page numbers from which they are taken. Some of the relevant passages are excerpted here, available at: http://www. clas.ufl.edu/users/burt/spliceoflife/beingandtime.pdf.

3 Ibid.

4 Ibid., p. 4.

5 Ibid.

6 Ibid., p. 166.

7 Ibid., p. 167.

8 Ibid., p. 179.

9 Ibid., p. 189; emphasis by Heidegger.

10 Ibid., p. 189.

11 Ibid., p. 194.

12 Ibid., p. 195.

13 Ibid., p. 194.

14 Ibid.

15 Ibid., p. 166.

16 Marjorie Grene, *Introduction to Existentialism* (Chicago: University of Chicago Press, 1959), p. 50.

17 References will be to the original theatrical release of the film, including its highly controversial voice-over narration, which director Ridley Scott removed from both the 'director's cut' (which came out a decade later) and the 'final cut', which was released in 2007.

18 This hasn't deterred several commentators, in both philosophy and social work, from trying to reconstruct a Heideggerian theory of empathy. Google 'Heidegger on Empathy' for a list of articles on the issue.

19 Scott has been extremely coy about this, and a great deal of ink has been spilled on the appearance of a unicorn in later versions of the film and how it points to Deckard's replicant status. In discussing the issue for a BBC Channel 4 documentary that came out in 2000, and with reference to his Director's Cut (which was released a decade after the original), Scott indicated that Deckard is indeed a replicant, but I don't think that settles the matter. It could well be the case that the Director's Cut means something quite different from the theatrical edition, for, as a BBC News feature observed at that time: 'Little suspicion was raised (about Deckard being a replicant) by the original 1982 version of the film', available at: http://news.bbc. co.uk/2/hi/entertainment/825641.stm (accessed 7 August 2014).

20 It is important to note in this connection that Zhora beat Deckard to a pulp, Leon was about to kill him before Rachael intervened, Pris would have defeated him if she hadn't gotten so fancy, and he lost his climactic struggle with Roy. If he was a replicant as well, he should have been able to put up a better fight in each of these cases.

Chapter Six

1 Stanley Cavell, *The World Viewed: Reflections on the Ontology of Film*, enlarged edition (Cambridge, MA: Harvard University Press, 1979), pp. 2–3.

2 Martin Heidegger, 'The Origin of the Work of Art', in trans. by, Young and Hanes, *Off the Beaten Track* (Cambridge: Cambridge University Press), available at: http://www.clas.ufl.edu/users/burt/ filmphilology/heideggerworkofart.pdf (accessed 12 August 2014).

3 Ibid., pp. 2–3.

4 Ibid., p. 4.

5 Ibid., p. 14. It is interesting to note that, in 1968, Meyer Shapiro pointed that they were men's shoes, not women's, and that Heidegger was exercising a great deal of artistic license. See an article on the subject from *Harper's Magazine*, available at: http://harpers.org/ blog/2009/10/philosophers-rumble-over-van-goghs-shoes/.

6 Ibid., p. 15.
7 Ibid., p. 20.
8 Ibid., p. 20.
9 Ibid., pp. 21–22.
10 Literally 'to make or declare something (typically a church) sacred; dedicate formally to a religious or divine purpose'.
11 Ibid., p. 22.
12 Ibid., p. 29.
13 Ibid., p. 23.
14 Ibid., p. 37.
15 Ibid., p. 43.
16 Ibid., p. 37.
17 Ibid., p. 46.
18 Ibid., p. 44.
19 Ibid., p. 45.
20 Ibid., p. 46; emphasis added.
21 Ibid., p. 44.
22 Ibid., p. 47.
23 Quoted from 'Drew's Script-O-Rama', available at: http://www. script-o-rama.com/movie_scripts/t/thin-red-line-script-transcript.html (accessed 11 August 2014).
24 For example, Robert Ray, *A Certain Tendency of the Hollywood Cinema 1930–1980* (Princeton, NJ: Princeton University Press, 1985).
25 It is telling in this connection to note that Malick used excerpts from Charles Ives's short musical composition 'The Unanswered Question' in the soundtrack to the film.
26 Gavin Smith deftly distinguished between the Christianity of Captain Staros, the regressive savagery of Private Dale, the mystical connection Bell feels towards his wife, the hard pragmatism of Colonel Tall, the matter-of-fact every-man-for-himself existentialism of Sergeant Welsh and the serene Emersonian idealist that is Private Witt. *Film Comment* Jan/Feb 1999, p. 8.
27 Robert Sinnerbrink, 'A Heideggerian Cinema? On Terence Malick's *The Thin Red Line*' in *Film-Philosophy*, Vol. 10, No. 3, 2006, available at: http:/www.film-philosophy.com/2006v10n3/sinnerbrink. pdf (accessed 12 August 2014).

Chapter Seven

1 Mary Litch, *Philosophy Through Film*, 2nd edition (New York: Routledge, 2010), pp. 209–226.

2 Albert Camus, *The Myth of Sisyphus and Other Essays*, trans. by Justin O'Brien (New York: Alfred A. Knopf, 1961), p. 54. Further references to be followed by the page numbers from which they are taken.

3 Ibid., p. 3.

4 Ibid., p. 4.

5 Ibid., p. 6.

6 Ibid., p. 9.

7 Ibid., p. 12.

8 Ibid., p. 13.

9 Ibid.

10 Ibid.

11 Ibid., p. 29.

12 Ibid., p. 30.

13 Ibid., p. 27.

14 Ibid., p. 35.

15 Ibid., p. 16.

16 Ibid., p. 50.

17 Ibid., p. 53.

18 Ibid., p. 55.

19 Ibid.

20 Ibid., p. 57.

21 Ibid., p. 58.

22 Ibid.

23 Ibid.

24 Ibid., p. 59.

25 Ibid., p. 62.

26 Ibid.

27 While Camus is adamant that these examples are not ideals for all to follow, his own profligate lifestyle suggests that he truly identified with Don Juan and understood this way of life from the inside (unlike, for instance, his example of the conqueror).

28 Ibid., p. 69.

29 Ibid.

30 Ibid., p. 71.

31 Ibid. It is interesting to note in this connection that George Bernard Shaw, in the 'Don Juan in Hell' dream sequence in *Man and Superman*, gives the Don a choice between Heaven and Hell, and he chooses Hell.

32 http://www.imdb.com/title/tt0113627/reviews?ref_=tt_ql_8.

33 Roger Ebert, Review of *Leaving Las Vegas* from 2004, available at: http://www.rogerebert.com/reviews/great-movie-leaving-las-vegas-1995 (accessed 21 August 2014).

34 David Gonsalves on ecritic, posted 10 January 2007, available at: http://www.efilmcritic.com/review.php?movie=2313&reviewer=416 (accessed 22 August 2014).

35 Janet Maslin, Review of *Leaving Las Vegas* for the *New York Times*, 27 October 1995, available at: http://www.nytimes.com/movie/revi ew?res=9C07EFDE1F39F934A15753C1A963958260 (accessed 24 August 2014).

36 Ibid., p. 123.

37 Ibid., p. 55.

38 Thomas Hanna, *The Art and Thought of Albert Camus* (Chicago: Henry Regnery Co. 1958), p. 46. Further references will be followed with the page numbers from which they are taken.

39 Ibid., p. 71.

40 Albert Camus, *Caligula and 3 Other Plays* (New York: Alfred A. Knopf, 1958), p. vi.

41 Maurice Friedman, *Problematic Rebel* (Chicago: University of Chicago Press, 1970), p. 423.

42 Ibid., p. v.

43 Albert Camus, *The Rebel* (New York: Vintage Books, 1959), p. v.

44 Ibid.

45 Ibid.

46 Ibid.

47 Friedrich Nietzsche, *The Will to Power*, edited by Drazan Nicolic (Chicago: Aristeus Books, 2012) 'Nihilism. It is ambiguous: A. Nihilism as a sign of increased power of the spirit: as *active* nihilism. B. Nihilism as decline and recession of the spirit: as *passive* nihilism'. Section 22.

Chapter Eight

1 Albert Camus, 'Letters to a German Friend' (1944), published in *Resistance, Rebellion and Death*, available at: http://r3lativ.blogspot. com/2011/02/albert-camus-letters-to-german-friend.html (accessed 1 September 2014).

2 Albert Camus, *The Rebel*, trans. by Anthony Bower (New York: Alfred A. Knopf, 1967), p. 4. As usual, further references to this text will be followed by the page number from which it is taken.

3 Ibid., p. 5.

4 Ibid.

5 Ibid., p. 6.

6 Ibid., p. 7.

7 Ibid., p. 13.

8 Ibid., p. 16.
9 Ibid.
10 Ibid., p. 17.
11 Ibid., p. 22.
12 Ibid., p. 74.
13 Ibid., p. 77.
14 Ibid., p. 165.
15 Ibid., p. 178.
16 Ibid.
17 Ibid., p. 194.
18 Ibid., p. 193.
19 Ibid., p. 197.
20 Ibid., p. 212.
21 Ibid., p. 220.
22 Ibid., p. 209.
23 Ibid., p. 240.
24 Ibid., p. 250.
25 Ibid., p. 281.
26 Ibid., p. 289.
27 Ibid., p. 296.
28 As there is no online script available for this film, quotes are taken
 from the DVD.
29 Roger Ebert, Review of *Missing* in *The Chicago Sun-Times*, 1
 January 1982, http://www.rogerebert.com/reviews/missing-1982
 (accessed 2 June 2015).
30 Ibid.
31 Ibid.
32 Michael Wood, '*Missing*: Who Would Care About Us If We
 Disappeared?', available at: http://www.criterion.com/current/
 posts/704-missing-who-would-care-about-us-if-we-disappeared
 (accessed 2 September 2014).
33 User review attributed to Ucurian, http://www.imdb.com/title/
 tt0084335/reviews?ref_=ttexrv_ql_3.

Chapter Nine

1 Jean-Paul Sartre, *Being and Nothingness*, trans. by Hazel Barnes
 (New York: Washington Square Press, 1993), p. 29, available at:
 www.dhspriory.org/kenny/PhilTexts/Sartre/BeingAndNothingness.pdf
 (accessed 12 October 2014). All other quotes will be followed by the
 page numbers from which they are taken.
2 Ibid., p. 31.

3 Ibid., p. 47.
4 Ibid., p. 48.
5 Ibid., p. 49.
6 Ibid.
7 Ibid., p. 59.
8 Ibid., p. 60, emphasis added.
9 Ibid., p. 66.
10 Ibid., p. 70.
11 Ibid., p. 93.
12 Ibid., p. 200.
13 Ibid., p. 479.
14 Ibid., p. 222.
15 Ibid.
16 Ibid., p. 265.
17 Ibid., p. 297.
18 Ibid., p. 430.
19 Ibid., p. 425.
20 Ibid., p. 394.
21 Sander Lee, *Eighteen Woody Allen Films Analyzed* (London: McFarland and Co., 2002), p. 168. The present chapter is deeply indebted to his analysis of *Husbands and Wives*.
22 Ibid., p. 533.
23 Ibid., p. 534, emphasis added.
24 Ibid., p. 539, Sartre's emphasis.
25 Ibid., p. 540.
26 Ibid., p. 541.
27 Ibid., p. 542.
28 Ibid.
29 Ibid., p. 543.
30 Ibid., p. 544.
31 Roger Ebert, Review of *Closer* for the *Chicago Sun-Times*, 2 December 2004, available at:http://www.rogerebert.com/reviews/closer-2004.

Chapter Ten

1 Jean-Paul Sartre, 'Search for a Method' Part 1, in trans. by Hazel Barnes *Critique of Dialectical Reason* (New York: Vintage, 1968), available at: https://www.marxists.org/reference/archive/sartre/works/critic/sartre1.htm (accessed 1 November 2014).
2 Ibid.
3 Ibid.

4 Ibid.
5 Ibid.
6 Ibid.
7 Ibid.
8 Ibid.
9 Ibid.
10 Ibid.
11 'Search for a Method', 2nd Part, available at: https://www.marxists. org/reference/archive/sartre/works/critic/sartre3.htm.
12 This public statement of his Marxist sentiments can be found, available at: www.youtube.com/watch?v=USsUQUTpYyA (accessed 9 November 2014).
13 Marguerite La Caze, 'Sartre Integrating Ethics and Politics: The Case of Terrorism', in *Parhesia, Number 3 (2007)*, available at: http:// www.parrhesiajournal.org/parrhesia03/parrhesia03_lacaze.pdf (accessed 10 November 2014).
14 Ibid.
15 Available at: https://www.marxists.org/reference/archive/sartre/1961/ preface.htm (accessed 12 November 2014).
16 Ibid.
17 La Caze, 'Sartre Integrating Ethics and Politics'.
18 Ibid.
19 All quotes taken from the transcription on *Drew's Script-O-Rama*, available at: http://www.script-o-rama.com/movie_scripts/m/michael-collins-script-transcript-neeson.html (accessed 15 November 2014).
20 As in many Hollywood biopics, dramatic license is taken at several points in *Michael Collins*. Armoured cars did not drive into the middle of Croke stadium and open fire with machine guns, or a good deal more than fourteen people would have died. De Valera is shown arranging for the ambush personally, yet there is no historic evidence of his having done so. But a good deal of the film seems faithful to the facts, including, surprisingly, its depiction of the romantic triangle and its possible political ramifications.
21 James Mackey, *Michael Collins: A Life* (Edinburgh: Mainstream Pub. Co., 1996), p. 302.
22 Julian Sharpe, 'The Tragedy of Michael Collins', available at: http:// www.marxist.com/tragedy-michael-collins100907.htm (accessed 12 November 2014).
23 Jean-Paul Sartre, 'The "Situation" in Literature', in Hoffman and Kitromilides, eds, *Culture and Society in Contemporary Europe: A Casebook* (Sydney, Australia: Allen and Unwin, 1983), p. 53.
24 David Drake, 'Jean-Paul Sartre and the Algerian War of Independence 1954–1962', available at: http://www.westminster.ac.uk/__data/

assets/text_file/0010/247249/8-DRAKE.TXT (accessed 14 November 2014).

25 Stanley Hoffmann, Review of *Camus and Sartre: The Story of a Friendship and the Quarrel that Ended It* by Ronald Aronson, which appeared in the January/February 2000 edition of *Foreign Affairs*, available at: http://www.foreignaffairs.com/articles/60360/stanley-hoffmann/camus-and-sartre-the-story-of-a-friendship-and-the-quarrel-that- (accessed 15 October 2014).
26 Ibid.
27 Ibid.

Chapter Eleven

1 The connection here may be more direct. In Yates' original book, Frank has the following thought: 'As an intense, nicotine-stained, Jean-Paul Sartre sort of man, wasn't it simple logic to expect that he would be limited to intense, nicotine stained, Jean-Paul Sartre sorts of women?' (De Beauvoir was, of course, Sartre's long-time companion.) Richard Yates, *Revolutionary Road* (New York: Dell Publishing, 1961), p. 23. The only allusion to Sartre in the film that has been remarked upon is the appearance of his novel *Nausea* in a stack of books in the Wheelers home.
2 Simone de Beauvoir, *The Second Sex* (1949), trans. by H.M. Parshley (London: Penguin, 1972) introduction, available at: http://www.marxists.org/reference/subject/ethics/de-beauvoir/2nd-sex/ (accessed 20 November 2014).
3 Ibid., p. xix.
4 Ibid., p. xxi.
5 Ibid.
6 Ibid., Chapter One– 'Biology'.
7 Ibid., Conclusion.
8 Ibid., Chapter Three– 'History'.
9 Ibid., Conclusion.
10 Ibid.
11 Ibid.
12 Ibid.
13 Excerpts from Simone de Beauvoir, *The Ethics of Ambiguity* (Citadel Press, 1949), available at: http://www.marxists.org/reference/subject/ethics/de-beauvoir/ambiguity/index.htm (accessed 23 November 2014).
14 Ibid., Part I: Ambiguity and Freedom.
15 Ibid.

16 Ibid.
17 Ibid.
18 Ibid.
19 Constance Mui and Julien Murphy, 'Revolutionary Road and the Second Sex', in Boulé and Tidd, eds, *Existentialism and Contemporary Cinema: A Beauvoirian Perspective* (Oxford: Berghahn Books, 2012), p. 69. My reading of the film is deeply indebted to this book chapter, and further quotes will be followed by the page numbers from which they are taken.
20 Ibid., p. 70.

Chapter Twelve

1 Gary Gutting, Stanford Encyclopaedia of Philosophy entry on Foucault, available at: http://plato.stanford.edu/entries/foucault/#4.1 (accessed 1 December 2014).
2 Michel Foucault, *Madness and Civilization: A History of Insanity in the Age of Reason*, trans. by Richard Howard (New York: Random House, 1964), available at: https://libcom.org/files/Michel%20 Foucault%20-%20Madness%20and%20Civilization.pdf (accessed 26 December 2014). Further references will be followed by the page numbers on which they appear.
3 Ibid., p. 13.
4 Ibid., p. 4.
5 Ibid., p. 14. This tradition is carried on in *Revolutionary Road* (see the earlier text), with John Givings being the ironic voice of reason and truth in a sea of lies.
6 Ibid., p. 23.
7 Ibid., p. 26.
8 Herman Melville spoke of Captain Ahab as having similar insight in the mid-nineteenth century:

> There is a wisdom that is woe, and a woe that is madness, and there is a Catskill eagle in some souls that can alike dive down into the deepest gorges and soar out of them again ... even in his lowest swoop the mountain eagle is still higher than other birds upon the plain, even though they soar.

 Herman Melville, *Moby Dick* (New York: Penguin Classics, 2001), chapter 96.
9 Ibid., p. 35.
10 Ibid., p. 58.
11 Ibid., p. 67.

12 Ibid., p. 74.
13 Ibid., p. 83.
14 Ibid., p. 85.
15 Ibid., p. 60.
16 Ibid., pp. 89–90.
17 Ibid., p. 95.
18 Ibid., p. 116.
19 Ibid., p. 64.
20 Ibid., p. 159.
21 Ibid., p. 194.
22 Ibid., p. 197.
23 Ibid., p. 252.
24 Ibid., p. 275.
25 Ibid., 278.
26 William Redfield (Harding) described it (in the 'making of' documentary on the special two disk DVD edition) as 'a functioning institution for the incarceration of mentally disturbed people ... or for the examination of people who have been charged with or convicted of crimes that are judged to be ... related to cuckoo'.
27 Several of the inmates at the asylum (all of whom were making their big screen debuts) were to go on to bigger and better things, including Dourif, Christopher Lloyd and Danny DeVito.
28 In the novel their dialogue continues:

> Chief: I been talking crazy, ain't I?
> McM: Yeah Chief, you been talkin' crazy.
> Chief: It wasn't what I wanted to say. I can't say it all. It don't make sense.
> McM: I didn't say it didn't make sense, Chief, I just said it was talkin' crazy.

Here the theme of the madman seeing the truth is sounded clearly. Ken Kesey, *One Flew Over the Cuckoo's Nest* (New York: Signet, 1963).
29 T.M. Luhrmann, 'Redefining Mental Illness', in *The New York Times*, available at: http://www.nytimes.com/2015/01/18/opinion/sunday/t-m-luhrmann-redefining-mental-illness.html?ref=opinion&_r=0 (accessed 18 January 2015).

INDEX

Note: Page references with letter 'n' followed by locators denote note numbers.